The
Canon
EOS System

by Bob Shell
(All photos by author unless otherwise credited)

HOVE~FOUNTAIN BOOKS

The Canon EOS System

Bob Shell

The PRO Series
Series editor: Bob Shell
Editor: Dennis Laney
Sub-editing and Design: Shirley Kilpatrick
Typeset by: Icon Publications Limited, Kelso, Scotland
Printed in Hong Kong
First published in Great Britain 1990 by
HOVE~FOUNTAIN BOOKS
the joint imprint of

Fountain Press Ltd
2 Claremont Road
Surbiton, Surrey, KT4 4QU
ISBN 0-86343-305-7

Hove Foto Books
34 Church Road
Hove, Sussex, BN3 2GJ
ISBN 0-906447-47-X

British Library Cataloguing in Publication Data
Shell, Bob
 The Canon EOS System
 1. 35mm single lens reflex camera. Techniques
 I. Title
 771.32
 ISBN 0-906447-47-X

This publication is not sponsored in any way by Canon Inc. Information, data and procedures in this book are correct to the best of the author's and publisher's knowledge. Because use of this information is beyond author's and publisher's control, all liability is expressly disclaimed. Specifications, model numbers and operating procedures may be changed by the manufacturer at any time and may, therefore, not always agree with the content of this book.

Contents

ACKNOWLEDGEMENTS

No book is the work of the author alone, and this is particularly true in a guide book of this sort. I wish to extend my thanks to a number of people who have helped to make this project a success.

I would first like to express a special vote of thanks to Canon USA, without whose help such a project would have been doomed to failure from the start. Mike Matzkin, Dave Metz and Chuck Westfall of Canon and Terry Shea of the Rowland Company deserve special thinks in this regard for their patience and cooperation in supplying test equipment and technical information.

Other firms have also been helpful by supplying product samples or other support used in the preparation of this book. These firms are: Agfa-Gevaert, Fuji, The Saunders Group, The Polaroid Corporation, Theodore Bromwell and Heico Inc.

To Gene Kester of Photoflex goes a special thank-you for supplying the Multidome and Halfdome softboxes used in taking the studio photos for this book, and for his suggestions on the photography.

Charlie, Mack and Mike of PFS Photo Finishing helped greatly by processing the colour photos for the book, I thank them for their excellent and speedy work.

I'd also like to thank my friend Peter Dechert for suggestions on the book and for the photos in the history chapter.

Many of the photos in this book would not exist without the assistance and professionalism of my models, they worked hard and deserve at least half the credit for the photos in which they appear.

The last, and most important, of these acknowledgements goes to my wife, Darlene, whose unflagging support made it all possible, and who contributed some excellent photographs to the book.

The Canon Story

In 1933 a small company was founded in Japan under the name Seiki Kogaku Kenkyujo. This company was convinced that a high-quality 35mm camera could be designed and built in Japan for sale in the world market. A series of research prototypes was constructed over the next few years, all bearing the Kwanon name, the original name under which the company had intended to market these cameras. Due to a number of problems none of the Kwanon cameras ever went into production.

By the time the company was ready to go ahead with a serially produced camera in 1935, the camera name had been changed to the present Canon. With this change in name the long Canon dynasty was inaugurated and has continued to the present day.

The first camera bearing the Canon name was the Hansa Canon of late 1935. Canon, from the company's inception, was not content simply to copy German cameras as so many other Japanese firms did, but generated an ever-increasing list of original design elements and technological developments. The Canon rangefinder cameras which followed the Hansa Canon were a long-running series of cameras made to very high standards of fit and finish and accepting an excellent series of lenses. At first the lenses were supplied by Nippon Kogaku (Nikon) but later Canon developed their own in-house optical manufacturing facilities and went on to develop many pioneering designs in optics. The increasingly sophisticated Canon rangefinder cameras were made continuously until the last model, the Canon 7s, which appeared in its final version in late 1968. Today these fine cameras are avidly collected by enthusiasts and many are still in use.

In 1959 two cameras appeared which changed forever the history of 35mm photography. They were the Nikon F and the Canonflex. Professional photographers who had been using Nikon and Canon rangefinder cameras began to make the transition to the reflex cameras, which offered greater ease of composition and direct viewing of depth of field. Although the first SLR (Single Lens Reflex) from Canon, the Canonflex, was very well designed and thought by some authorities to be built better than the Nikon F, it did not catch on very well with the professionals due to some peculiarities of operation. It wasn't until the end of the 1960s that

The first camera to bear the Canon name.
Photo: Peter Dechert.

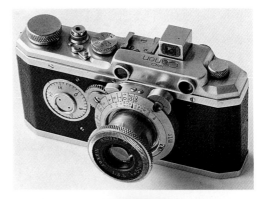

The Canonflex was Canon's first SLR camera.
Photo: Peter Dechert.

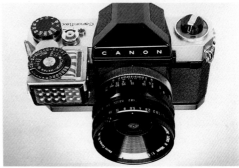

Canon began to succeed well in the professional and advanced amateur sectors with their Ft series of SLR cameras, followed later by their very professional F1.

A real landmark in camera production came in 1973 when Canon introduced the AE-1 camera. This was not only an electronically controlled camera but was also designed for automated mass-production, largely by robot. The top cover of the AE-1 was the first use of Canon's new development in which injection-molded plastic parts were then plated with metal. This allowed the manufacture of lightweight and reasonably tough parts with complex configurations without the high costs associated with similar parts made from stamped metal. By adopting these lighter, less expensive parts, simplifying the overall design and doing with inexpensive electronics what had formerly been done with mechanical components, Canon was able to make and sell the AE-1 for an incredibly low price. Very soon after its introduction the AE-1 had become one of the best-selling cameras of all time, and many

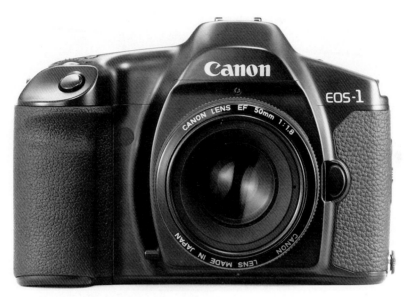

The Canon EOS 1. The professional member of the EOS family.

thousands of these fine little cameras are still in use today. Following the AE-1, several other cameras based on the same overall design were produced, culminating in the A-1.

As a follow-up to the incredibly successful "A" series of cameras Canon continued with their efforts toward technological excellence with the "T" series of SLR cameras. At the present time these cameras are still quite popular. For information on the T-70 and T-90 cameras see the individual guides to these cameras also published by Hove Foto Books.

While working on the T series cameras, Canon engineers were looking toward the future. Automatic focus was obviously coming. Canon had shown a prototype of an autofocus camera in 1963 and a second, more advanced prototype in 1964. Although they stated that these cameras were near production, in reality it was more than twenty years before a practical autofocus system for SLR cameras was a reality. Canon's early efforts on autofocus prepared them for the future, and their research efforts in this direction were well ahead of many of their competitors.

For those more interested in the history of Canon, I can recommend the book Canon Rangefinder Cameras 1933-68 by my friend Peter Dechert, published by Hove Foto Books. Peter is now at work on a sequel which will be a complete history of Canon SLR cameras.

1: The EOS Concept

When autofocus SLR cameras became technically feasible most major camera makers set up research projects directed at producing prototypes which could be developed into production cameras. Canon was involved in this research very early, and their programme was different enough from that of other manufacturers that their ultimate design priorities were also very different. The system used by all other makers of autofocus SLR cameras except Canon utilizes a motor in the camera body which is coupled to the focusing mechanism in the lenses by a drive shaft and gears. While this system does work, there is energy loss due to friction and the motor in the camera must be designed to operate with all sorts of lenses from simple and lightweight to complex and heavy.

Canon's engineers studied this approach, but they decided from the beginning of their programme that the proper place for the autofocus motor was in the lens itself. By placing the motor right where the focusing motion was needed they could avoid energy loss problems caused by friction, and they could also tailor each motor to the needs of the lens into which it was fitted. This reasoning at first lead to the **T-80** camera and its lenses.

Unfortunately this camera was not a great success with photographers largely due to the unwieldy size and shape of the lenses which resulted from the need to house the motors available at the time. Realizing that they were right about the need for the motor to be in the lens in spite of the lack of success of the T-80, Canon's engineers decided to literally start from the ground up and design new motors for the lenses in the upcoming new system.

By taking this approach they were able to design the motors to best fit the lenses rather than the other way around. The result of this research effort was the development of two new types of motors which can be

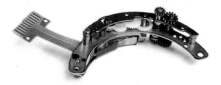

The AFD or Arc Form Drive motor.

fitted into the lenses without increasing their size or weight much above that of non-autofocus lenses of similar characteristics.

The first of these new motors is called the **Arc Form Drive** (AFD). The AFD is an arc-shaped electric motor. In operation it is very similar to any other DC electric motor, it is only the shape that is different. The lens is driven from the motor by a series of gears which are mounted on the AFD plates. Since the entire operating system of the EOS cameras is based on digital processing by an onboard computer in the camera, the lens must send a digital signal to the camera to let the computer or **Central Processing Unit** (CPU) know how far the lens has moved. Canon has devised a way to do this that is both simple and elegant.

In a cut-out opening in the top of the AFD can be seen a small wheel with alternating silver and black stripes. This wheel is called a "chopper" and as the gears turn to focus the lens they also turn this wheel. Just above the wheel, mounted in the opening is a small **Light Emitting Diode** (LED) and a small sensor or detector which responds to the light from the diode. In turning, the wheel alternately reflects and interrupts this light and generates a direct digital pulse signal in the sensor. This information, along with other lens information, is returned to the camera body through the electrical contacts inside the lens mount.

The second new motor devised by Canon for the EOS lenses is called **UltraSonic Motor** (USM). The USM really has very little in common with traditional motors, lacking both coils and an armature. Basically it consists of two metal rings, as shown in our photo. One of these rings, the stator, is fixed in the lens barrel and has a number of piezoelectric elements bonded to it. The other is the rotor, pressed against the stator but free to move. By applying an electrical signal of suitable frequency, polarity and phase to the piezoelectric elements the rotor is caused to turn and drive the focusing mechanism. The USM is faster and quieter than the AFD motor, but for technical and cost reasons it was limited at first to application in lenses of relatively large diameter.

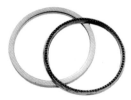

The two rings which form the basis of the USM or UltraSonic motor.

After they had developed these special motors to drive the focusing mechanism of their lenses, the designers at Canon concluded that it would be a good idea to eliminate all mechanical connections between the camera body and the lens. After all, these mechanical pins and levers which protrude from the rear of all other SLR lenses were a constant source of trouble, being easily damaged due to their exposed position when the lens is off the camera.

Canon was not the first to conceive of this idea of transmitting all information and actions between the camera body and the lens electrically. Rollei had used such a system in their SLX camera quite a while earlier, but that was a medium format camera, and no one had applied the concept to a 35mm SLR. After Canon had developed the two autofocus motors the only remaining action in the lens was the opening and closing of the iris diaphragm. A third motor was then developed for this and can be seen in our photo. This is a special type of motor called a stepping motor, that is a motor which turns to a particular position in response to a digital signal, and the use of this sort of motor in the lenses insures that the diaphragm will consistently produce an opening of exactly the same size at any given setting.

By using these motors in the lenses Canon has eliminated all mechanical actions between camera body and lens. All information and all electrical signals to the motors move through a series of electrical contacts inside the bottom of the lens mount which mate with a set on the rear of each lens. Thus when the lenses are removed from the cameras there are absolutely no protruding pins or levers to worry about. Reasonable care to keep the electrical contacts clean is all that is needed to keep these lenses operating perfectly.

To match these new and unique lenses Canon has developed cameras which are equally sophisticated. At the time of writing, seven EOS cameras have been introduced*. The first four, the **EOS 1, EOS 620, 630** (**600** in Europe) and **650** are more advanced in features and specifications. The **EOS-RT** is a special-purpose camera and is an EOS 630(600) body but with a pellicle mirror. The simpler **850** and **750**, while offering a more limited range of features, still accept all of the EOS lenses and are capable of taking excellent photographs in situations where the more advanced features of the other cameras are not critical. They make an excellent introduction to the EOS system, and excellent second bodies for owners

* But see page 232ff

The electrically driven diaphragm mechanism.

of other EOS models. My hope is that readers of this book who already own EOS 850 and 750 cameras will keep them, but will be motivated by reading this text to purchase one of the more advanced models.

To make the cameras both light in weight and durable, Canon has made the bodies from a composite design. The lens mounting bayonet is made from metal and is firmly attached to a central casting, also of metal. Critical camera parts such as the reflex mirror, focusing screen, shutter and shutter cocking motor are mounted on this solid metal framework. At the rear, the film gate (the metal plate across which the film travels and which has the actual picture aperture in it) is also made from metal and attached to the central casting. Thus the actual "camera" is made from metal and the critical dimension from the front of the lens mounting bayonet back to the film is maintained by metal-to-metal contact.

Since making the entire camera in this way would make it quite heavy without accomplishing much to improve durability, the balance of the camera body is made from several types of industrial resin (plastics) reinforced with glass fibre. This results in a remarkably rugged camera body which is far lighter than it would appear to be.

To protect important electrical circuits and the camera's CPU from electromagnetic interference or damage the top cover of the camera is made from plastic which is heavily plated with metal and then given a special scuff-resistant black coating.

AUTOFOCUS IN THEORY AND IN PRACTICE

Automatic focusing systems have been the dream of camera designers and photographers for years. Even those photographers who are the strongest skeptics about autofocus will be forced to admit that it works, and that it works far better than their eye in many situations. In some situations it is the only way focus can be assured.

There are basically two types of autofocus systems which could be called active and passive. An active system actually provides its own reference for focus, generally by shooting out an infrared beam which is reflected from the subject to a sensor. By simple triangulation such a system determines the subject distance and sets the lens accordingly. Just as with older rangefinder cameras, this system operates independently from the taking lens and is not really suitable for an SLR camera with interchangeable lenses. However, it is the system of choice for simple autofocus cameras and most of those on the market today use this system. A variation of this active autofocus uses sound waves instead of infrared radiation and is used on some Polaroid cameras.

The other type of system is that which I have defined as passive because it does not generate its own reference, it relies on the ambient light. Such systems generally work by sensing differences in subject contrast, since a subject always shows the highest image contrast when it is in focus. In these systems the lens is moved by a motor until the point of highest contrast is reached. While different manufacturers use different designs and forms of sensors they all operate in basically the same way.

The BAse Stored Information Sensor or BASIS. The heart of the autofocus system.

For the EOS cameras Canon has chosen to design and build their own autofocus sensor rather than buying it in from an outside source as most other camera makers have done. This has allowed Canon the freedom to design a sensor which is an integral part of the system as a whole.

The sensor developed by Canon is called the **BAse Stored Information Sensor** (BASIS). All autofocus sensors have a threshold of operation, that is a minimum amount of light which must be present for them to function. In designing the BASIS, one particular goal of Canon has been to make this threshold as low as possible so that the cameras will function in very dim light. Canon's stated sensitivity is EV 1 in all but the EOS-1 in which special amplification circuits are used to extend the sensitivity down to EV –1. The EOS-1 uses a new crossed array BASIS which is sensitive to both horizontal and vertical contrasts. (If you are unfamiliar with the term EV, an explanation will be found in the *Sensitometry* section, page 80.)

You will find that the autofocus system in your EOS camera works for such a large percentage of the situations and subjects you are likely to encounter that you will wonder how you ever did without it.

With modern autofocus, auto-exposure cameras it is quite possible for anyone to produce perfectly exposed and focused photos which are otherwise absolutely dreadful. For this reason I hope that you will pay particular attention to the chapter called *Picture Taking*, page 180, which takes you beyond the technical aspects and into the artistic side of photography.

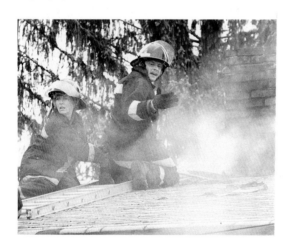

Photojournalists need rapid, accurate focusing with consistent exposure, good lenses and reliable camera functioning in all conditions. This prizewinning photo of firefighters at work on a roof was taken by Randy Lilly.

THE EOS CAMERA MODELS

At the time of writing, there are seven EOS cameras **(see appendix for recent additions to this range)** but eight different model designations. Canon have chosen to call one model the EOS 630 in North America and the EOS 600 elsewhere. Throughout the book I will refer to this model as the EOS 630(600). The Canon models are the 850, 750, 650, 630(600), 620, RT and EOS 1. All are essentially similar in adhering to the EOS concept, but differ in capabilities and specific design features. The photographs on this and following pages show the cameras and point out the location of the controls. On page 46 you will find a chart of the features on the various models of EOS camera.

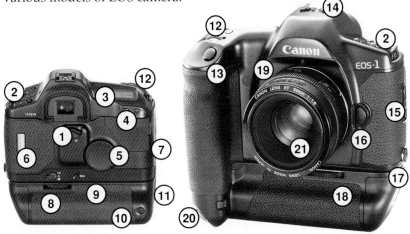

Key to EOS-1 controls:
1) Quick On-Off Switch 2) Metering, Filmspeed and Mode Button cluster 3) LCD Display Panel 4) LCD Panel illumination and Partial Metering Buttons 5) Exposure (over-ride/A) Control Thumb-wheel 6) Film Cassette Viewing Window 7) Trapdoor covering infrequently used controls 8) Master Power Switch with optional sound-warning 'on' position 9) Film Manual Rewind Switch 10) Exposure Hold secondary button on Booster E1 11) Remote Release Socket 12) Exposure (program shift/S) Control Finger-wheel 13) Shutter Release 14) Dedicated shoe for Speedlite flash units 15) Camera back opening release catch and button 16) Lens Release Button 17) PC-Synch Flash Terminal 18) Screw to fit/remove Power Drive Booster E1 19) Self-timer LED 20) Remote Release Socket 21) Lens Identification Ring with Slot for Lens Hood.

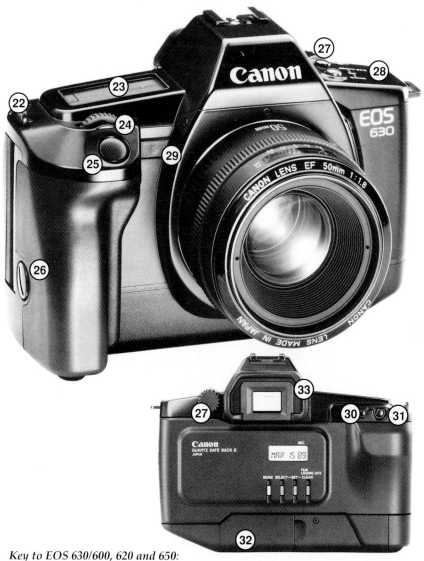

Key to EOS 630/600, 620 and 650:
22) Neckstrap fittings 23) LCD Display Panel 24) Electronic Input Dial (finger-wheel) 25) Shutter Release 26) Thumbscrew to remove handgrip and replace with optional grip/battery holders 27) Main On-Off Switch with optional position for audio warning signals 28) Mode and Exposure Compensation Buttons 29) LCD flashing light for self-timer indication 30)Display Panel illumination 31) Partial Metering Button 32) Hinged cover for rarely-used controls and settings

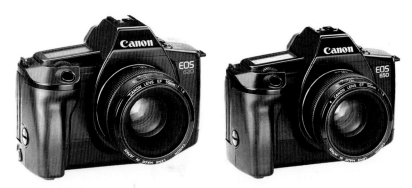

Above: the EOS 620 (left) and EOS 650 (right) share a fundamentally similar control layout to the EOS 630 shown on the facing page.

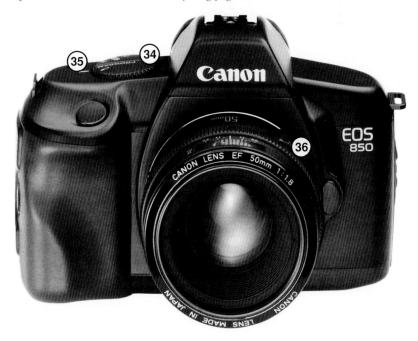

Bottom: the EOS 850 more closely resembles the EOS 750 (overleaf) and is simpler than the 600-series. In the EOS range, higher three-figure model numbers indicate fewer features or more fully automatic operation.
 34) Main On-Off, Program/Mode Dail 35) Frame counter
 36) All EOS lenses feature an Auto/Manual focus switch which is not on the body

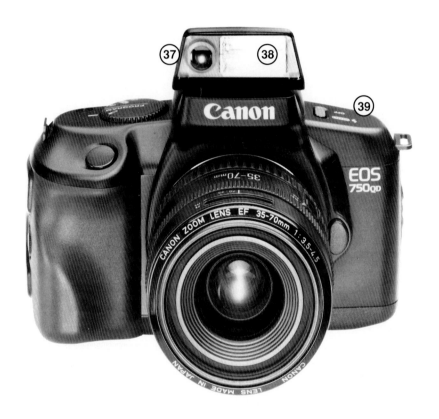

EOS 750 QD:

This camera has the features of the 850 combined with a built-in automatic camera-top strobe which can pop up and be ready for shooting almost instantaneously, if the camera detects a low light-level. The Quartz Date function built in to the camera is a simplified version of the Data Back shown on the previous spread.

37) Infra-red pre-flash for focusing in the dark 38) Flash tube 39) On-Off Switch for manual flash operation and Automatic Flash switch-on mode.

This camera is shown fitted with a 35-70mm EF zoom lens, popular alternative to the standard 50mm lens, making the 750 QD into a complete outfit for quick and easy photography.

The EOS RT

The EOS RT is a specialist's version of the EOS 630(600) made in limited quantities for professionals and dedicated amateurs. This camera has a fixed pellicle mirror which is an ultra-thin film allowing 65% of the light to pass through, the remaining 35% being reflected on to the focusing screen. Because there is no movement of the mirror before exposure, the release time has been reduced to 8 milliseconds, comparable to that of a non-SLR camera; hence the name RT, which stands for Real Time.

The pellicle mirror gives three other advantages; the viewfinder image is visible throughout the exposure, release is much quieter and there is less sharpness-destroying residual vibration.

The price paid for the advantages of a pellicle mirror is a 2/3rd stop loss in effective lens aperture. Normal TTL metering will compensate for this automatically, but when using a hand-held meter, or setting the flash manually, 2/3rd stop extra exposure will be necessary.

The EOS-RT has eight more Custom Functions than the EOS 630(600). These are:

	CF Control changes to:	from regular operation:
8	Shift metering pattern to centre-weighted average metering for more choice	Evaluative metering
9	Aperture priority AE with flash locks shutter speed at 1/125th sec to eliminate camera shake. Particularly suited to Softfocus EF 135mm.	Shutter speed set according to subject's peripheral brightness
10	Start continuous wind-on demand with camera set for single operation, display panel illumination button provides instant over-ride for continuous operation	Display panel illumination button turns on light
11	Delay film winding until pressure on shutter button is released	Winds after exposure
12	Limit continuous exposure to 3 frame sequences	Continuous exposure to end of roll
13	Allow multiple exposure without resetting	Cancels upon completion
14	Shift 'real time' release lag to 40ms, same as F-1	8ms
15	Disable all preset custom functions	–

The short release time coupled with the viewfinder image being visible through the time of exposure, make the EOS-RT particularly suited for sports photography, photo-journalism and even portrait photography. Facial expressions can be captured precisely at the moment the photographer wants. The additional benefit of quiet operation will appeal to wildlife photographers, or those who work in public places where silence is mandatory. The camera will also find scientific application where vibrations must be avoided or the image must be monitored or tracked through long exposures.

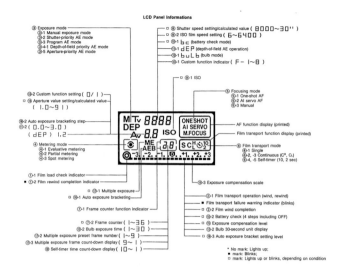

③ Exposure mode
③-1 Manual exposure mode
③-2 Shutter-priority AE mode
③-3 Program AE mode
③-4-1 Depth-of-field priority AE mode
③-5 Aperture-priority AE mode

□ ⑧ Shutter speed setting/calculated value (8000~30'')
⑧-2 ISO film speed setting (6~6400)
⑧-1 bc (battery check mode)
⑪-1 dEP (depth-of-field AE operation)
⑪-1 buLb (bulb mode)
⑪-1 Custom function indicator (F- 1~8)

□ ⑨-1 ISO

⑪-2 Custom function setting (0/ 1)
□ ⑩ Aperture value setting/calculated value (1.0~9)

⑪-2 Auto exposure bracketing step ⑪-2 (0.0~3.0) (dEP) 1.2

④ Metering mode
④-1 Evaluative metering
④-2 Partial metering
④-3 Spot metering

⑤ Focusing mode
⑤-1 One-shot AF
⑤-2 AI servo AF
⑤-3 Manual

AF function display (printed)
Film transport function display (printed)

⑥ Film transport mode
⑥-1 Single
⑥-2, -3 Continuous (C", C₁)
⑥-4, -5 Self-timer (10, 2 sec)

①-1 Film load check indicator
■ ①-2 Film rewind completion indicator

⑪-3 Exposure compensation scale

□ ⑪-1 Multiple exposure
□ ⑪-1 Auto exposure bracketing
⑦-1 Frame counter function indicator

⑥-1 Film transport operation (wind, rewind)
■ Film transport failure warning indicator (blinks)
□ ⑥-2 Film wind completion
□ ⑨-2 Battery check (4 steps including OFF)
⑪ Exposure compensation level
⑥-2 Bulb 30-second unit display
□ ⑪-3 Auto exposure bracket setting level

□ ⑦-2 Frame counter (1~36)
⑥-2 Bulb exposure time (1~30)
⑪-2 Multiple exposure preset frame number (1~9)
⑪-3 Multiple exposure frame count-down display (9~ 1)
⑨ Self-timer time count-down display (10~ 1)

* No mark: Lights up;
■ mark: Blinks;
□ mark: Lights up or blinks, depending on condition

The LCD Panel and the Basic Camera Controls

On the top right side of the EOS 650, 630(600) and 620 cameras is a light grey area in which all information on the camera's operation is displayed. The information is displayed in an alpha-numeric code on a Liquid Crystal Display, commonly called LCD. By using this LCD and computer-type internal switching, Canon has been able to produce a camera with a multitude of features and functions with a minimum of necessary controls. The main switch, a rotary switch with four positions is located on the left top rear of the camera, just beside the eyepiece. This turns the camera on and off and sets the major operational functions. All of the camera's commonly used modes are controlled by two buttons on the left top cover and a control wheel just behind the shutter release button. Two small buttons on the rear of the camera just back of the LCD panel control partial metering and LCD illumination. Other functions which were judged to be seldom used are controlled by four buttons under a small trapdoor on the lower back side of the camera.

When the camera is turned off (the **L** or Lock position on the main switch) nothing appears on the LCD panel if the camera is not loaded with film. If there is film in the camera two important pieces of information will be displayed, the frame counter number showing the number of the next exposure to be made and (toward the bottom middle of the LCD) a pictographic image of a film cassette with three bars to represent the film coming out.

When the camera is switched on by turning the main switch to either of the positions to the left of **L** the rest of the display will be activated. The fourth position of the main switch, a green rectangle to the right of the **L** position is the camera's "auto program only" position and will be covered later.

It will be easiest to follow this explanation of the LCD indications if reference is made to the diagram overleaf while reading. Along the top of the LCD is a narrow band marked off by a dark line. When the camera is on, one of four indicators will appear in this area indicating the exposure mode to which the camera is set. From left to right the indicators are **M** for Manual, **P** for Program, **Tv** for Time-value, otherwise known as shutter priority, and **Av** for Aperture-value, more commonly called aperture priority. An in-depth explanation of these modes will be found in Chapter 2.

To change from one of these modes to another it is necessary to depress the front button on the left top plate (marked **MODE**) and, while holding the button, rotate the control wheel in the direction of the desired change. Each click of the control wheel will move to the indicator directly to the left or right of the one displayed.

Just below the band which displays the operational modes of the camera is an area in which two more pieces of operational information are displayed. On the left side is an area which will display the letters **ISO** followed by a number. This ISO number is the relative sensitivity of the film to light, commonly called film speed. Since the EOS cameras are equipped with an automatic film speed sensing system it is not normally necessary to be concerned with this display, which will only appear just after the loading of the film. However when using film which is not supplied in DX-coded cassettes, or when using film you have loaded yourself from bulk rolls, you will need to be able to set the camera for the correct ISO number. How this is done is explained in the section *Manual ISO Setting*, page 66. Should the ISO display appear and blink on and off after loading of the camera this is a signal that the camera has not been able to sense a code on the cassette and the ISO setting will have do be done manually. During normal operation of the camera the shutter speed and *f*-stop information will be displayed in this area instead of the ISO information.

To the right of the ISO display area is another display area which will be blank except when its mode is engaged. This is the display area for the exposure compensation setting. When the button on the left top cover

marked **EXP.COMP** is pressed this display is activated and may be set by rotating the control wheel.

At the bottom left of the LCD is an area marked off with an orange rectangle. The camera's two autofocus modes are indicated here. The normal mode is called **ONE SHOT**, and in this mode the camera will focus and then fire when the shutter release button is pressed. It will not fire until it has achieved focus and will not fire at all if it can not focus. Pressing the shutter release button half way in this mode locks the focus, however, and so if the subject moves after this time you may get an out of focus photo. For following moving subjects the second autofocus mode, called **AI SERVO** (**SERVO** in 650 and 620), is better. To change from **ONE SHOT** to **SERVO** you must open the small trapdoor on the back of the camera toward the bottom left side. Inside is a small orange button labeled **AF**. When this button is pressed the control wheel may be turned to shift from one mode to the other. In the **SERVO** mode the camera's autofocus system will continuously track a moving subject and exposure may be made at any time. It is important when using this mode to make sure that the subject is not moving too fast for the camera to track. A bit of practice on moving subjects should give you a feel for what you can and can't do with this system.

Also within this same orange rectangle on the LCD panel is a third indicator, at the bottom. In normal operation this area is blank, but if you switch the lens from autofocus to manual focus this area will indicate **M FOCUS** as a reminder.

Moving to the right along the bottom of the LCD panel there is an area which will display an image of a film cassette if one is in the camera, as mentioned previously. When the camera is empty nothing will appear in this area. If the film has been loaded but has not threaded properly when the camera back was closed the cassette will appear but the three bars indicating film advance will flash on and off as a signal that the film has not advanced properly. If this happens, remove the film and reload. If the film has been rewound but not removed from the camera the image of the cassette alone will appear, and it will flash on and off. This is to remind you to remove the film.

The same three bars which appear when you have loaded film to indicate correct film transport also serve another purpose, the battery check. Again inside the trapdoor on the camera back there is a small button with a drawing of a battery to identify it. When this button is depressed it should cause one or more of these bars to appear. See

Batteries and Battery Check, page 76.

Just above the location of the first of the battery test-film advance indicator bars are two small indicators which only appear when the functions they indicate are operating. The top of these is a small rectangle with the letters **AEB** inside and refers to the camera's **Auto Exposure Bracketing** feature. This is activated by depressing the two small buttons so labeled inside the trapdoor. It allows the photographer to automatically make exposures which bracket the metered exposure. Just below the **AEB** indicator is another consisting of the letters **ME** in a small rectangle. This appears to indicate that the camera's **Multiple Exposure** mode is activated, which is done by depressing both of the buttons on the camera's left top cover (those marked **MODE** and **EXP.COMP**). When this system is activated in this way the **ME** indicator appears and at the same time the frame counter sets itself to 1. By holding the two buttons down and turning the control wheel it is possible to set the frame counter for any number from 1 to 9. This allows the set number of exposures to be made on a single frame of film. After each exposure the camera's shutter and mirror cocking motor operates but the film advance motor does not so that the film remains stationary.

The frame counter, as already mentioned, lies just to the right of the **AEB** and **ME** indicators. It counts up as the film is advanced and automatically sets to 1 when the film is loaded. Thus it always indicates by number the next exposure to be made and not the number already made. This should be remembered, as an indicator showing 36 on a 36 exposure roll means that there is still one frame left. Unlike many cameras, there is no need to fire off blank frames at the beginning of the roll to set the counter, the camera automatically advances to the proper position for the first exposure when it is loaded. Likewise there is no need to do anything to activate the rewind, the camera senses the end of the roll and does this automatically. You simply keep taking photos until the sound of the rewind motor lets you know that the camera has started to rewind the film. The frame counter counts down as the film is rewound. Once the film is back in the cassette the image of the film cassette on the LCD will begin to flash on and off as a reminder to remove the film from the camera. During time exposures the frame counter will display and count the number of seconds of the exposure.

And now we come to the last of the indications on this very versatile LCD panel. On the far right is a narrow vertical rectangle outlined in blue. Moving from the top down the possible indicators are an **S**, a **C** and

a small drawing of a clock face. Inside the trapdoor on the camera back is another of those small buttons marked with these same indicators. By pressing this button and turning the control wheel the indicator visible may be changed.

The first indicator, the **S** at the top, stands for **Single frame**, this is the setting used for general picture taking. When shifted to the **C** position the camera is set for **Continuous** shooting and will take photos in rapid succession. The last position which you can set on this drive mode indicator is indicated by the small image of a clock face. This is the position which activates the self timer. When the self timer is activated the camera will fire about ten seconds after the shutter release button is pressed.

On the top of the camera at the back, just in line with the frame counter on the LCD panel is a small black button. When this button is pressed the LCD panel is lit from underneath by an electro-luminescent panel. This is useful for reading the display information in dim light, especially for use in theatres when photographing the floodlit stage from the darkened audience and in other similar situations. When the button is pressed a soft blue glow appears behind the LCD and remains lit for about eight seconds, giving plenty of time to read the information without unnecessary drain on the battery. If it does not stay on long enough it is no use holding in the button, it still switches off after eight seconds. For longer times it must be reactivated by pressing the button again after each eight second operation.

While the use of this LCD panel allows the display of very much information in a small space, this type of display does have some drawbacks. In very cold temperatures the LCD panel will respond very slowly. When working in temperatures below about 0 °C (32 °F) the camera should be kept warm by being carried inside clothing close to your body, taking it out for the shortest possible period of time. At very high temperatures the LCD panel may become dark overall and display no information. This will happen at around 60 °C (140 °F) which is a very good reason not to leave the camera in a car in hot weather or too near a heat source in winter. Optimum operating temperature for the camera is about 20 °C (68 °F). Should the LCD panel fail to function from being too hot or too cold it will resume functioning when returned to the normal temperature range, although frequent exposure to heat may damage it.

LCD displays also have a limited lifespan, generally from three to five years. After that time the display information will become increasingly

dim and the LCD will have to be replaced. Canon has considered this in the design of the EOS cameras and has provided easy access for the repair shop to make this replacement. The buffer battery of the EOS-1, which retains the camera's factory programmed memory, is replaced at the same time and has about the same life span.

The Viewfinder Information Display

The most important information from the LCD panel is also visible inside the EOS 650, 630(600) and 620 camera's viewfinder making it unnecessary to take the camera away from the eye while working. The EOS 850 and 750 cameras have viewfinder display only and lack the external LCD panel. Because these two simpler cameras have fewer features, their viewfinder display is limited to autofocus, autoexposure and flash confirmation lights.

Canon's designers have wisely chosen to display information so that it does not intrude into the picture area. It is instead displayed in a long rectangle directly underneath the image area (in the horizontal camera position). When the camera's shutter release button is lightly depressed the camera's metering system is turned on and this display is activated and remains visible for eight seconds. In normal operation there will be two numbers displayed in this viewfinder area, the first being the **shutter**

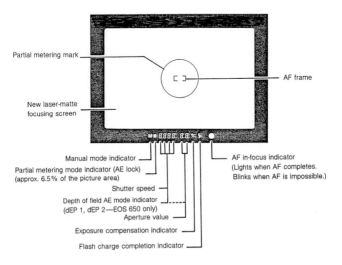

Partial metering mark

AF frame

New laser-matte focusing screen

Manual mode indicator

Partial metering mode indicator (AE lock) (approx. 6.5% of the picture area)

Shutter speed

Depth of field AE mode indicator (dEP 1, dEP 2—EOS 650 only)

Aperture value

Exposure compensation indicator

Flash charge completion indicator

AF in-focus indicator (Lights when AF completes. Blinks when AF is impossible.)

speed and the second the *f*-**stop**, or aperture. At the far right, outside this rectangular display, is a circular indicator which indicates proper focus. When focus is correct this indicator glows green. The indicator will flash rapidly if the autofocus system is unable to focus. This same indicator can also be used as an aid when manual focus is used, indicating correct focus with a constant green glow.

When the camera is set to its **Manual** mode of operation a reminder in the form of an **M** will appear inside the far left margin of the display. This should make it almost impossible to make a Manual exposure accidentally. Just to the right of this Manual operation reminder, between its location and the shutter speed display, is another reminder in the shape of an asterisk (*) which appears whenever the camera's partial metering mode has been activated. This, too, makes it difficult not to notice that you have accidentally activated the spot meter by the position of your thumb.

Moving to the right past this reminder we come to the main exposure information. This is displayed in the form of two numbers, as in **90 5.6**. The first number is the shutter speed, shortened by convention but in this case indicating 1/90th second. The second number is the aperture number or *f*-stop, also shortened and here indicating an aperture ratio of 1:5.6. The meaning of these two numbers is explained in the section Ω, page 80.

To the right of the *f*-stop number is an area which displays another reminder, in this case an indicator which appears in the form +/–. This indicates that the exposure compensation mode is active. When the compensation is set to **0**, this symbol disappears. The last bit of viewfinder information appears just to the right of this +/– indicator. It appears in the form of a stylized lightning bolt which has become the the the universal symbol for electronic flash. When used with one of the Canon flash units designed for these cameras, or with a properly dedicated unit from another manufacturer, this lightning bolt symbol will appear when the flash is charged and ready to fire. In this way the ready status of the flash may be monitored without taking the eye away from the viewfinder.

Since this in-finder information is also produced by an LCD panel, it is subject to the same temperature and lifespan limitations as the main external LCD panel described above. It must be replaced at the same time as the external LCD panel. The internal LCD is illuminated by its own light source whenever activated and is not dependent on an external source of light as in some other cameras. The camera automatically

adjusts the brightness of this illumination to correspond with the light coming through the lens so that this panel will be easily visible on very bright days but will not be distractingly bright when the camera is used in dim light.

Since all important exposure information is visible in the viewfinder it is very easy to follow action sequences without taking the camera away from your eye. This makes the EOS cameras admirably suited for journalistic photography, nature photography, sports photography and any other type of work in which peaks of action must be captured without the distraction of having to take the camera away from your eye. Once you have learned the positions of the controls most adjustments may be made with the camera at eye level.

The EOS cameras are ideal for action photography – you can monitor the exposure without removing your eye from the viewfinder. The EOS RT, with its fixed pellicle mirror, allows the most precise release timing. Photograph by courtesy Randy Lilly.

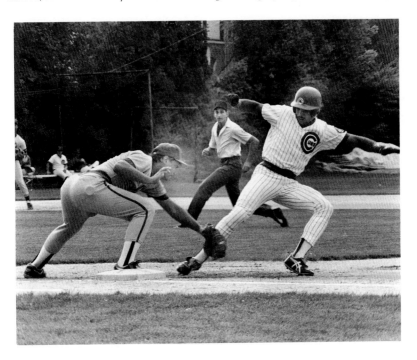

THE EF LENS MOUNT

When Canon engineers developed the EOS system it became apparent to them early in the project that there would be no way to make this new system and utilize the existing Canon FD lens mount. It would have been possible to make the new cameras use a modification of the FD mount, but this would have placed serious limits on the camera designers as well as placing restrictions on the Canon lens design team. It was decided, with some reluctance I am sure, to abandon the breach-lock mount which had been the trademark of Canon SLR cameras since the first Canonflex. In its place they have designed a new, standard configuration, quarter-turn bayonet mount. Since they were starting from scratch the designers decided to try to make this new mount as immune to obsolescence as possible. Since lens designs are restricted by the maximum diameter of the rear lens element, it is an advantage for the designer to have the largest possible bayonet opening to work with. In the case of the EF lens mount the bayonet has an inner diameter of 53mm, the largest opening yet seen in a lens mount for a 35mm SLR camera. This has allowed greater freedom to Canon's lens designers and has made possible some truly exotic lens designs such as the new 50mm $f1.0$ EF lens. This will also make it easier for other new high speed lenses to be developed in the future.

In operation the EF lens mount is very similar to most other existing bayonet mounts. To remove the lens from the camera the lens release button on the front of the camera (in the 3 o'clock position) is pressed in and the lens is grasped and turned through approximately one-quarter of a turn in the clockwise direction. It is then pulled straight out from the camera body. Even though the Canon EF lenses have no protruding pins or levers on the rear surface and are thus not as subject to damage as older designs, it is a good idea always to put a rear lens cap onto the back of the lens as soon as it is removed from the camera. This will protect the rear glass from abrasion, will keep the electrical contacts clean and will keep dust and grit from getting into the rear of the lens. Each Canon EF lens is supplied with both front and rear caps and both should be kept on at all times when the lens is not in use.

If another lens is not to be fitted immediately, the camera body should

also be protected by its plastic body cap. This protects the reflex mirror from damage and keeps dust and dirt out of the mechanism.

To fit a lens onto the camera, simply align the raised red dot on the lens barrel (just behind the **AF - M** switch on most lenses) with the inset red dot at the top centre of the camera body bayonet and gently push the lens into the body until the mating flanges on body and lens are in contact. The lens is locked onto the camera by turning counter clockwise until a soft click announces that it has locked into place. There is no need to depress the lens release button when fitting a lens onto the camera.

If resistance is met with at any stage in the mounting or dismounting of a lens, stop immediately. Do not apply force. The lens should go onto or come off the camera with ease. If you hear a gritty or grinding sound when you start to turn the lens, it is a sign that dirt or sand is on the mating surfaces. If this happens when mounting the lens, take it off again immediately and wipe both the camera body mount and lens rear bayonet with a soft, clean cloth. Then try mounting the lens again. If there is still resistance or a grinding sound, go no further. Take the equipment to your photo dealer or repair shop for inspection. As with anything else on your camera, force should never be required to mount or dismount a lens and can only damage the mechanism.

Although it was technically impossible to produce and FD to EF lens adaptor without optical elements, Canon have now produced one which produces a minimal increase in focal length. The FD-EF converter has a magnification factor of 1.26X and a 2/3rd stop light loss. Diaphragm operation is manual. The converter can be used with lenses of 200mm or greater focal lengths, and with the 50-300, 85-300, and 150-600 zoom lenses. The converter has a 4 element, 3 group multicoated optical design.

For special purposes some simple lenses and accessories such as slide duplicators, soft focus lenses and non-automatic bellows units and lenses may be fitted to the EOS-1, 650, 630(600), RT and 620 cameras. Due to the lack of manual indexing, such accessories are not suitable for use on the EOS 850 and 750 cameras. These products are made by a number of suppliers and are generally attached to the camera body by means of an adapter called a "T-mount". Since there are no mechanical or electrical connections in these products, the camera's autofocus and focus confirmation systems will not work. However the camera's light meter will still operate, but only in the Manual and Av modes. In the Manual mode the lens aperture setting on the camera body is set to $f1.0$ and the reading

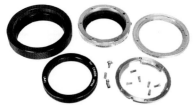

By using a T-mount (left) or home-made adaptors, other lenses and accessories may be adapted to the EOS cameras.

taken by adjusting the shutter speed and non-coupled diaphragm if the system has one. In the Av mode the aperture setting on the camera body is also set to *f*1.0, but in this mode the camera will automatically pick the correct shutter speed. (In the Program and Tv modes the light meter will still respond, but there is no way for the camera to control the diaphragm so incorrect exposure would result.) Microscope and telescope adapters may be used in the same way. It is important when using any of these systems with the EOS cameras that a series of test exposures be made to determine how accurately the metering system will work with the particular set-up you are using.

While talking about the lens mount this is also a good time to mention that the EOS-1, 650, 630(600), RT and 620 cameras are designed to accept interchangeable viewing screens. These used to be called focusing screens, but that terminology is not really appropriate for a screen used in an autofocus camera. Some of them are useful when focusing the camera manually because they have focusing aids built into them. If you find that you are manually focusing there cameras frequently and have some trouble focusing on the standard screen, you may want to investigate these other screens. I mention this in the section about the lens mount because the screens are changed through the lens mount. Each of the screens is supplied with a storage box and a special plastic tool for changing. Never attempt to do this with anything other than this tool – there are too many areas inside the lens mount which are subject to damage from contact with fingers or an improper tool.

THE SHUTTER

The Canon EOS 650, 630(600), RT and 620 cameras use a shutter which is an evolutionary development of the original EMAS shutter first used in the T 50 and T 70 cameras. EMAS stands for ElectroMagnetic Attraction Shutter. This shutter is a vertical travelling design with very lightweight blades made of metal-coated plastic. These lightweight blades can be spring driven at a very high speed which allows the EOS 620 to achieve a very fast maximum shutter speed of 1/4000th of a second, an action stopping speed which will freeze fast subject motion. The slightly slower shutter used in the EOS 650 and 630(600) delivers a maximum shutter speed of 1/2000th of a second; a similar shutter is used in the 750 and 850 cameras. They are called ElectroMagnetic Attraction Shutters because the shutter blades are held in their cocked position by two small permanent magnets surrounded by electromagnets. The new shutter designed for the EOS-1, while basically similar in operation to the EMAS units, is different enough to justify Canon not calling it an EMAS. At press time technical details in this new shutter had not been made public, but it has a maximum shutter speed of 1/8000th of a second and can be set in 1/3rd step increments instead of the 1/2 steps of the EMAS shuttered models.

When the shutter is cocked the locking arms are moved into contact with the permanent magnets against spring tension and are held there by the magnetic attraction. When the shutter is fired the camera's electronic systems sends two pulses of electricity to the electromagnets. These pulses energize the electromagnet, opposite in polarity to the permanent magnets. This neutralizes the permanent magnets and releases the locking arms. The interval between pulses determines the shutter speed.

After the exposure the blade sets are moved back to the cocked position together so that no light can pass them during the cocking action and the blades are relatched into place by the locking arms again being held by the permanent magnets. Studying our diagram for a few minutes should make this all clear.

Because of its location at the back of the camera just in front of the film, the EMAS module belongs to the general class of shutters referred to as focal plane shutters. They are located as close to the plane of focus as is practical. The two sets of blades used in the EMAS may be referred to as

curtains by some writers, a reference dating to the time when all such shutters had cloth blinds or curtains instead of metal or plastic blades.

An important characteristic of the EMAS and all other current focal plane shutters is that there are limits on how fast the blades can be made to travel across the film aperture. It is mechanically impossible to achieve very fast speeds, 1/4000th second for example, by having the first set of blades travel completely across the aperture before the second set is released. Present technology does not provide us with blade materials or mechanical designs capable of this.

To accomplish the higher speeds the operation is altered so the second set of blades, referred to as the closing blades (or sometimes as the second curtain), is released before the first set has travelled all the way across the film aperture. The closing blades then follow the opening blades across the aperture creating a moving slit. This slit gives each part of the film's surface area an exposure equivalent to the set speed, but does not expose the entire film area at the same time. The actual speed at which the blade sets cross the entire aperture will be the fastest speed at which the shutter opens fully before beginning to close. In the case of the EOS-1 and 620 cameras this speed is 1/250th second, 1/125th second in the other EOS cameras.

In addition, this fastest speed at which the shutter is fully open is also the fastest speed at which the camera will synchronize with electronic flash, since the flash produces a burst of light of very short duration which must be allowed to strike the entire surface of the film. Of course it is perfectly possible to use flash at any speed slower than this speed. In practice with the EOS-1 and 620 this means that you can use electronic flash at 1/250th second or any slower speed, 1/125th second with the other EOS cameras.

If you were to attempt to take photos with electronic flash at speeds faster than the synchronization speed you would get photos in which only a part of the image is exposed by the light of the flash. Typically such photos show a normal image over part of the area and then a black band

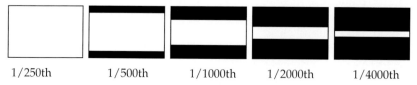

| 1/250th | 1/500th | 1/1000th | 1/2000th | 1/4000th |

The difference in the slit width of the shutter at various speeds

horizontally across the bottom of the photo blacking out more or less of the image. The higher the speed, the broader this black band will be.

When using the Canon EOS cameras with one of the dedicated flash units made for the cameras this is not a problem since the flash communicates with the camera and will not allow the speed to be set too high. When used in the camera's automatic modes the flash and camera will work together to set the correct shutter speed automatically. However when using EOS cameras with a flash from a manufacturer other than Canon it is important to keep this in mind unless the flash is specifically designed to operate in a dedicated manner with the EOS cameras. When using the EOS-1 or 620 with professional studio flash equipment it is important not to set the camera for a speed faster than 1/250th second. With some older studio flash equipment even this may be too fast, as some of these older units have rather long flash durations, and it would be a very prudent idea to make some tests at different shutter speeds to determine which provides the best synchronization.

The ability to synchronize the camera's shutter with flash at speeds as high as 1/250th second is a feature relatively new to photography. In most older focal plane shutter designs the fastest speed which could be used with flash was 1/60th second. The reason that this may be important is that you may wish to make sure that your exposure is made only by the light from the flash and not from ambient light. When the ambient light is rather bright it may cause "ghosting" or secondary images in the photos if a slower speed must be used with the flash. Also flash is frequently used to fill in the shadows in outdoor photography under contrasty light, and the faster flash synchronization speed provides much greater flexibility in balancing the fill flash to the ambient light.

Another interesting design feature of the shutters in the EOS-1, 630(600), 650 and 620 is that you have the option with certain Canon flash units of selecting either standard flash synch, which fires the flash just as soon as the shutter is open, or a secondary option called "Second Curtain Synch" which fires the flash just prior to the second blade set's closing. A more detailed explanation of this along with suggestions for its use will be found in the FLASH chapter.

One last point about the shutter which can not be overemphasized: When you have the back of the camera open for film loading DO NOT TOUCH THE SHUTTER. Because the blades must be very thin and light to move as fast as is required, they are also fragile. A misplaced finger can

lead to an expensive repair. Equally it should be emphasized that under no circumstances should this shutter be subjected to streams of high-pressure compressed air such as those sometimes used to clean out the interiors of cameras. If such a stream of air is used to clean the interior of this camera, it must be scrupulously kept away from the shutter. Air under pressure can dislodge the shutter blades from their guide tracks and create a needless and expensive repair. My personal recommendation is to buy a squeeze bulb type of blower from a camera dealer and use it carefully to blow any dust or debris off the shutter blades. Any dirt which cannot be blown away by gentle use of such a blower may be loosened with gentle touches of a soft camel hair brush and then blown away. See the section on Maintenance in the Appendix for a more detailed coverage of camera care.

Above: a high shutter speed helps capture aerial action! Photograph by courtesy of Michael Vordo. Top right: modern colour films are capable of rendering richly saturated colours which very faithfully reproduce the colours of the subject. Photo: Agfa Gevaert. Bottom right: When working on self-assigned photos for creative stimulation and for the portfolio, don't neglect the simple. Photo: Agfa Gevaert.

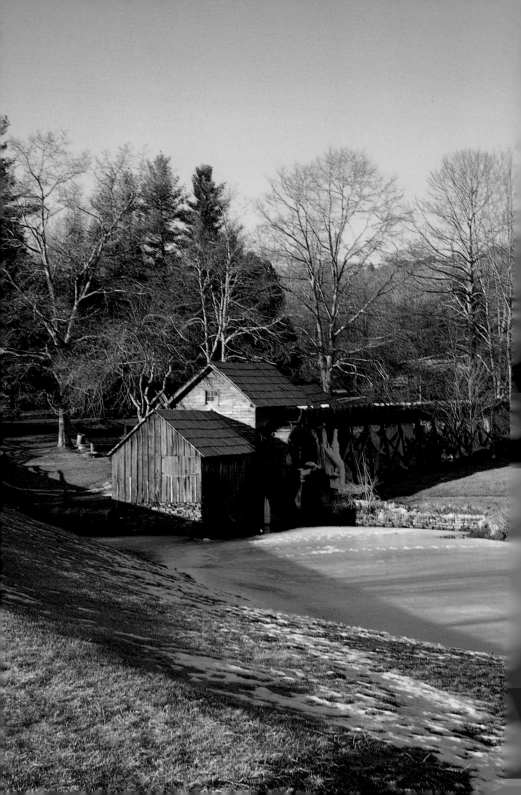

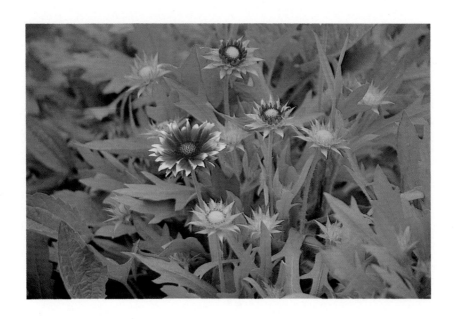

Left: Mabry Mill in the Blue Ridge Mountains of Virginia is said to be the most photographed mill in the world. However, most photographers photograph it in warm weather, not the dead of winter. The common can become uncommon when seen in a new way.

Above: this photo is a good example of why you should not always leave the main subject in the centre. After allowing the EOS to focus on the flower, the photographer used the focus hold to recompose the photo for a more pleasing arrangement of the elements. Photo Darlene Shell.

Overleaf: a single-light low key portrait. When photographing black models in the studio, I find that an incident light meter reading is essential.

THE LIGHT METERING SYSTEM

Early photographers had no way of measuring the light falling on their subjects and had to use a mixture of experience and luck to get correct exposures. This sad state of affairs led to the invention of the photo-electric exposure meter which could take the amount of light falling on a photosensitive material and convert that to photographically useful information. The next step in this evolution was to build the meters into the camera, and the last and current stage was to place the photosensitive sensors, called photocells, inside the cameras so that they measure the light actually coming in through the camera lens. In recent years nearly every 35mm SLR camera has had such a meter which measures light Through The Lens, abbreviated TTL. Since this measures the light after it has been reflected from the subject and passed through the camera's lens, it is accurate enough for most photography.

All meters which measure light reflected from the subject are designed to assume a subject reflectance equivalent to a subject with an even grey tonality. Technically this medium grey is exactly halfway between the darkest and lightest tones which film is capable of recording, and this turns out to be a grey tone with a reflectance of 18%. If you were only taking photographs of these 18% grey subjects, or if all your photo-graphic subjects averaged out to 18% on the nose, you would never have exposure problems and almost any light meter would do. In practice, we photographers stubbornly insist on photographing subjects which do not average out to 18% reflectance, and the camera makers have had to accommodate us by designing new types of light meters.

Basically there are just two types of TTL meters, those which take a general reading of the entire image area and arrive at an average value for the exposure and those which read only a smaller, clearly defined area. The first type is generally referred to as an averaging meter (sometimes full averaging meter) while the second sort is referred to as a partial meter. The Canon EOS 750 and 850 have the full area metering only, but all the top end models have both.

While it is rather easy to devise an averaging meter which just lumps everything together and averages it out, this produces a meter which will not give usable exposure information in far too many situations. In the

A very high contrast lighting situation – bright sky and dark foreground. The Canon metering system is programmed to recognize such frequently-encountered conditions and will provide far better exposure than a normal 'centre weighted' TTL meter.

past this was solved by biasing the meter to take more of its information from the central portion of the picture on the assumption that the most important element was usually in that area. Such meters are called centre weighted. While better than a general average, the centre weighted type of meter is often fooled into giving incorrect exposure information.

Canon wanted to provide the EOS cameras with a better meter, one which would give correct exposure information in the greatest number of exposure situations. After studying many thousands of typical photos taken by amateur and professional photographers they devised the evaluative metering system used in all the EOS cameras. This is a radically new type of meter. Instead of taking an overall average reading, this meter actually takes separate "partial" readings from six different areas of the subject and then analyzes the information using a complex internal program to determine proper exposure. In this way the camera can ignore an overly bright or dark tone in one of the six areas and not incorrectly bias the exposure. If one or more of the six areas gives a reading which is greatly different from the overall exposure the camera is able to determine from its internal program that this area should or

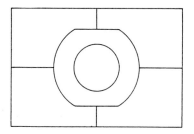

The zones in Canon's evaluative metering system.

should not be given emphasis. A good example is when photographing outdoors with the upper part of the image containing an area of bright sky. Unless this sky area predominates, it is largely ignored when computing the exposure so that detail will not be lost in more important parts of the image. Older averaging systems were incapable of making such choices because, in modern parlance, they were not "smart" systems, they were able only to handle all images in the same way and would underexpose the main subject when confronted with a bright sky area or bright background.

This is not to say that the Canon system is foolproof. There are always exposure situations which will fool any metering system. That's why we have photographers instead of simply entrusting all photography to robots carrying cameras. Canon has provided several ways for the photographer to override the system, the first and simplest being with the partial meter. When taking a photograph of a subject against a generally light background, sky or sunlit window for example where the light area predominates in the image, the camera will be fooled into underexposing the subject if using the six area evaluative mode because most of the six areas will be reading the light background area.

There are also situations where centre-weighted metering is useful, and many professionals learned their trade on cameras which use this metering method so the EOS-1 has the option of switching the multi -area

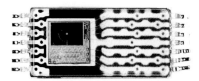

The six zone photocell used in the EOS light meter.

41

evaluative metering over to a simpler centre-weighted system.

The partial area metering mode of the EOS-1, 650, 630(600), RT and 620 switches the internal metering system so that the camera meter reads only a small, clearly defined area in the centre of the image. This area is about 6.5% of the total area and is delineated by a circle inscribed on the camera's viewing screen. By placing the circle on the important subject and taking the light reading, the influence of too light or too dark a background will be eliminated and the main subject will be correctly exposed. The partial area metering is activated by pressing a button on the top rear of the camera just behind the LCD panel in the EOS 650, 630(600) and 620 cameras. This button will fall comfortably under your right thumb, and must be held in while operating the partial area metering system. A bit of practice may be needed to get the feel of this feature, but it is a very valuable tool and every photographer using the EOS cameras should be familier with the increased control it allows. In the EOS-1 the limited area metering is selected by pressing the metering mode button and rotating the main control wheel until the proper graphic is displayed on the LCD panel.

Because professionals encounter situations in which even the 6.5% limited area metering covers too large an area, the EOS-1 is also equipped with a true spot meter which reads only a 5mm circle in the centre of the viewfinder, or 2.3% of the image. This allows readings to be taken from a very small area, particularly with telephoto lenses.

In using the Canon EOS 650, 630(600) RT and 620 cameras for some time both for commercial and personal photography I have found that the six area evaluative metering system is extremely accurate and can cope with almost any sort of lighting and subject matter. It is important always to keep in mind that the meter assumes a reflectance of 18% and will only meter with absolute accuracy when the tonal values of the subject average out to about that value. If photographing subjects of greater reflectance (e.g. snow scenes, at the beach, etc.) or subjects of very low reflectance (e.g. black cats, African skin, etc.) an adjustment must be made to render the subject on the film correctly. This can be done in several ways, but the most direct method is through the camera's built-in exposure compensation facility. For a detailed explanation of this feature see the section *Exposure Compensation*, page 62, chapter 2.

An alternative method of determining exposure under difficult subject conditions is to ignore the camera's built-in metering system altogether and use a separate, hand-held light meter. The following brief

discussion of these meters will be of interest to those who intend to work with such meters and may be skipped by those who intend to use only the camera's built-in metering system.

Hand-Held Light Meters

There are basically two types of hand-held auxiliary meters, those which read continuous and those which read the short bursts of light produced by electronic flash units. Either of these types of meters may read light in two ways, they may read the light reflected from the subject back to the meter, or they may read the light falling on the meter itself. These two types of reading are commonly referred to as reflected and incident.

Reflected reading meters read the light reflected from the subject, and are thus very similar to the camera's built-in meter. Since the metering system in the EOS cameras is so sophisticated, I can see little need for using such a hand-held meter for general photography. It would certainly be no more accurate than the camera's own meter. Unless you need the capability of metering in very dim light for exposures which are hours in length or the ability to measure the light from studio flash units, there will be no benefit in using one of these.

There is a specialized type of reflected meter which may occasionally be of use in difficult shooting situations, called the narrow-angle spot meter. Such meters commonly read an angular field of only one degree or so and are thus capable of taking readings from a much smaller area than the camera's spot meter. Again, I do not recommend the purchase of one of these for general photography, but for those whose work is critical enough to require this very tiny metering angle nothing else will do. Of course, if you have invested in the EOS-1, the camera comes with a built-in spot meter which is just as accurate as these separate spot meters.

Incident reading meters measure the light incident (falling on) the meter itself. They can be distinguished from reflected meters by the white, hemispherical dome which covers the photo cell. Since this sort of meter reads the light falling on itself, it is unlikely to give erroneous readings due to differing subject reflectance. In use the meter is held in the subject position and the dome is pointed towards the camera. The exposure determined in this manner will be accurate without modification in nearly every case. Of course, if you are using an incident meter

and your subject is a distant mountain range it is not generally practical to drive to the mountains for a meter reading and then back again to take the photo. Even if you could, the light would surely change! In such situations it is not important how far from the camera the meter is held so long as the light falling on the meter is the same as that falling on the subject. In the case of distant mountains it would only be important to make sure that the meter was not shaded by a tree or passing cloud.

Another important use for the incident meter is to determine lighting contrast, often referred to as lighting ratio. This is done by first taking a highlight reading in which the meter's dome is pointed towards the light source and then taking a shadow reading with the meter's dome pointed directly away from the light source. The difference between the two readings is the contrast range in f-stops. Since different films have different degrees of latitude, that is different lighting ratios which they are able to record accurately, it may be important to know this and match the contrast recording ability of the film to the scene, or vice versa. See the chapter on FILMS for information on the contrast range which different films are capable of recording.

Another use for a good incident meter is to determine the evenness of light used in copy work and other photography in which even illumination is desired. For this type of work, most of these meters may be fitted with a flat diffuser in place of the hemispherical one used for general photography. Readings are taking with the flat diffuser's front surface parallel to the subject from centre, mid areas and corners. Light deviation can easily be seen in this way, and the lights may be adjusted to provide absolutely even illumination.

For those photographers who feel that they will not use a good incident meter enough to justify the cost, an inexpensive alternative is to purchase what is known as a grey card from a photo dealer. This is a carefully made piece of cardboard or plastic with exactly 18% reflectance. This card is placed in the subject position, or under the same light, with its flat face parallel to the front of the camera. A meter reading is then taken with the camera's meter from a position close enough so that only the grey card is seen through the viewfinder. With the EOS cameras the card does not have to be brought close to the camera so long as it is close enough to fill the spot metering circle in the viewfinder and the reading is taken in the camera's spot metering mode. Contrast range can be determined with a gray card by first taking a reading with the grey card facing the light source and then taking another reading with it facing

away from the light source. It is important to make sure that the shadow from camera or photographer does not fall on the card, as this will give incorrect readings.

You may think that the difference between the highlight and shadow readings would always be the same, since no light from the source will be striking the shadow areas. This is not the case because there is always some light reflected into the shadows by the surroundings. It is the reflectance level of these surroundings which ultimately determines the lighting ratio and the contrast range.

In the past most photographers who worked in the studio would have a special flash meter for taking readings from the studio flash units. Today, however, there are many very good meters on the market which will read ambient light as above and also the light from studio flash units. Thus a single good meter may be pressed into double duty. Operation of most of these meters for reading the light of studio flash units is essentially identical to the methods detailed above for reading ambient light. Many of these meters will have to be connected with the studio flash units by a cable so that the activation of the meter fires the flash units, but some operate in a cordless manner and some may be used either way.

Remember when taking flash readings that the meter should be set for the flash synchronization speed of the camera in use and will give a readout of the correct f-stop to be used. Exposure control is done by adjusting the light output of the flash units, moving them to different distances or both.

I have tested and used many different light meters over the years, but my present personal favourite in a good all around meter is the Sekonic L-328. This is an incident meter which will read both ambient and flash, it may be converted to a reflected reading meter with an accessory, and it is both dependable and extremely accurate, giving readings graduated in 1/10th f-stop increments. It is small and lightweight, and is powered by a single AA cell.

SUMMARY OF THE FEATURES OF THE DIFFERENT EOS MODELS

	850	750	650	630(600)/RT	620	EOS-1
Aperture Priority Mode			•	•	•	•
Shutter Priority Mode			•	•	•	•
Program Mode	•	•	•	•	•	•
Depth Mode	•	•	•	•		•
Manual Mode			•	•	•	•
Auto Exposure Bracketing				•	•	•
Exposure Compensation			•	•	•	•
Film Prewind	•	•				
Built-in Flash			•			
Depth of Field Preview			•	•	•	•
Manual Focusing	•	•	•	•	•	•
Manual Fine Adjustment of Focus in AF mode (USM lenses only)				•		•
Predictive Autofocus				•		•
Program Shift			•	•	•	•
Partial Metering			•	•	•	•
Multiple Exposures				•	•	
Custom Functions				•		•
Programmed Image Control				•		•
1/2000th Top Shutter Speed	•	•	•	•		
1/4000th Top Shutter Speed					•	
1/8000th Top Shutter Speed						•
1/125th Flash Sync Speed	•	•	•	•		
1/250th Flash Sync Speed					•	•
Mid-roll Film Rewind			•	•	•	•
Self-Timer	•	•	•	•	•	•
Predictive Autofocus				•		
Interchangeable Viewing Screens			•	•	•	•
TTL Program Flash AE	•	•	•	•	•	•
A-TTL Program Flash AE	•	•	•	•	•	•
DX Auto ISO Setting	•	•	•	•	•	•
Manual ISO Setting			•	•	•	•
Remote Release Capability			•	•	•	•
Camera Shake Warning	•	•	•	•	•	•
Second Curtain Flash Sync			•	•	•	•
Battery Check	•	•	•	•	•	•
AE Lock			•	•	•	•
1.2 fps max Motor Speed	•	•				
3 fps max Motor Speed			•		•	
5 fps max Motor Speed				•		•
One Shot AF Mode	•	•	•	•	•	•
Servo or AI Servo Mode			•	•	•	•
Audible Focus Confirmation Cannot be Cancelled	•	•				
Audible Focus Confirmation User Cancellable			•	•	•	•
LCD Information Panel (External)			•	•	•	•
Switchable Illumination for External LCD Panel				•	•	•
Interchangeable Handgrips			•	•	•	•

2: The Operational Modes

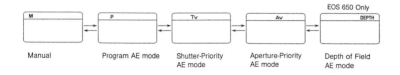

Manual Program AE mode Shutter-Priority Aperture-Priority Depth of Field
 AE mode AE mode AE mode

LCD panel display for the operational modes available with the EOS cameras.

MANUAL

The Manual control mode of the Canon EOS-1, 650, 630(600) and 620 cameras is provided for the photographer who is familiar with the concepts of exposure control (see the sections on sensitometry and films in Chapter 3). Most working professional photographers will be pleased that this mode is available because many of them did their basic apprenticeship in photography in the days before automatic cameras and they still tend to mistrust fully automatic systems. Of course, when using a separate hand-held light meter as many professionals do it is essential that the camera has full manual control. Lastly, when working with studio flash units or standard flash units other than those made to interface with the EOS cameras, manual control is necessary.

Manual Operation of the EOS 650, 630(600), RT and 620

The camera is set to its manual mode by pressing the MODE button on the camera's top left side and rotating the control wheel until a large **M** appears in the upper band of the LCD panel. At this time the camera will automatically set itself to a shutter speed of 1/125th second and an aperture of *f*5.6. These values were chosen because they are good starting points from which to reach other values.

To change to another shutter speed it is only necessary to rotate the control wheel. Moving it to the right will raise the shutter speed and moving it to the left will lower it. Each click of the wheel represents a half

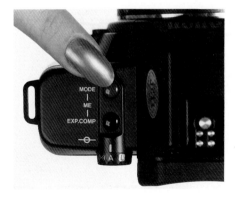

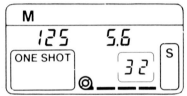

*For manual operation: press the shooting mode selector and turn the electronic input dial until **M** appears in the display panel.*

step in the progression, so to double or halve a speed it is necessary to move the wheel by two clicks. Shutter speeds range from a marked 30" (thirty seconds) at the slow end (actually 32 seconds, see section *Sensitometry*, page 80) to 4000 (1/4000th second) at the fast end in the 620, 2000 in the 650 and 630(600). If exposures longer than 32 seconds are required, rotating the control wheel one click past 30" produces the indication "bulb" on the LCD panel. In this position the shutter will remain open as long as the shutter release button is kept depressed. For such long exposures I suggest that you use one of the Canon remote cable switches which incorporates a lock so that you do not have to keep the button depressed (See *Accessories*, page 224, for details). If you want to time long exposures manually, the camera's built-in clock can be used. As you open the shutter on the bulb setting the frame counter blanks out and then begins to count seconds for you. It will count from 1 to 30 and then it starts over again, so you will have to watch it for really long exposures of several minutes. In such cases it is probably more convenient to use some sort of external clock or timer.

Incidentally, if you have the camera set to one of the very long shutter times and need to return quickly to the higher speeds it is not necessary to turn the control wheel through its whole sequence of clicks. Simply press the MODE button and turn the control one click in either direction and back again and you will have returned to the 1/125th ƒ5.6 default setting. If you use this trick, just remember that it resets the ƒ-stop as well as the shutter speed.

If you wish to use the camera's built-in meter in the manual mode you must activate the meter by pressing the small button marked with an **M**

Button to activate the EOS built-in light meter.

on the left side of the camera body just below the lens release and depth of field preview buttons. This activates the meter and the displays on the top of the camera and in the viewfinder will show one of three symbols for exposure in place of the shutter speed. If **CL** appears you are in a situation which would create over-exposure and the camera is telling you to **CL**ose the aperture. If you rotate the control wheel to the right you will be moving in the proper direction. You simply rotate the wheel and change the *f*-stop until the **CL** vanishes and is replaced by the **oo** symbol. This symbol indicates correct exposure. Just as the shutter speeds are clicked in half steps, so are the *f*-stops, so each click of the wheel represents a change of half a stop, two clicks a full stop.

If on pressing the **M** button the display indicates **OP** this means just the opposite of the above, that you are now in an underexposure situation and you need to **OP**en the aperture. Turning the control wheel to the left until the **oo** symbol appears will set the correct exposure.

In either of the above cases if you have turned the wheel and the *f*-stop numbers have ceased to change it means that you have run out of *f*-stops on the lens in use. You must change the shutter speed to bring proper exposure within the range of the available *f*-stops or you must switch to a different lens with either a larger maximum aperture or a smaller minimum aperture as the situation requires.

If you wish to adjust exposure by changing the shutter speed and not the *f*-stop the operation becomes a bit more complicated, although the process may be simplified on the EOS 630(600) by customising the control functions. On the EOS 650 and 620 and on the 630(600) at normal function settings, while you have the **M** button depressed the control

wheel will only change the aperture. What you must do is release pressure on the **M** button, change the shutter speed and then return pressure to the button to see if the change has given you the correct exposure. If the **OP** is displayed you must move to a slower shutter speed because this would have the same effect (more light) as **OP**ening the diaphragm. Moving the control wheel to the left will accomplish this. If, on the other hand, the **CL** indicator appears you will have to move the control wheel to the right and get a faster shutter speed since this will have the same effect as **CL**osing the diaphragm. Since metering information is not available while you are doing this you will have to stop after every half-step click and press the **M** button to see if you are at the correct exposure yet. When you finally get the **oo** signal you have found the correct setting.

Since this process is rather cumbersome, I would suggest that you will be happier in this situation simply to use the camera's Av mode and let the camera automatically select the shutter speed. It will be the same one you arrived at through this process anyway.

In the manual mode the camera's exposure compensation may still be used to bias the camera's light meter.

The manual mode may be used with the main switch in either of the two positions to the left of **L**. The only difference between the two positions is that in the **A** position the camera is quiet, while in the other position, identified by a drawing of propagating sound waves, the camera makes beeping sounds to let you know that the autofocus has been able to focus and to warn you if the shutter speed you have selected is too slow to be safely hand held.

Manual Operation of the EOS-1

Because so many professionals choose to use manual exposure, the professional EOS-1 has been designed for much easier manual operation. Switching into manual mode is done by pressing the mode button and rotating the main control wheel until **M** appears on the LCD panel.

In the manual mode, shutter speeds are controlled by the main control wheel which falls under the right index finger, while *f*-stops are controlled by the secondary wheel on the camera back, which falls under the right thumb. The placement of these two controls allows true one-handed operation. The camera has a shutter speed range of 1/8000th at

the fast end down to 30 seconds (actually 32 seconds, see above) at the long end.

As the shutter speed and f-stop are changed, exposure may be judged by observing a bar graph inside the finder. This bar graph is placed vertically, along the right side of the viewfinder screen, and indicates exposure increments of 1/3rd step with a moving pointer. When the pointer is centred on the bar graph the exposure is correct according to the meter.

Should you prefer to control the f-stop from the main control wheel and the shutter speed from the secondary control wheel, activating custom function number 5 changes these controls.

Normally both shutter speeds and aperture values on the EOS-1 change in 1/3rd step increments as the control wheels are turned. This is excellent for slide films which require very accurate exposure. For those who shoot colour negative and black-and-white films, which have much more exposure latitude, engaging custom function number 6 changes the system so that both shutter speeds and f-stops will change in full step increments.

Unlike the RT, 650, 630(600) and 620, the EOS-1 does not have a bulb setting past the 30 second position on the shutter control. Instead the bulb setting is a separate mode, engaged by pressing the Mode button and rotating the main control wheel until **bulb** appears on the LCD panel. In this way, you do not have to dial through all the shutter speeds to reach bulb. The bulb setting on the EOS-1 operates differently from that of the other EOS cameras and produces very little battery drain, even when the exposure is very lengthy.

PROGRAM

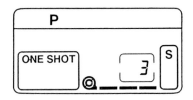

The Program mode is the most automatic of all since in this position the camera will select both the shutter speed and the ƒ-stop. It is the only exposure mode provided on the EOS 750 and 850. The program mode is automatically set when the main switch on the EOS 650, 630(600) or 620 is moved to the position to the right of **L** indicated by a green rectangle. In this position the Program mode is maintained even if the camera operator attempts to switch to one of the other operating modes. Also, when in the "green rectangle" setting, the audible beep indicators for focus confirmation and camera shake operate. This full Program setting of the main switch is the best position to set if you are going to hand the camera to a non-photographer.

The Program mode of the EOS 650, 630(600) and 620 may also be selected by moving the main switch to either of the positions to the left of L and then pressing the MODE button and turning the control wheel until the P indicator appears on the LCD panel. Unlike the manual mode in which shutter speed and ƒ-stop are displayed continuously on the LCD panel they will only appear in the **P** mode after light pressure on the shutter release button. They will remain visible for eight seconds and then disappear. This conserves battery power.

In the Program mode the EOS cameras will select the shutter speed and ƒ-stop combination for best exposure from a sequence programmed into the camera. This sequence attempts to provide the best compromise between fast shutter speed and small aperture. You will probably find, as I have, that this combination of shutter speed and ƒ-stop is usable for most general photography but is rarely exactly what you would have chosen if you were using manual control. In most cameras with Program modes you have no control over this and must either take what the camera picks or use another exposure mode.

In the Canon EOS-1, RT, 630(600) and 620 it is possible to bias the program of the camera intentionally to more accurately suit the needs of the photographer. For this Program bias to work the camera's main switch must be set to one of the two positions to the left of the L position. Program bias cannot be used in the "green rectangle" setting. If you are working with the camera in the Program mode and you notice from the

viewfinder display that the camera is picking a shutter speed slower than you would like for the situation, you may increase the shutter speed simply by rotating the control wheel toward the right until the speed you want appears on the display. This bias will be held by the camera as long as the display is activated, which you will recall is eight seconds. If you need longer than eight seconds to compose your photo, you may hold the bias by maintaining pressure on the shutter release button after you have activated the viewfinder display. After each exposure the bias will be lost after eight seconds unless you keep pressure on the shutter release button.

Of course if it is the diaphragm opening you wish to change instead of the shutter speed you will do it in the same way since both parameters change together in the Program mode. You simply turn the control wheel until the f-stop you want appears on the display.

On the EOS-1 the Program mode functions exactly as in the other EOS cameras detailed above, but with the added control provided by the secondary control wheel on the camera back which allows exposure to be biased in 1/3rd stop increments through a range of +3 to –3 stops. To operate you simply activate the camera with light pressure on the shutter release button and turn the secondary control wheel to dial in the amount of exposure bias you wish. This is displayed on the bar graph inside the camera to the right of the viewfinder screen and on the upper LCD panel.

Additionally the camera automatically sets the program to match the lens in use, adjusting it to information provided by the ROM (Read Only Memory) microchip in the lens. In the case of zoom lenses the program is adjusted to match the focal length in use and changes as the lens is zoomed.

The Program mode is also used with the Canon speedlites when using flash outdoors as fill-in. A full explanation of this will be found in chapter 4, *Electronic Flash*, page 157.

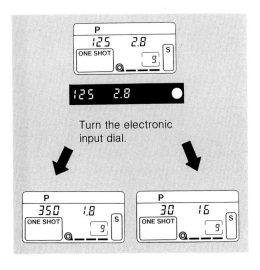

Turn the electronic input dial.

SHUTTER Priority – Tv

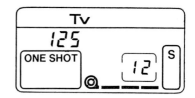

In switching modes from left to right on the Canon EOS 650, 630(600), RT and 620's LCD panel, the next position after Program is one marked **Tv**. As with the other modes, switching is done by pressing the MODE button and rotating the control wheel. **Tv** stands for Time Value and is Canon's own terminology for what is usually called shutter priority. This is a very simple mode in which the camera user sets the desired shutter speed and the camera's computer selects and sets the appropriate ƒ-stop. In fact, this was the first of all automatic exposure modes offered on an SLR camera.

This mode is useful when the photographer knows in advance that a particular shutter speed will be best for the intended photos. This will apply when photographing moving subjects with which the photographer has had previous experience. It also applies when the photographer wants to use the slowest practical speed for hand holding of a particular lens and can in this way pre-set the shutter speed to correspond with the focal length of the lens. It may also be used to select and hold a slow shutter speed when intentional blurring of a subject is desired.

In addition to the shutter speed that the photographer has chosen the camera will also display the ƒ-stop that it has selected. In this mode the shutter speed is continuously displayed but the aperture number appears only after the camera's metering system is activated by light pressure on the shutter release button. The control wheel is used to change the shutter speeds by simply turning, there is no need to press any buttons.

If it is impossible for the camera to provide a correct exposure with the range of ƒ-stops available the aperture number displayed will flash on and off as a warning. The photographer must then change the shutter speed to get the exposure within the range of the available apertures, or must switch to a lens with a different aperture range.

The Tv mode may also be used for fill-in flash when the photographer knows in advance that a certain shutter speed must be used to avoid ghosting from ambient light images.

On the EOS-1 the secondary control wheel on the camera back may be used to dial in exposure bias in the **Tv** mode.

APERTURE Priority – Av

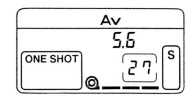

Pressing the MODE button and moving the control wheel one more click to the right brings us to the next of the Canon EOS 650, 630(600), RT and 620's exposure modes. This one is indicated on the LCD panel by **Av** and is Canon's terminology for Aperture Value which is the same thing everyone else calls aperture priority.

This exposure mode is exactly the reverse of the **Tv** mode just discussed. Here the photographer picks the desired *f*-stop and allows the camera to pick the appropriate shutter speed. If the aperture selected will require a shutter speed which is not available the shutter speed on the displays will blink on and off as a warning.

The aperture controls the amount of light passing through the lens, it also controls the depth of field. At larger apertures this depth of field is shallow, at smaller apertures it is deep. See the section *Depth of Field*, page 118, for an explanation of this effect.

If you are new to this game and can't pre-visualize the depth of field provided by different apertures and you have an EOS-1, 620, 630(600), RT or 650, make use of the built-in depth of field preview. How this is used is also explained in the *Depth of Field* section.

It is important to watch the shutter speed indication when using this mode to make sure that you do not accidentally take photos at too slow a speed. You will then get perfectly exposed blurs! The audible camera shake warning may be of help to you in this sort of situation as it will provide an extra reminder. To operate the audible signals the main switch is moved to the setting just to the left of **A**, the one marked with a drawing which looks like ripples on a pond and indicates sound. Don't confuse the camera's autofocus confirmation signal with its shake warning, the sounds are different.

The Av mode may be used with the Canon Speedlites to operate at a specific *f*-stop for depth of field control. It is important when using this mode with other flash units not dedicated to the EOS cameras that you watch the shutter speed indicator so that it does not go above the fastest speed at which the camera can synchronize with flash.

On the EOS-1 the secondary control wheel on the camera back may be used to dial in exposure bias in the **Av** mode.

DEPTH

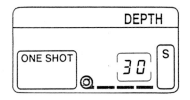

The Depth mode is found on the EOS-1, 650, 630(600), RT, 750 and 850 cameras. This is a unique system invented by Canon and not found on any other cameras. Basically it uses the camera's autofocus system and onboard computer to determine the proper f-stop and focus to provide a desired depth of field. For more information see chapter DEPTH OF FIELD.

Operation is very simple. After setting the EOS camera to the **DEPTH** mode, you then take two separate focus readings. First you focus on the closest distance you wish to have in sharp focus and press the shutter release button. The camera will come to focus at this distance and store the information, indicating that it has by a display on the viewfinder information panel. You then pick out the farthest distance you wish to have in sharp focus and place the camera's autofocus sensor area on a subject at that distance and press the shutter release button again. The camera will come to focus at that distance, store the information and then compute the proper f-stop to provide the depth of field which you want.

Lightly depressing the shutter speed button after the first two operations will display the shutter speed and f-stop combination computed to supply the desired depth of field and proper exposure on the EOS-1, 650 and 630(600). You must make sure that the shutter speed is not too slow for hand holding.

On the EOS 850 and 750 there is no alpha-numeric display and the information is conveyed instead by a flashing indicator light.

Of course, this mode is useful when you want a great depth of field, as in landscape photography. Less obvious is its use to restrict depth of field when only a shallow zone of focus is desired.

On the EOS-1, the secondary control wheel can be used to bias exposure after both depth readings have been taken and the aperture and shutter speed to be used are displayed by the camera. Operation is as described above in the Program mode.

AUTOMATIC EXPOSURE BRACKETING

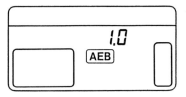

Professional photographers have been bracketing shots for years as cheap insurance on important photos. To do this one photo is taken at the metered exposure and then others both above and below that metered setting. Usually this bracketing is done in sets of three exposures, with the extra exposures differing from the main exposure by one or more steps. How much these secondary exposures differ from the main exposure will depend on the lighting and on the type of film in use. It will also depend on the photographer's personal taste and experience. In the past exposure bracketing was a slow process, not well suited to moving subjects or fast-changing situations.

With the EOS-1, 620, 630(600) and RT Canon has automated this process. Although complex in design, this feature is remarkably simple to operate. To engage the automatic bracketing system on the EOS 620, 630(600) or RT you must open the small trapdoor on the lower rear of the camera. Simultaneously press both the AF and battery test buttons (second and fourth). If you find it difficult to press both small buttons at the same time, it will work if you press the **AF** button and then press the battery check quickly afterwards. When this is done properly the letters **AEB** will appear on the LCD panel and just above them will appear the numerals **0.0**. This information will be displayed for eight seconds after you release the buttons to give you time to adjust the system.

To engage the automatic bracketing on the EOS-1 you press the battery test and drive buttons which are located under the trapdoor on the camera's right end. (An operational peculiarity of the EOS-1 which may cause problems is that this camera cancels the **AEB** setting when a lens is removed or when the camera back is opened. Thus it is important with this camera to remember to reset **AEB** after lens or film change.)

By rotating the control wheel to the right you can set numbers on the LCD panel from 0.5 to 5.0. Turning the wheel to the left will allow you to lower a value if you set one too high, but will have no effect at the 0.0 starting point. The value set will determine the degree of over and under-exposure your bracketed shots receive around the metered exposure.

Wait a few seconds to return to normal operation (indicated by the return of the rest of the information to the LCD panel replacing the

bracketing value just set). **AEB** will remain visible as a reminder.

Once **AEB** has been set and the camera has returned to normal indications, the operating procedure is unchanged. The AEB may be used with any of the exposure modes so long as the main switch is in either the **A** or audible signal position. When the shutter is released the camera will take three photos in rapid succession, with the first photo "under-exposed", the second at the metered exposure and the third photo "over-exposed". If you have previously set the camera for Exposure Compensation the **AEB** system will use the compensated exposure as its starting point and bracket around that exposure.

It is important that you understand that this Automatic Exposure Bracketing operates differently in the camera's different exposure modes, as this provides an extra measure of creative control.

When you are using the camera in the manual mode you may still use the Automatic Exposure Bracketing, and it will simply bracket around whatever exposure you have set manually, whether determined by the camera's meter or some other source. In this mode the bracketing is done by altering only the shutter speed, leaving the aperture fixed as set.

An example of a situation in which you would use this sort of bracketing would be an outdoor portrait in which you have determined exposure with an external incident meter. You have determined that a particular aperture will render the model's face in sharp focus from nose to ears, but you want nothing else in focus. After you have determined the aperture which will provide this carefully selected depth of field you do not want to alter it, and you are not sure enough of your meter to trust it without bracketing. This would produce a situation in which **AEB** could only be used with Manual exposure control.

When the **AEB** is used with the Program mode it will accomplish the bracketing by changing both the shutter speed and the *f*-stop. This means that this combination would only be suited to situations in which neither the shutter speed nor the aperture is critical. However, it is unlikely that you would be using the Program mode in such a situation anyway. For most general photography this would be a perfectly acceptable mode to use with **AEB**.

In both the Tv and Av modes it is important to know that the **AEB** will only alter the exposure factor which is selected by the camera. In this way your priority in choosing a specific aperture or shutter speed will not be

The subdued colours of winter foliage can form an exciting counterpoint to bold colours such as this scarf.

overridden by the camera. Knowing that the camera will bracket by altering only the aperture in the **Tv** mode and only the shutter speed in the Av mode may be important as the specific qualities of a photo may require keeping one of these factors constant.

There are specific situations in which the above will not apply. For example if you are taking photographs in the **Tv** mode and decide to use a one step exposure bracket. Let's say that a metered exposure is 1/125th at *f*5.6. With the camera in AEB the camera will take three photos in rapid-fire manner. The first will be taken at *f*8, the second at *f*5.6 and the third at *f*4. The shutter speed will be at 1/125th for all three exposures.

However if you attempt to take this sequence of photos with a lens which has a maximum aperture of *f*5.6 the camera will be unable to open the lens up to *f*4 for the third exposure. It will automatically shift the shutter speed for that exposure. In this specific situation you would get a first exposure of 1/125th at *f*8, a second of 1/125th at *f*5.6 and a third of 1/60th at *f*5.6. If you knew in advance that 1/60th would be too slow you would have to change to a lens with a wider maximum aperture or use a different film to allow the exposure range you want.

Another important consideration is how much to bracket. This can be determined by the type of film in use. For example, if you are using a medium-speed black-and-white film which has several steps of usable latitude it would make no sense to use 0.5 steps in the bracketing because there would be hardly any difference in the three negatives produced. In such a case you would use at least a full step of bracketing, more likely 1.5 or 2.0. In the case of a colour slide film with very limited latitude the 0.5 bracket might be appropriate. Experimentation and experience will be your guide.

While the EOS-1, 630(600), RT and 620 cameras offer this feature there is an important operational difference in the cameras. On the EOS 620, the AEB system works for only one set of three bracketed exposures, and must be reset for each subsequent set of three exposures. This can be annoying when many bracketed exposures are to be taken. The EOS-1, 630(600) and RT have corrected this problem, on these cameras the AEB remains engaged until intentionally canceled by the photographer. This is an infinitely better idea, allowing the photographer to shoot as many brackets as desired without having to continually re-activate the AEB.

Forests shrouded by fog offering interesting and exciting picture possibilities. Determining exposure for subjects such as this can be difficult so I bracketed widely to be sure of getting just the effect I wanted.

EXPOSURE
COMPENSATION

As mentioned in the chapter on the light meter, all camera meters are designed to assume a subject reflectance of 18% – equivalent to a medium grey tone. In that section I told you how to deal with problems of very high or very low subject reflectance from the point of view of metering technique. Another way of dealing with the same problem is through the exposure compensation capability built into the EOS-1, 650, 630(600), RT and 620 cameras.

For example, consider a holiday on the beach. If you take photos there of your family and friends using any of the EOS camera's exposure modes, you will find that your finished prints or transparencies will be dark and murky, showing little detail and certainly bearing little relation to the bright scenes you saw and thought you had preserved in the photos. That's because the camera looked at all that light coloured, brightly illuminated sand and tried to deal with it as a medium grey. In attempting to render the overall light level of the scene to correspond with its programmed 18% reflectance value the camera has underexposed the photos, making them dark and dingy. To restore the natural brightness of the scene you will have to tell the camera that it is not dealing with an average of 18% reflectance, that the subject reflectance is much higher than that. You do this by using the camera's exposure compensation control.

Canon has thoughtfully provided the EOS-1, 650, 630(600), RT and 620 cameras with a simple exposure compensation control. On the EOS-1, exposure compensation is controlled by the secondary control wheel on the camera back, or with the main control wheel and the right hand exposure compensation button, and is displayed on the bar graph inside the viewfinder and on the top LCD panel.

On the top left of the EOS 650, 630(600), RT and 620 cameras is a button marked EXP.COMP. When this is depressed a +/– symbol will appear on the LCD panel just above the frame counter along with numerals reading 0.0. By rotating the control wheel to the left values from –0.5 to –5.0 may be set, while rotating the wheel to the right allows setting of values from +0.5 to +5.0. The EXP.COMP must be kept depressed while making the setting. As soon as this button is released the numerical

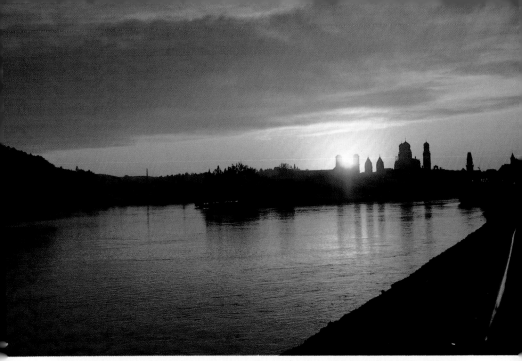

Above: sunset on the Danube at Passau, taking the meter reading from an area of the sky well away from the sun, in this case about 1/3rd of the image away in the upper left. Below: flower study at a botanical garden, EOS 620, 35-105mm. To produce saturated colour the exposure compensation was set to -0.5. Photo: Darlene Shell.

indication disappears but the +/− symbol remains on the display as a reminder that the exposure compensation is in use. A similar +/−symbol also appears in the viewfinder display just to the right of the *f*-stop number as an additional reminder.

It may seem a paradox to you that you would need to use a + compensation, that is add more light, to get the above mentioned beach photos to turn out correctly, but if you always remember that the camera is programmed to reduce all scenes to an 18% average reflectance, you will realize that the higher the reflectance the more light the camera will hold back. By telling the camera that the reflectance is higher than 18%, that is by using a + compensation, you will achieve the proper tonal range in the finished print or slide.

Now consider for a moment the opposite situation. For a change from the beach you have decided to go on holiday in Africa and you want to take some informal photos of the new friends you have made there. Several of them have that magnificent very black skin seldom seen outside Africa. After taking their photos with the camera set to any of the modes, you come home and have the photos processed. The results are terrible, the black skin colours have been lightened up to a medium gray and the whole of the photos look washed out.

The problem, as you have guessed, is just the reverse of that encountered at the beach. Here the reflectance of the subject is much lower than the 18% average programmed into the camera, and the camera has over-exposed in its attempt to bring this low reflectance up to the 18% level.

In this case you would have to program in a − compensation, cut back on the amount of light striking the film.

In both the very bright and very dark subjects discussed, the amount of compensation which must be applied varies with the exact reflectance of the subject and with the type of film in use. You will have to make test exposures in very critical situations, but the table supplied will give you some very good starting points from which to make your tests. In cases where tests are impossible, these guide-lines should get you close to the correct exposure, certainly within the latitude of most modern black and white or colour negative films.

Since the exposure compensation control on the EOS 650, 630(600) and 620 cameras operates only in half steps you may find that it is not precise enough for some colour slide films which require very critical exposure accuracy. In such cases you may use the manual ISO override to provide compensation in one-third step increments. For most photography the

amount of control provided by the exposure compensation system will be more than adequate.

The exposure compensation control on the EOS-1 operates in 1/3rd step increments, in keeping with the professional concept of this camera and maximum image control.

Suggested Exposure Compensation for Difficult Subjects

SUBJECT AND LIGHTING	COMPENSATION
Caucasian skin, direct sun with reflected light from white sand or snow	+1 to +1.5
Caucasian skin, hazy sun with reflected light from white sand or snow	+0.5 to 1
Caucasian skin, direct sun with reflected light from average surroundings,spot meter reading*	+1
Negro skin, medium dark, spot meter reading	−1 to −1.5
Negro skin, dark, spot meter reading	−1.5 to −2
Reflective water under bright sun, spot meter reading	+1.5 to +3

*Average Caucasian skin is about one step more reflective than 18% grey for which meters are calibrated. As a general rule for difficult subjects, try to estimate how much darker or lighter the subject is than 18% grey and compensate accordingly. Alternatively, try to take a meter reading from a subject of a more average reflectance under the same illumination. These guidelines apply when using the spot meter or when metering very close with the full area integrated meter. In most situations the full area integrated meter will compensate adequately if the subject of unusual reflectance is surrounded by objects of a more average reflectance.

MANUAL ISO SETTING

Like most modern cameras your Canon EOS-1, 650, 630(600), RT and 620 have an automatic sensing system for setting the film speed. This operates through a series of electrical contacts inside the camera's film chamber. When the camera is loaded with a new cassette of film these contacts come in contact with the surface of the cassette where a series of conductive and non-conductive patches painted onto the cassette inform the camera through their placement not only the correct ISO rating of the film but also the number of exposures on the roll.

This sensing and cassette coding system is called DX-coding and was first developed by Kodak and then later adopted by most other film makers. At the time of writing there are still a few films available which are not supplied in DX-coded cassettes, but I anticipate that it is only a matter of time before this coding is universal on everything except special purpose films.

Canon has realized that advanced amateur and professional photographers will not stand for anything less than control of all exposure factors and has provided an easy way for the photographer to set or modify the film speed on the EOS-1, 650, 630(600), RT and 620 cameras. Because the EOS 850 and 750 are aimed at a more amateur market, they lack this feature. Manual ISO setting on the EOS 650, 630(600), RT and 620 is done by opening the trapdoor on the rear of the camera and pressing the two middle buttons at the same time. On the EOS-1 the AF and Metering buttons on top of the camera are pressed. When this is done the ISO speed which the camera has set from the DX sensors will be displayed on the LCD panel with the ISO legend. At this time the control wheel may be used to change the number in one-third step increments. In contrast to the EOS 650, 630(600), RT and 620 camera's other controls in which moving two clicks always corresponds to a full step of change, here it requires three clicks to change by a full step. Turning the wheel to the right increases the number, to the left decreases it.

Having this control is especially important on any camera aimed at the professional and advanced amateur market because these photographers frequently work with special purpose films (such as Infrared) which may have no ISO rating established by the manufacturer and they

also commonly load their own film from bulk rolls into reusable film cassettes. Such cassettes are usually uncoded. If an uncoded cassette is loaded into the EOS-1, 650, 630(600), RT or 620 camera it will automatically set itself to an ISO of 100. This number will be displayed on the LCD panel and will flash on and off to get the photographer's attention. In this way it is nearly impossible for the photographer to load an uncoded cassette and not be reminded that the ISO must be set manually.

The EOS 750 and 850 do not have manual ISO setting. Because they automatically default to ISO 25 when loaded with non DX-coded film cassettes, they are not usable with bulk-loaded film or special purpose films which come in non-DX coded cassettes.

Should you be traveling in Russia or Eastern Europe you may encounter films in uncoded cassettes which do not have ISO numbers on the package. Such films are rated by the Russian **GOST** system. See the conversion table in the FILMS chapter to convert these numbers into ISO numbers.

The range of ISO numbers which can be manually set on the EOS-1, 650, 630(600), RT and 620 is from 6 to 6400, so it is unlikely that they will soon be made obsolete by new films. Should a film faster than 6400 appear, you can use the exposure compensation system to increase the speed. For example, with the ISO set to 6400 you can set the exposure compensation to –1.0 and have the equivalent of 12,800, –2.0 to get 25,600, and so on.

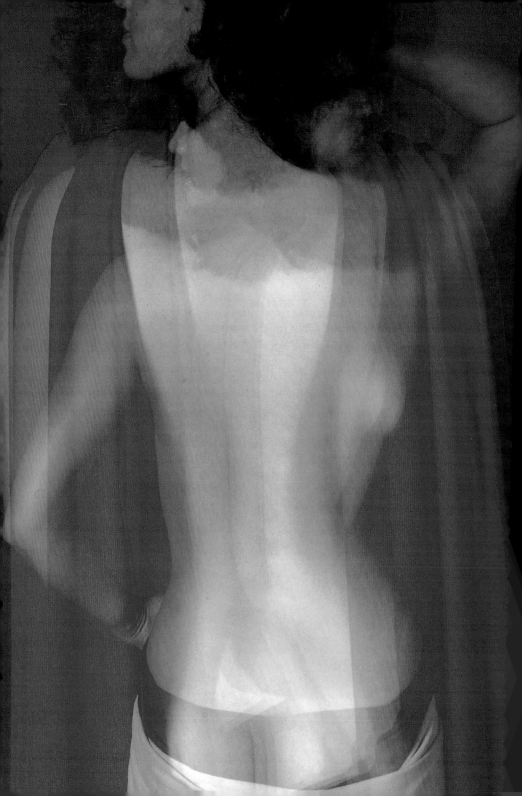

MULTIPLE EXPOSURES

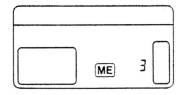

Because the ability to superimpose two or more exposures on the same frame of film is a feature commonly used by professional photographers, Canon have designed the EOS-1, 630(600), RT and 620 to allow this to be easily done. Multiple exposures are impossible with the EOS 650, 850 and 750 cameras. To set the camera for Multiple Exposures on the EOS 630(600), RT and 620 simply press both the **EXP.COMP** and **MODE** buttons on the left top of the camera at the same time. On the EOS-1 the **MODE** and **METERING** buttons are used. The frame counter will then display a **1** and the letters **ME** will appear just to the left of it. Using the control wheel it is possible to set numbers from 1 through 9, allowing that number of exposures to be made on a single film frame.

Since the EOS cameras have two internal drive motors, one which transports the film and another which moves the mirror and cocks the shutter, this Multiple Exposure mode simply shuts off the film transport motor for the number of exposures set. At the end of the Multiple Exposure sequence the frame counter sets itself back to normal operation and the film advance motor moves the film forward to the next frame. The frame counter always indicates the number of the next photo to be taken, not the last one taken as in most other cameras. Thus when it indicates 36 it means that you have taken 35 photos and the next one you take will be number 36. When making multiple exposures it counts each frame of film as 1 regardless of how many exposures have been made on that frame, so it may always be relied on to give a correct indication of the film yet to be used.

For technical reasons Canon have limited the number of exposures which can be made on one frame to nine. In the unlikely case that you need to make more than nine exposures on a frame, the camera can be fooled into allowing you to do so. To take any number of photos greater than nine you must first set the **ME** control to 9. As you take your photos the frame counter will count down from 9. You must remember to take

Multiple exposures are easily done with the EOS 630 (600) and 620. In this photo I used a black seamless background and only compensated slightly for the overlapping image. This is a triple exposure with a zoom lens, the model changed position slightly and the zoom setting was changed for each exposure.

only eight photos at which time the frame counter will indicate 1. If you forget and take the last one the camera will advance the film, there is no way to prevent it. But if you take only eight photos, so that the frame counter stops at 1, you may then use the **ME** control to reset the counter to 9 all over again, and take eight more photos. You may continue adding your exposures in multiples of eight indefinitely, and the camera will not move the film until you finally take the frame numbered 1 on the counter.

In a similar manner, if you change your mind after setting the counter and want to take fewer exposures on a frame you may lower the number on the counter by turning the control wheel with the buttons pressed. If you turn the wheel past 1 the frame counter will go blank and the camera will advance the film without firing the shutter when you release the MODE and EXP.COMP buttons.

If you are taking multiple exposures of subjects against normally lit backgrounds you will need to make an exposure compensation to avoid over-exposure of the finished photo. As a general rule, the compensation should be about one step for each two exposures. This is easily done with the Canon EOS-1, 630(600), RT and 620 by simply setting the exposure compensation to the proper figure. For a double exposure you would set it to –1.0, for a triple exposure to –1.5 (–1.3 on EOS-1), for a quadruple exposure to –2.0 and so on. This must be taken as a general guide only, as specific subjects may require more or less compensation. For important photos it would be a good idea to shoot several tries using different degrees of compensation. This is especially true when shooting colour slide film which has very limited latitude, and for this reason you may want to shoot your multiple exposures on colour print or black and white film.

When making multiple exposures of a subject against a black or very dark background it is usually not necessary to make any compensation unless the main subject (or subjects) will overlap in the separate exposures. The reason for this is that each subject which does not overlap will be exposed onto the film only once. Since little or no light is being reflected from the background there is no need to compensate for additional exposure as there is none. In the case of partially overlapping subjects on dark backgrounds the only guide can be experiment and experience.

If you do not process and print your own film it is important to advise your processing lab when a roll of film has multiple exposures on it. Otherwise they are likely to assume that they are mistakes or camera

malfunctions and return the negatives unprinted. You may explain what you have done, but frequently a long explanation will not be read. A terse "print regardless" usually gets the point across.

When setting up important photos which require multiple exposures the new Polaroid 35mm films (see FILMS chapter) offer a real advantage because they can be evaluated in a matter of minutes. The Polaroid film may be used as the final product or as a very accurate "exposure meter" for exposures on some other sort of film.

Multiple exposures can be great fun and an interesting creative outlet. They may be planned and executed with great care and precision, or they may be taken in a more relaxed manner, trusting to serendipity for interesting results. If you have never worked with multiple exposures, let the existence of this feature on your EOS-1, 630(600), RT or 620 be the spur to get you going. You will certainly not be bored with the results.

Below: one advantage of long telephoto lenses is the ability to take close-up photos of animals and birds without frightening them(or endangering the photographer).

Next page: while the "Macro" setting of zoom lenses does not get you into true macro range, it is often close enough for photos such as this one of a bursting milkweed seed pod.

PROGRAMMED IMAGE CONTROL

This feature is found only on the EOS-1, 630(600) and RT. With the camera's main switch set to the green rectangle, depressing the MODE button will cause a number to appear in the frame counter area of the LCD panel. These numbers run from one to seven, each indicating a set of camera controls suited to a particular type of photography. The numbers may be changed with the control wheel and will be fixed when the MODE button is released.

Each of these control settings selects a combination of AF mode, film wind, and metering. The settings are as follows:

1. **Standard** – This is the same as the normal green rectangle setting, that is the standard program exposure mode with one shot advance and multi pattern metering.

2. **Quickshots** – In this position the camera provides continuous servo autofocus and continuous film advance for following action. Metering is standard multi-pattern.

3. **Landscapes** – This provides one shot autofocus and single frame film advance, particularly suited to landscapes with wide angle lenses. Metering is standard multi pattern.

4. **Sports** – This mode is intended for use with telephoto lenses and fast moving subjects. It provides continuous servo autofocus and continuous film advance. The standard multi pattern evaluative metering is used.

5. **Portrait** – Also designed for use with telephoto lenses, but this time at very close focusing distances typical of head and shoulders portraits. Here the autofocus is set for one shot while the film wind is set for continuous. Standard multi pattern metering is used in this mode.

6. **Close-ups** – Particularly useful with macro lenses, this setting gives a combination of one shot autofocus, single frame film wind and spot metering.

7. **Indoor** – This setting is for use with the 420EZ and 300EZ flash units with the flash set to the I setting.

While all of the combinations offered by these seven settings could be achieved by using the camera in the **A** position of the main switch and manually selecting the combinations, this feature of the EOS 630(600) and RT allows a quick selection of the desired combinations with a single control. A label on the rear trapdoor of the camera serves as a reminder of the purpose for each setting.

CUSTOM FUNCTION CONTROL

The EOS 630(600), EOS-RT and EOS-1 cameras offer the unique ability to be user customized in several important functions. These custom functions differ slightly in these cameras, and are set differently.

On the EOS 630(600) and RT with the main switch at the **A** position or the audible signal position all of the following selections can be made. In the green rectangle position only 1,2,3, and 6 can be used.

To operate the Custom Function Control, the film wind selector and battery check buttons inside the rear trapdoor are pressed simultaneously. The number **1** will then appear in the frame counter area of the LCD panel, and may be advanced through **7** with the control wheel. At each position either the normal mode or a change may be selected with the spot metering button. When the spot metering button is pressed at any number a bar mark appears just to the left of the frame counter to confirm that the setting has been changed from normal. To change back again you simply dial in the same number and press the spot metering button again.

The seven Custom Control Functions are:

1. **Film rewind cancellation** – In the normal mode the film automatically rewinds upon completion of the roll. If this is changed, the film will not rewind until the film rewind button has been pressed.
2. **Film leader out** – Normally the camera rewinds the film fully into the cassette. If you prefer to have a small portion of the leader remain outside the cassette, as when shooting Polaroid 35mm film, you change this function and the film will be rewound with about 3/4 inch of leader outside the cassette lips.
3. **Film speed setting** – In normal operation, the camera automatically sets its meter to the DX-coded ISO speed of the cassette. If this function is changed you may manually input the ISO speed of each film loaded.
4. **Autofocus activation** – Normally the autofocus mechanism is activated by partial pressure on the shutter release button, which is also how AE lock is activated. By changing this function the autofocus activation is switched to the button usually used for spot metering, making focusing and metering two totally separate operations. In many situations I have found this to be very much easier to use than the standard set-up, but of course you do not have the partial meter available after this change.

5. **Manual exposure operation** – In the normal manual exposure mode the shutter speed is controlled by the control wheel, and the aperture is controlled by pressing the manual aperture button and then turning the control wheel. This function allows you to reverse these two so that the aperture is controlled by the control wheel alone and the shutter speed by the manual aperture button and control wheel. For those times when manual metering is desired but an aperture priority is desired, this changeover is quite useful.
6. **Camera shake warning cancellation** – This allows you to eliminate the camera shake warning beeper in all positions of the main switch.
7. **Manual focus operation** – This allows manual fine tuning of focus after autofocus operation without having to switch the lens out of the autofocus mode. This is very convenient in situations in which subject move ment is a problem, and in situations in which the actual desired point of focus is near to the area of the autofocus sensor, but not centred in the frame, and in which camera movement is restricted (as when mounted on a tripod). This feature only works with those lenses featuring the USM motor system.

On the EOS-1, the custom functions are accessed by opening the right side trapdoor on the camera and pressing the top button which is marked CF. The LCD panel will then display the functions in the form of **F – 1** through to **F – 8**, with an **0** underneath. This **0** indicates that the camera is set to the factory-set function. Turning the main control wheel to the left lowers the function number, to the right raises it. To change the function at any setting, you press the **CF** button again and the **0** will be replaced by an **I** to indicate that the alternate choice has been selected.

The alternates at the eight positions are as follows, 1-5 and 7 are the same as with the EOS 630(600):

F-1. **Film rewind cancellation**
F-2. **Film leader out**
F-3. **Film speed setting**
F-4. **Autofocus activation**
F-5. **Manual exposure operation**
F-6. **Shutter speed and aperture set** – shutter speed and aperture values are set in one-step increments instead of the normal 1/3rd-steps.
F-7. **Manual focus operation**
F-8. **Evaluative metering shift** – switches from evaluative metering to centre-weighted average metering.

The EOS-RT offers the same seven custom functions as the EOS 630(600), together with F-8 from the EOS-1 and seven more of its own which are listed on page 19.

BATTERIES AND BATTERY CHECK

The Canon EOS cameras operate on one battery, type 2CR5, which is a six volt lithium type. This battery has a very high capacity and by Canon's estimate will operate the camera through about 100 rolls of 36 exposure film or about 150 rolls of 24 exposure film. I see no reason to doubt these figures as I have shot many thousands of photos with my EOS cameras and have rarely exhausted a battery.

Nevertheless, the battery should be tested frequently and this is very simply done without disturbing the camera's other settings. To test the battery you must open the small trapdoor and locate the button identified by a drawing of a battery, it is the one on the far right. The camera's main switch must be in one of the "on" positions. The button is then pressed and held. When this is done the letters **bc** will appear toward the left of the LCD panel and one or more bars should appear at the very bottom.

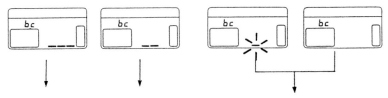

In temperatures about 20°C/68°F

If all three bars appear then the battery has plenty of power and you may continue without concern. If only two of the bars appear that tells you that the battery is beginning to get low and it is time to locate a replacement. You may still continue to take photos but you should keep the spare battery close at hand. As these batteries are not yet as common as the older types it is probably a good idea to purchase a spare early and carry it in your camera bag. They have a very long storage life so there is little worry that the battery will deteriorate before you need it.

If the battery test procedure makes only one bar appear on the LCD and this one bar is flashing on and off it is definitely time to replace the battery. If the **bc** notation appears but no bars at all appear then the battery is totally dead.

During the time that the battery check button is held in the camera will make a periodic clicking noise. That is normal and indicates that internal systems are cycling during the test.

To replace the battery in the EOS 650, 630(600), RT or 620, or to install the first one if you have not done that yet, follow these steps. First, remove the hand grip. This is done by using a coin or screwdriver to loosen the retaining screw in the side of the grip. Once the screw is started it is usually easiest to turn it the rest of the way by hand using its knurled edges. Once the screw is completely loosened it will turn freely but will not fall out of the grip because it is held in by a retaining clip. The grip can then be removed by pulling downward and toward the left as shown in our photo.

After laying the grip aside the camera should be turned upside-down and the battery compartment will be visible in the bottom of the camera

Above and left: removing the handgrip. Below left: the orange battery retaining clip. Below: make sure the battery is inserted correctly, with the two metal contact strips as shown.

on the end previously covered by the hand grip. If you are replacing a battery you must first remove the old one. This is done by pressing down on the orange battery retaining clip so that the battery will snap free. The battery is then grasped by the end and pulled straight out. The new battery is inserted in the reverse of this operation and pushed in until it passes the orange retaining clip and is held in place by it. When inserting the battery make sure that the metal contact strips on the battery are in the correct position, on the end of the battery first inserted and upwards (with the camera inverted). Use the same coin or screwdriver to re-tighten the retaining screw in the hand grip but be careful not to over-tighten as this may damage the camera.

Because of a switch on the EOS-1 which engages the internal buffer battery to protect the camera's memory, the camera will not be switched back to the new lithium battery until the handgrip has been re-attached and the screw fully tightened. None of the camera's controls will respond until this has been done.

Changing and installing the Lithium battery in the EOS-1 is generally similar. The screw which retains the grip is on the bottom of the camera, and once loosened the grip slides off straight down. The battery is enclosed within the grip and simply slides into place with the contacts in the marked positions. When the EOS-1 is used with the Power Booster E-1, power for the camera is provided by eight AA batteries in this attachment.

Power for the EOS 850 and 750 is supplied by one 2CR5 Lithium battery inside the handgrip, but these cameras forego the visual battery check and use an audible signal instead. The frequency of the beeper denotes battery condition, varying from 8Hz which indicates a good battery to 2HZ which indicates that replacement is in order.

Once the new battery has been installed and the grip replaced use the battery test procedure to make sure that the new battery is making proper contact. If you get no response from a newly installed battery, remove it as described above and make sure that it is installed correctly. If the battery is installed correctly and you still get no response when operating the battery test, remove the battery once again and carefully clean the metal contact strips with a soft clean cloth or a piece of lens cleaning tissue. You may wish to dampen the cloth or tissue lightly with a bit of lens cleaning fluid to make sure of proper cleaning. It may also be advantageous to clean the battery contacts carefully inside the camera itself. This is done by wrapping some of the cloth or tissue around a small

dowel or pencil and reaching into the battery compartment to carefully brush the contacts clean. If you use lens cleaning fluid, apply only a little directly to the cloth or tissue.

If you have done all of this and you still get no response from the battery test it is most likely that you have been sold a defective battery. Most good camera shops have battery test equipment and should be able to test the battery for you in this case. If the battery tests shows that the battery is good but the camera still will not respond, then it is time for a trip to the repair shop.

A word about repair shops may be in order here. Because the Canon EOS cameras have much more in common with computers than with most older cameras, it is wise not to entrust the repair of one of these cameras to just any shop. It would be best to make certain that the camera is repaired by someone who has had training from Canon on the special requirements of these cameras. Many common problems with EOS cameras are self-diagnosing, telling the computer equipped repairman exactly what the problem is after connection of the camera to a computer through a special interface. This also tells the repairman how many times the shutter has been fired over the life of the camera, which helps in predicting the need for lubrication and adjustment.

If you have worked with a home computer you will know that the memory in storage at any time is only held there so long as power is available to the computer. In the event of a power failure all of this is lost. The same is true of the internal memory of the EOS cameras, but the problem is overcome by use of a dual EPROM, except in the EOS-1 which has a buffer battery. The buffer battery is a small battery installed inside the camera at the factory which provides just the power required to retain this memory when there is no main battery installed in the camera. This is what holds the memory while the camera is at your dealer before you buy it, and it is what holds the memory while you have the main battery removed during battery replacement. The buffer battery is not designed to be replaced by the user but to be replaced at the same time as the LCD panel, which is estimated to last about five years. The buffer battery should have about the same life-span. Although quite rare, it is possible for the buffer battery to be defective. In this case you will not get any readout on the LCD panel when you press the battery test button. Should this happen the camera should be returned to Canon or a Canon-authorized shop for service as the camera's memory will have to be reprogrammed after the buffer battery is replaced.

3: Fundamentals and EOS

SENSITOMETRY

For the purpose of this book I will very loosely define sensitometry as the science of getting the correct amount of light to the film. A number of factors are involved in this.

The first factor which determines the amount of light needed for a proper exposure is the film itself. Different films have different degrees of sensitivity to light, requiring either more or less light to produce a properly exposed image. Films which require less light to produce a good image are referred to as "fast" films, films which require more light as "slow" films. This degree of sensitivity to light is expressed in numerical fashion by several different systems. For an explanation of these systems see the following section on films.

Now we have considered the relative sensitivity of the film we know this governs how much light needs to reach the film to expose it properly. There are two controls on the camera which govern this.

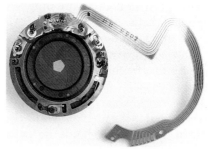

Diaphragm mechanism.

The first of these is inside the lens and is referred to as the iris diaphragm or commonly just the diaphragm. This works like the iris in your eye, opening or closing to change the size of the hole through which the light passes. In the camera this is accomplished with a mechanism using thin metal blades which move against one another to change the size of the opening. This opening is also referred to as the lens aperture. These openings are given numerical designations to allow consistency of exposure from one lens to another. The numbers by which these

openings are designated are relative measurements of the diameter of the opening, and by established convention are arranged in a sequence which will halve or double the area (not diameter) of the opening from one to another. This doubling or halving of the area of the opening also doubles or halves the amount of light which can pass through the opening. Each time we progress along the scale we have changed the amount of light which can pass by a factor of two, and each change by a factor of two is referred to as an exposure step, or simply a step.

Because the progression of these steps follows the increase in area of the opening and not its diameter, the relationship is not arithmetic and the progression may seem unfamiliar at first. The standard progression of these numbers, starting at the largest opening and moving to the smallest is: 1.0 – 1.4 – 2.0 – 2.8 – 4.0 – 5.6 – 8 – 11 – 16 – 22 – 32 – 45 – 64 , etc. The numbers may be easier to remember if you will note that doubling any number gives you the second number following, so that you need only remember the two starting numbers of 1.0 and 1.4 to derive the rest. The exception here is 45, and that is because these numbers are rounded off. Moving from any one of these numbers to the next in the sequence always alters the amount of light passing through the opening by a factor of two. These numbers are actually only half of a ratio which is shortened for convenience. For example the number 2.8 would properly be expressed as the ratio 1:2.8, where the first number is the focal length of the lens (see chapter on *Lenses*, page 190, for definition) and the second number is the apparent diameter of the opening through which the light passes. Thus a lens opening of 2 is twice as large as one of 2.8 and will pass twice as much light, while an opening of 4 is half the size of one of 2.8.

These numbers are referred to as f-stops and given the notation f in photographic shorthand. This is a shortened form of "focal stops" and goes back to the early days of photography when adjustable diaphragms had not been invented and the photographer used a set of metal plates with different sized holes in them to control exposure. These plates were inserted into the lenses to "stop" some of the light, thus the term f-stop or simply stop. Most commonly you will find these numbers written in the form: $f2.8$.

Of course there are fractional stops in between these full stops. They appear on the digital readout of the EOS cameras and are simply half stops except in the EOS-1, where 1/3rd stop increments appear. These are provided to allow you to make finer adjustments of exposure than

Aperture values and the corresponding diaphragm openings demonstrated in this example of a 50mm f1.4 lens.

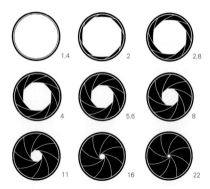

would be allowed by whole stops alone. While the EOS cameras indicate the *f*-stop on the top of the camera on the LCD panel and in the viewfinder, you should know that most older cameras actually have the control to set the *f*-stop on the lens itself. If you attempt to use another camera after learning on an EOS you may be confused by this at first, but it is just a case of the control doing the same thing but from a different location.

The second part of the camera's light control system is the shutter. By opening and closing it controls how long the light is allowed to strike the film. Shutter speeds are an easy numerical progression. Starting with one second and moving to faster speeds the progression will be 1 – 2 – 4 – 8 – 15 – 30 – 60 – 125 – 250 – 500 – 1000 – 2000 – 4000. These speeds are shortened forms also, being the denominators of fractions in which the numerator is always 1. Each would be written in the form 1/8, but for convenience the 1/ is omitted. It is only important to remember that the speed marked 250 on the camera means 1/250th second and not 250 seconds! Moving from one number to the next in the sequence again alters the amount of light by a factor of two. Moving to a higher number cuts in half the time the light is allowed to strike the film, moving to a lower number doubles that time. As in the case of the diaphragm, Canon has provided in-between speeds to allow fine tuning of exposure.

By convention some of the numbers used are not exact multiples but on a properly calibrated shutter the relation will be correct. For example, a good shutter when set to 15 will actually deliver an exposure of 1/16th second. This is unimportant in the fast speeds where the difference would not be significant, but it is important to remember this when working with long exposures. The Canon EOS cameras have shutter speeds longer than one second which are timed by the camera's very

accurate internal clock. These longer speeds are displayed in the form 1", 2", etc. Here the progression is the same as in the shorter speeds, so you must remember that a set speed of 15" will actually produce an exposure of 16 seconds, while a set speed of 30" will produce and exposure of 32 seconds.

It is all a balancing act to get the three factors, film speed, shutter speed and diaphragm opening, balanced so that the film gets the proper exposure. Since you have control of all three factors, it is just a matter of learning to use them to your advantage. The next section on *Sensitivity Ratings of Films* will help you to understand how to use that factor to best advantage, while the sections on *The Shutter*, page 31, *Selecting Canon EOS Lenses*, page 126, and *Depth of Field*, page 118, will help you to understand the other factors in the equation.

Camera instruction books and advertising frequently make use of a number called EV (Exposure Value) when making comparisons. As an example, Canon makes a point of saying that their BASIS autofocus sensor will operate all the way down to EV 1. An EV number is simply a number on a scale which corresponds to a set of diaphragm openings and shutter speeds which all deliver the same exposure at a given film sensitivity (usually ISO 100). For example EV 1 is equivalent to 1 second at $f1.4$. But it is also equivalent to any other set of shutter speed and f-stop which will produce the same exposure on the film. So EV 1 is also equivalent to 2 seconds at $f2$, 4 seconds at $f2.8$, 1/2 second at $f1.0$ and so on.

Some older cameras had direct reading EV scales which could be referenced to separate meters which gave readings in EV numbers. This is rarely seen today and so EV has been relegated to the esoteric purpose of providing comparisons of one camera with another. From the user's point of view it is only necessary to realize that the stated range of EV 1 to EV 18 for the EOS autofocus sensor is broad enough to cover almost any exposure situation you are likely to encounter. Similarly the light meter's range from EV 1 to EV 20 is quite broad and will handle nearly any conceivable exposure situation.

SENSITIVITY RATINGS OF FILMS

As mentioned in the preceding section, the sensitivity of the film you are using is one of the three important factors which determines the correct exposure and produces pictures of professional quality. There used to be many different systems for rating film sensitivity, some film and light meter manufacturers even devised their own, and it was often difficult to cross reference from one system to another. Order was brought from this chaos by the adoption of two main systems. These were the numerical progression system of the American Standards Association and the geometric progression system of the Deutsche Industrie Norm. Unfortunately neither of these systems gained universal acceptance. In the USSR and Eastern Europe a third system called GOST was developed. It is arithmetic, but not the same as ASA.

The American Standards Association system (ASA) is simple to learn and use and also easy to remember since it uses simple doubling and halving of numbers. A film with an ASA sensitivity of 200 is exactly twice as sensitive as one with a sensitivity of 100. Between each full step in the ASA scale there are fractional steps, normally divided into 1/3 step increments. Thus between our examples of 100 and 200 there are ASA speeds of 125 and 160. Most films developed in recent years have been designed to fall as closely as possible to whole step numbers for simplicity of use, but there are still some older films in production which fall on the 1/3 steps, such as Kodachrome 64. In many modern films the ASA number has become part of the film name which also simplifies things for the photographer. Examples of such names are Ektachrome 100, Fujichrome 50 D, Agfachrome CT 100, etc.

In contrast to this system, that developed for Deutsche Industrie Norm (DIN) is not so easily learned or understood. The easiest way to remember this is that the DIN scale is based on degrees, and that three degrees added to a number exactly doubles the sensitivity while three degrees subtracted from a number cuts the sensitivity in half. Thus a film with a DIN sensitivity of 18° is twice as sensitive as a film with a DIN sensitivity of 15°. Adding one degree to a DIN number increases the sensitivity by 1/3 step, so this system is like the ASA in being based on 1/3 step increments.

Speed	ISO	ASA	DIN	GOST	Grain	Resolution
Slow	20/14°	20	14°	18	Very fine	Very high
Slow	25/15°	25	15°	22	Very fine	Very high
Slow	32/16°	32	16°	28	Very fine	Very high
Slow	40/17°	40	17°	36	Fine	High
Slow	50/18°	50	18°	45	Fine	High
Medium	64/19°	64	19°	56	Fine	High
Medium	80/20°	80	20°	70	Fine	High
Medium	100/21°	100	21°	90	Fine	High
Medium	125/22°	125	22°	110	Fine	High
Medium	160/23°	160	23°	140	Medium fine	Medium high
Medium	200/24°	200	24°	180	Medium fine	Medium high
High	400/25°	400	25°	360	Coarse	Medium high
High	800/30°	800	30°	720	Coarse	Medium
High	1000/31°	1000	31°	900	Coarse	Low
High	2000/34°	2000	34°	1800	Coarse	Low
High	3200/36°	3200	36°	2700	Coarse	Low

The ISO (International Standards Organization) rating combines the two systems into a single system. Rather than coming up with a new system they decided to simply combine both of the old ones and use a composite number that takes both ASA and DIN and expresses them together. Thus a film with an ASA rating of 100 and a DIN rating of 21° would now have an ISO rating of 100/21°. However camera makers did not really take to this and almost all of them simply use the first half of the number, the old ASA rating. The Canon EOS cameras follow this scheme, but identify the number as ISO.

The GOST scale, not normally encountered outside the USSR and a few Eastern European countries, is a simple numerical progression in which doubling the number doubles the sensitivity. However it has a different reference point from the ASA scale. You may use the following table to compute values in one system from those in another or you may simply remember that GOST numbers are about 1/4 step off from ASA in the medium speed films. A film with a GOST speed of 180 will be the same as an ASA of 200.

An important tip when traveling in Eastern Sector countries is to bring all of your own film along. The film you are accustomed to using may not be available there and the film of local origin may be difficult or impossible to have processed when you get back home. Black and white films

are not usually much of a problem since practically all of them can be processed in standard chemicals and any good lab technician can determine processing of an unfamiliar black and white film by making clip tests, that is clipping off short sections from the leader of the film for test processing. Colour films are a different matter, and if you are buying an unfamiliar film it is important that it be possible to have it processed by your lab at home. Any film marked "Process E6" can be processed by any lab which deals with Ektachrome while any film marked "Process C41" can be processed by any lab which handles Kodacolor. Other films are to be used only at your peril, particularly if processing in unfamiliar chemicals is required. It is also a very good idea before buying a quantity of an unfamiliar film to test fit one of the cassettes into your camera. I have found that some types of film cassettes fit into the EOS cameras very poorly, being just a bit too large in diameter to easily slip into the film chamber. Although I know of no case of camera jamming or damage from this, I would avoid it because a cassette which fits too tightly may cause camera malfunction.

The new ultrafast films can record scenes in very dim light. Here I used a film with an ISO of 3200 to record this railroad crossing at night.

BLACK-AND-WHITE FILMS

Even if you initially buy your camera with the intention of taking only colour photos, I urge you to experiment occasionally with black and white. If you are considering setting up your own home darkroom as it is always easier to learn developing and printing with black and white materials before progressing to colour. Black-and-white films are available from most major manufacturers, but nearly all of them are similar enough to allow generalization.

In situations in which maximum detail is important the slower films should be the choice. These films are the ones with ISO ratings from about ISO 20/12° up to about ISO 50/18°. Generally these films must be reserved for photography in bright sunlight or with the camera mounted on a tripod due to the slower shutter speeds they will require. The inconvenience of having to work with a tripod is offset by the much greater amount of detail these films are able to record.

Nearly every film manufacturer makes a general-purpose film in the

A study in form and texture, the province in which black-and-white excels.

range of ISO 100/21° to ISO 125/22°. I have found all of the ones I have used to be very good and certainly capable of professional results if properly exposed and processed. Kodak's T-Max 100 can be handled like any other medium speed film but will produce prints with much finer grain and higher detail resolution. All of the black-and-white photos I took to illustrate this book were taken on this film, which has become my black-and-white standard.

Last in the range of the black-and-white films are the fast films which start out at about ISO 400/27° and continue to about ISO 3200/36° with normal processing. With special processing it is possible to achieve much higher film speeds. Films at the upper end of this scale used to be so grainy that they were not really good for general use and were reserved for special effects and technical use, but the recent improvements have given us a new generation of very fast films which produce results indistinguishable from much slower films of the past.

When you hear photographers talking who have been processing black-and-white for many year, you may hear them mention 'push' processing. This means that they increase the effective sensitivity of a film by increasing its development. This does not, however, improve the finished results although it can be used to rescue a mistake. These should be few and far between in the days of DX-coding and the Canon EOS system. Unless you want to produce a grainy print for effect, 'push' processing should never be done as a matter of course.

The speed barriers of older films are being broken today with new types of film. The best way to keep up with what is happening in the world of fast films is to read one or more of the better photography magazines, as they cover these developments in depth as they come along.

There is one special category of black-and-white films which should be mentioned here. These are the so-called chromogenic black-and-white films like Ilford XP-2. These can be processed by ordinary colour laboratories and do not need special black-and-white chemicals.

Photography and particularly film choice is a very subjective art. It is best to remember this when talking to photographers, as many of them will tell you of their own personal work habits as though these were the only possible ways to do things. I hope you will use my comments and suggestions throughout this book as a starting point for your own experimentation. You may find yourself agreeing with me, but I will not be offended if you don't.

COLOUR FILMS

Modern colour films come in two basic types, those in which the final product is a colour slide or transparency and those in which the final product is a colour print. In both cases the basic technology is the same. Colour print films produce a colour negative in which all the colours are reversed. When this negative is printed onto colour paper which is coated with a multi-layer emulsion similar to that of the film, the colours are reversed again and come out correctly in the print.

Colour Slide Films

Colour slide films are generally distinguished from other films by having the suffix "-chrome" as part of their names, as in Kodachrome, Agfachrome, Fujichrome, etc. There are three different types of slide film currently available, differing in characteristics and in how they are processed.

The first type is typified by Kodachrome, the first commercially successful colour film. Kodachrome films are unique today in that they have a much longer storage life than other types of colour slides. Oddly enough, although Kodachrome slides will outlast most others in dark storage they will fade much faster from prolonged exposure to light as in frequent projection.

While Kodachrome films have dyes added during processing all other standard colour slide films have their dyes added during manufacture. Due to the overall dominance of Kodak in the film business most manufacturers have decided to produce films compatible with Kodak's processing chemicals. This has made it much easier for the independent processing labs since they can now easily process nearly any film brought to them. The current Kodak developing process for slide film is designated E-6, and all of the slide films you are likely to encounter (except for Kodachrome) will state somewhere on the package that they are to be processed in E-6. The current Agfachrome, Fujichrome, Ektachrome and 3M Colour Slide Film are examples of E-6 compatible colour slide films.

In many places you can get very fast service on slide processing, sometimes only an hour or two. But what about those times when even

this is too long? Polaroid has come to our rescue with several very interesting films which are exposed in any 35mm camera and then, after rewinding, can be processed into slides in a matter of minutes in a small portable processor. For situations in which "right now" is too late, this is the only type of film to use. The Polachrome colour slide film is rated at an ISO of 40/17°, which is somewhat slow. In addition to the Polachrome colour slide film, Polaroid also make a general use black-and-white slide film, a high contrast black and white slide film and an unusual film called Polablue which produces white lettering on a blue background from originals with black lettering on a white background.

Once one of these Polaroid slide films has been exposed it is rewound into the cassette. Unfortunately Canon designed the EOS cameras – except for the EOS-1, 630(600) and RT – so that they wind the film all the way inside the cassette instead of leaving the film tongue protruding which is necessary for processing. However, Polaroid supplies a small gadget called a film tongue retriever which allows the film tongue to be gripped and pulled back out through the cassette lip.

Below: of all the colour films only Kodachrome could capture the soft subtle colours of this landscape. Photo: Darlene Shell. Right: some of my best outdoor photographs have been taken on overcast days when the light is naturally soft and the colours saturated.

Special Considerations in Colour Slide Photography

As a general rule colour slide films have a very limited latitude, which is to say that they will tolerate little deviation from the ideal exposure, typically less than one step of over or underexposure. This means that your metering technique must be very good if you intend to shoot colour slides. Colour slide films will tolerate under-exposure far better than over-exposure, so it is better to err in that direction.

Many professional photographers feel they get the best results with colour slide films if they rate them about 1/2 step higher than the manufacturer's rated ISO speed. This is easily done on the EOS 650, 630(600), RT and 650 by setting the exposure compensation control to –0.5, although if you find that this half step of underexposure is a hair too much you may prefer to simply increase the ISO setting by one click on the control wheel. You will probably find that the more saturated colours produced in this manner are more pleasing than the colours obtained at the manufacturer's normal speed rating. If, however, you prefer the results from using the recommended rating, forget the adjustment.

If you are shooting colour photos which will ultimately be printed in books or magazines you should shoot colour slides. Printers throughout the world have standardized on colour slides as their desired original because the printing plates produced from slides are more easily controlled. If you are submitting colour slides to an editor for consideration do not submit them in glass slide mounts. The printer would have to remove them from the mounts to be able to make the printing plates from them and this would only increase the chance of damage.

If you have already produced a photo on colour print film and wish to submit it for publication, you should ask the publisher if they will accept colour prints. Many will not. It is possible to have colour slides made from colour negatives, but you must remember that the quality is never as good as it would have been if the original had been shot as a slide.

Colour slide films are manufactured with the intention that they will be exposed within a certain range of shutter speeds. The reason for this is that the emulsion layers sensitive to different colours of light may be exactly balanced to one another at only one specific exposure and will

Above right: a "found photograph" taken in late afternoon light at a roadside fruit market. I found the subdued colours and the low angle of the light interesting.
Below right: in still life photography, interesting and colourful compositions can be made with the simplest of props, often available from the nearest grocer or the backyard garden.

change slightly as that exposure changes. In normal photography this is not a problem, but you must consider this factor in dealing with very long exposures. This failure of film to respond properly to colours at very long exposures is referred to as reciprocity failure. Information on how to deal with it is contained in the instruction sheets supplied by the film manufacturer, but generally speaking films tend to lose sensitivity at these long exposures so that a light meter will indicate an incorrect exposure. As an example, many films will need about 50% more exposure if the light meter indicates an exposure of 30 seconds. Such long exposures will also cause colour shifts, usually toward blue or green, and you may need to fit a colour compensation (CC) filter to get realistic colour. If you find the need to make such long exposures, use the information supplied by the manufacturer as a starting point and make a series of test exposures to determine what will give the results you want.

While almost all of the colour slide films you will encounter are balanced for daylight or electronic flash (both of which have approximately the same colour temperature), you should be aware also of some special colour slide films designed for exposure to other light sources. These are called "tungsten" films and are for exposure to photographic lamps with a colour temperature of about 3200°K. These films are frequently favoured by studio photographers who like to use tungsten or "hot" lights, and they tend to respond better to long exposures than their daylight balanced cousins. Most of the major film manufacturers offer tungsten balanced films, and if your photography is to be done under such studio lighting you will find that these films produce better colour than daylight type film used with colour compensating filters.

Ordinary household lighting of the tungsten filament type is not controlled to a specific colour temperature and is often much warmer than the 3200°K photo lamps. You will find that using tungsten balanced film with these light sources will produce more realistic colours than daylight film under the same circumstances, but critical colour accuracy can not be assured. For informal portraits the warm glow frequently produced in photos of this type can be very attractive.

Portraits need not be boring head-on shots. Both the model and the photographer found these over the shoulder poses more attractive than more traditional poses from the same session.

Colour Print Films

The next class of films is called colour print films. These films all produce colour-reversed negative images and are intended for printing onto colour paper. While there is little variation in colour slide processing among careful labs, this is not the case with colour prints. The same negative submitted to ten different labs for printing will often produce ten different prints, each one varying from the others in subtleties of colour. The problem is a matter of subjective judgement. While the slide you get back is the original frame of film which has been processed and mounted, there is the extra step here of translating the original colour negative from the camera into a print. Even with great efforts at standardization, the final determination of whether the print is acceptable is made by the person doing the printing. Since the printer does not know what colour your subjects were beyond certain generalities, his judgement can lead to prints in which the actual colours are missed completely. This is particularly a problem when photographing unusual subjects which give the printer no automatic clues to proper colouring.

Recall what I have said about light meters. They are designed to assume that your subject averages out to medium grey of 18% reflectance. The same applies in the processing lab since the automated printing machinery used in most labs is also set to assume this averaging of all subjects to a medium grey. This means that negatives which ought to be printed with a much greater or lesser overall reflectance will be misprinted to average out to medium grey. Overall dark subjects will be printed too light and overall light subjects will be printed too dark.

To make matters even worse, these machines not only average tonal values out to an even grey, they also average colours! Large areas of a single bright colour will tend to be printed with too little of that colour and the colour balance of the rest of the print will be thrown off. As an example, I once did a series of nude photographs of a model against a bright crimson background. For reasons I can't recall I shot part of the session on colour slide film and part on colour print film. The slides were stunning with the colours just as I remembered them. The prints were a disaster. The background was printed in a pinkish-orange colour while the model's flesh was rendered a ghastly blue-green colour. It took three trips back to the lab to get these negatives properly printed.

Processing labs refer to this problem as "subject failure" to toss the blame for the problem back at the photographer. After all, if we'd all only

cooperate by shooting average, boring photos the labs would never have this problem! Realistically, when shooting really unusual colour situations it is best to use colour slide film. If you must work with colour print film, make sure to inform your lab of what you are doing. This is especially important if you are using "artistic" techniques such as double exposures, soft focus, trick filters, etc. because otherwise the lab is likely to assume that your art photos are just a bunch of mistakes and not print them at all.

Colour negative films are available from a number of manufacturers and all of the ones I have used are capable of producing good prints in the hands of a good lab. The range of ISO speeds is broad, starting at ISO 25/ 14° and going up to 3200/36°.

Colour print films tolerate exposure errors better than colour slide films. This is partly because the films themselves have more latitude and also because some correction can be done during the printing. Generally colour print films tolerate over-exposure better than underexposure, just the reverse of slide films. Just as many photographers rate their colour slide films slightly higher in speed than the manufacturer's recommendation, many also rate colour print films slightly lower. This often produces prints with more intense colours.

Although there are no grains of silver in a colour negative, the silver having been bleached away in processing, the colour dyes clump together in the areas where the silver grains were, giving an appearance of grain when enlarged. As with black and white films, the apparent grain increases with film speed. The recently introduced Kodak Ektar 25 film may be considered the colour negative equivalent of Kodachrome 25. Its ability to render fine detail is unmatched in the colour negative field. Kodak has also introduced Ektar 125 and Ektar 1000 films which make use of their T-grain technology to produce very fine grain at each film speed. I have been very pleasantly surprised at the quality of prints from the Ektar 1000.

Kodak also offers a line of Ektapress films in 100, 400 and 1600 speeds. These are professional films which are made to keep better at room temperature and do not require refrigeration except for prolonged storage. This is much more convenient than the older professional films which absolutely required refrigeration for maximum quality.

For portraiture I tend to favour the Kodak Vericolor 400, which offers colour quality and grain about equal to most former 100 speed films. It has become very popular with wedding photographers because the extra

speed makes shooting under available light much easier, and allows greater depth of field in flash photos.

Generally the colour quality of colour print films is better at the slower speeds, with the really fast films best considered special purpose films for shooting under bad lighting conditions. An exception to this is the Konica SR-V 3200 film which has remarkably good colour for such a fast film. It is, though, rather grainy.

An interesting development from Fuji is the REALA ISO 100 colour negative film. This film makes use of a new emulsion design which has an extra colour compensating layer and allows the film, within limits, to self-compensate for variations in colour temperature of light. This allows this film to produce very good results when exposed under mixed lighting, such as indoor tungsten mixing with sunlight through a window, or combined fluorescent and sunlight. It has been designed to emulate the automatic compensation of the human eye/brain to differing colour temperatures of light, which we tend to perceive as neutral. Reala produces particularly realistic and accurate flesh tones with very fine grain, and is being enthusiastically received by portrait photographers. Fuji has also applied some of this technology to their Super HG 200 and 400 films which now have much finer grain than in the past and produce more saturated colours.

Just as with colour slide films, there are special colour negative films made for exposure to studio tungsten lights.

Colour print films account for more than 80% of all photos taken. There are many brands and speeds to choose from. All of the major film makers offer one or more varieties. My suggestion, if you intend to work with colour print film, is to try several of the different types and then standardize on the one which produces the results you like the best. Just remember that the processing lab makes all the difference in the world with colour negative films, so try shopping around until you find a lab which will produce the quality you require at a price you can afford.

Colour Temperature

Normal daylight may seem the same to you all of the time, but that is because your brain automatically compensates for shifts in the colour balance of the light. Daylight is really only "white" at midday and changes toward the morning and evening. It becomes redder at these times. If you have ever taken photos under ordinary indoor incandescent

lighting you may have also noticed that these photos had a strong yellow or orange cast after processing. This is due to the fact that the colour of the light source was not the same as the one for which the film was balanced.

Colour films are ordinarily balanced for daylight, and these types of films will produce excellent results under daylight or any type of artificial light which mimics daylight in its composition. The overall colour balance or temperature of light is expressed in Kelvins. Midday daylight is around 5000-5500 K, and any light source which produces a colour temperature similar to this will produce good results with a Daylight type of colour film.

Ordinary tungsten house lights or special photographic lights called photofloods or photopearls have a different colour temperature, typically about 3200 K. The lower the colour temperature the redder the light. To produce proper colours under these light sources it is necessary to buy special tungsten light films. That the entire roll must be exposed under the same light. If you use Tungsten Type film under daylight the photos will be too blue.

It is also possible to match the film to a light source other than the one it was designed for by using a colour correction filter, see our ACCESSO-RIES chapter under Filters for details on this.

Colour Temperature of some Common Light Sources	
Source	**Approx. Colour temperature (Kelvins)**
Candle	1800
60-75 watt household lamp	2800
100 watt household lamp	2900
250 watt studio tungsten lamp (white frosted)	3200-3400
250 watt studio tungsten lamp (blue frosted)	5000
250 watt studio tungsten halogen lamp	3200
Flashbulb (clear)	4000
Flashbulb (blue)	5500
Sunlight (direct clear sky)	4500
Sunlight (indirect)	5500
Sunlight (overcast sky)	8000
Sunlight (north sky light)	15000
Studio electronic flash	5500-6000

These temperatures are only approximate. For critical work the colour temperature should by determined by using a colour meter or by careful film tests.

INFRARED

Just past the end of the visible red, begins a range of radiation referred to as infrared (IR). Infrared will pass through optical glass and is brought to focus by camera lenses just like visible light, but at a slightly different plane of focus. Special infrared-sensitive black-and-white and colour films are used to record these images.

If you decide to experiment with this film make sure to follow the instructions carefully. You will have to load and unload your camera in the dark.

If you are not doing your own film processing make sure that the lab you plan to use is familiar with processing of infrared, since it requires careful handling in the darkroom. Since exposure meters vary in their sensitivity to infrared, there is no such thing as an ISO rating for these films. Your own personal meter setting will have to be determined by trial and error. By experimentation I found that for my own situation working with the EOS 620 I got best results if I set the camera for an EI of 200-400 for black-and-white IR film. My photos were all taken in bright outdoor sunlight, so the rating may be quite different under other circumstances.

Infrared film also responds to some visible light, so it is necessary to block out most of the visible light to which it is sensitive. This is done with a number 25 red filter for general photography. Other filters may be required for specialized work, see the film instructions for details.

To make the compensation for infrared focus you must first focus the camera normally. If you used autofocus to bring it to focus you must then switch to manual focus. You may find it easier simply to use manual focus all the time for infrared work. After you have focused the lens you must look at the focusing scale. You will see either a red dot or a red line to the right of the centre line. You must then move the focusing ring until the portion of the distance scale which was lined up with the white centre line now lines up with the red dot or line. On zoom lenses there will be more than one red line, indexed to focal lengths, and you will use the one corresponding to the focal length you have set. If you are in between focal lengths, you will have to estimate a point between lines.

It is best to work with small apertures where the focus is less critical,

since the greater depth of field will cover any errors in focus. If you are working with the camera on a tripod and your subject is static all of this will be easier since you won't have to be constantly refocusing and setting for infrared.

It may sound like a lot of trouble to use infrared film, and it is, but the exotic and fantastic results which can be produced will more than justify the effort involved in producing them.

The surrealistic beauty of this image is a result of the use of infrared film. Many unusual effects are possible with this film, but it is somewhat difficult to work with.

SPECIAL POINTS ABOUT FILMS

While it is beyond the scope of this book to go into films in any more depth, I think that the information I have given will enable you to decide on the types which will best suit your needs. For general use it is best to standardize on one of the medium speed films for colour and one for black-and-white, and then get to know them thoroughly. If your needs are varied and these medium speed films will not always meet them, then I suggest that you make a point of experimenting with a number of different films so that you will learn what they can do and be able to pick the one best for the job at hand. Additional information can be obtained from the film manufacturers, all of whom have information booklets and brochures which you can get from your dealer or directly from the manufacturer or agent. Additionally the popular photography magazines are good sources of information on new films as they appear on the market.

The important points to remember about films are that the apparent grain always increases as the film speed increases, that ability to resolve detail decreases as film speed increases, and that with negative films contrast generally increases as speed decreases while the reverse is generally true with slide films.

When purchasing film you may find that some camera dealers carry both the ordinary films and a separate line of films designated professional. Many photographers think that the professional films must be better and begin to buy them instead of the ordinary amateur films. This is not always wise. In most cases the products marked professional will not produce pictures any better in quality than their amateur counterparts. In fact, in most cases they are essentially the same film.

All films age, and as they age the emulsion sensitivity changes. Black-and-white films will become slightly less sensitive if stored for long periods of time, but will generally not change in any other way if properly stored. Proper storage is in a dry place with a temperature around 20°C (68°F). For prolonged storage of black-and-white films, say much over six months, refrigeration is recommended to slow down any changes. Storage in cold will not harm the film if the original packaging is unbroken so that the film stays dry. Some photographers freeze film, but

for normal lengths of storage that is unnecessary. (And if you happen to use the Polaroid 35mm films, freezing them can ruin the processing chemical pod.)

With colour films the process becomes more complicated. As colour films age the different layers of the emulsion change sensitivity at different rates due to the differences in their composition. This causes a gradual change in colour balance. Colour film is like good cheese, it must be aged to develop the flavour. Film fresh off the manufacturing line is not yet usable, it must be held in controlled storage for a period of time to allow the emulsion to ripen before it can be shipped out to your dealer. Amateur films are shipped out while still a bit "green" because it is assumed that they will sit at the dealer's shop for a while and then be loaded into the customer's camera and used over a period of time ranging from several weeks to several months. By the time the film is developed it has generally reached maturity and will provide good results.

Professional films differ from amateur films in this one respect. They often start out exactly the same as the amateur versions, but they are kept at the factory and aged until the colour balance is fully ripened and then they are frozen to hold them at this point. They are shipped out to the dealer at that time with instructions that they should be held at his shop under refrigeration until sold. At the time of purchase the photographer assumes the responsibility for keeping the film refrigerated.

Film thus stored must be removed from refrigeration two or three hours before use and allowed to come up to room temperature while still in the sealed packaging – otherwise droplets of moisture would condense on the cold film surface and ruin it. The manufacturer assumes that professional films will be exposed completely in a comparatively short period of time, certainly no more than a few days, and then promptly turned in for processing. If there is to be a delay between exposure and processing the film should be sealed up in plastic bags and returned to refrigeration until it can be taken to the lab. All film should be kept as cool as possible at all times. In very hot weather it is important to keep the camera and film in a cool place and away from direct sun. Certainly never lock them inside a car as this will cook the film and ruin it.

I have found a small polystyrene cooler of the type sold for cold drinks to be a valuable and cheap tool for carrying film in hot weather. Not only will this keep many rolls of film cool throughout the day, but it also has space for some cold drinks at the same time and they revive the spirits of the photographer when working in the heat. Just be sure that any ice

used to keep things cool is in a sealed plastic bag so that it does not get the film wet. Keep the film in its own sealed bags for added safety. As an alternative to ice I have found the reusable gel packets which you put into your home freezer and transfer to the cooler very good for this purpose. Don't forget to return the film to the cooler after exposing it.

If you customarily send your film to the processing lab through the mail, you should realize just how hot it can get inside a letter box exposed to direct sun. If you must use the mail, either take your film directly to the post office and mail it inside or wait until late in the day before depositing it in the mail box. Be sure not to miss the last pickup of the day! Also keep in mind that the higher the ISO speed of the film, the more sensitive it will also be to heat.

Not all photos are shot in extreme heat, sometimes we have to work in the opposite extreme. As mentioned earlier in this book, the Canon EOS cameras must be kept as close as possible to normal room temperature to assure that the LCD panel and viewfinder display will function. Another reason for keeping them warm is that film sometimes becomes brittle in very cold conditions and can break off inside the camera. Moving film rapidly through a cold camera, as with a motor drive, can generate static electricity which will show up on the processed film in the form of marks looking like lightning bolts. On the whole I would not consider the EOS cameras other than the EOS-1 well suited for work in extreme cold and if your work calls for assignments under arctic conditions I would recommend purchasing an older, mechanical camera for such use.

On every film box there are two important pieces of information either printed or stamped. One of these is a date, the manufacturer's "use by" date for the film. Always check this date when buying film and try to get the film with the longest dating as it will be the freshest. Film close to "use by" should be avoided unless nothing else is available. Film which has gone past the "use by" date may sometimes be safely used, especially if you know the dealer and his storage conditions, but it should never be bought for full price. If you buy close dated or outdated film, reserve it for experimental or less important projects. Do not make the mistake of trusting it for important photos. This advice is less important for black-and-white film which ages more slowly and does not have the problem of changes in colour balance. In dealing with questionable colour film you must decide for yourself how much colour deviation you can tolerate in your work.

The second piece of information marked on the film box is the

emulsion number or batch number and refers to all of the film which was manufactured in one lot. While film may sometimes vary considerably from batch to batch, variations within a batch are always very small. For really critical work many professional photographers buy 100 or more rolls of film at a time, making sure that all carry the same emulsion number. They will then test a roll or two to determine the exact characteristics of that batch and freeze the balance of the film to prevent any change before it is used. While modern films vary little from batch to batch, there are subtle differences in colour balance and film speed which may matter to the discriminating professional photographer.

One last special note about films. In recent years a totally new hazard has been added to our quest for best picture quality, the airport X-ray machine. All films are sensitive to X-rays just as they are sensitive to light. While most airports have posted signs stating that their X-ray equipment will not damage film, independent tests have shown that this is not true. Even if a specific type of machine is film-safe you may run upon one which is improperly adjusted and gives too high a dose of X-rays. Repeated passes through properly adjusted machines have a cumulative effect. Generally the higher the film speed the more likely it is to be damaged by X-rays.

In my travels I have found that most airport security personnel are polite and receptive to the request that photo bags be hand searched and not passed through X-ray machines, but there are still some countries which employ churlish personnel who will refuse to honour such a request. They have insisted to me that the machine will not harm my film and offered the option of going to the end of a very long line where I just might be able to get a hand search (if I didn't miss my flight in the process), or they have rudely grabbed my bag from me and shoved it through the machine while pretending not to understand my protests, even when they were delivered in their native tongue!

The best solution to this is to carry your film in special bags made from lead foil to reduce X-ray penetration. SIMA makes a product called Filmshield which is offered in several sizes of bags and also in rolls, and in two thicknesses, one for ordinary films and one for high speed films. While this product is opaque enough to prevent X-ray damage it will still pass enough X-rays to allow the operator of the machine to see that the bag contains film. Lead-lined film boxes for the same purpose are made by POSSO.

WHEN AUTO EXPOSURE WON'T WORK

As has been mentioned earlier in the chapters on THE LIGHT METER, BASIC SENSITOMETRY and FILMS, there are situations in which the camera's built-in meter will not give correct exposure information. This chapter will give a brief summary of these situations and some practical suggestions on how to get good exposures under difficult conditions.

To understand why the camera's meter does not always give the best exposure information you must understand that built-in meters in SLR cameras are always of the reflected reading type. Since they respond only to light reflected from the subject, they are influenced by the reflectance of the subject. Light meters, as I have said before, are designed on the assumption that all subjects they see will have an average reflectance equivalent to middle grey or a reflectance of 18%.

Simply stated, the auto exposure system of the EOS cameras will give incorrect exposure information whenever the overall reflectance of the subject is much greater or much less than 18%. Specific examples are given in the above referenced chapters. The important point to remember is that the camera will determine an exposure which will render the subject as though its reflectance is 18%. Very bright subjects will be rendered too dark, very dark subjects will be rendered too light.

You may use the Exposure Compensation control on the EOS-1, 650, 630(600), RT and 620 to program the camera with a factor of over- or under-exposure. When photographing very light coloured subjects this would require a plus factor, that is an over-exposure factor, because this will offset the camera's tendency to underexpose light subjects and render them too dark. In the opposite situation, dark subjects which reflect little light, the required factor would be an underexposure or minus value to offset the camera's tendency to over-expose such subject. This works well when shooting a sequence of the same subject.

When you are shooting rapidly and encounter a subject of high or low reflectance and only expect to take a few photos of that subject, you may not want to set the Exposure Compensation control. Instead you may prefer to use the alternative subject method. In this situation you would seek a subject which is under the same light as the subject you wish to photograph, but has a closer to average reflectance. You would then take

a light meter reading from that subject and photograph your intended subject at the same exposure. This is most easily done in the Manual mode. Although you can hold a set of exposure values by lightly pressing on the shutter release button, this also locks and holds the focus, and it is rare that your alternative subject will have the required reflectance and be at the same distance as your main subject. Of course, if you wish to maintain automatic exposure you may switch the camera to manual focus. Which works best will depend on the specific situation. With the EOS-1 you can switch to Custom Function number 4 and initiate autofocus with the AE lock button, while with the EOS 630(600) and RT cameras the Custom Function Control allows you to set the camera so that the focus is controlled from the partial metering button and the exposure lock from the shutter release button. This makes use of the alternative subject method of metering far easier.

The partial metering switch.

Another method for coping with this situation is to find a small area of the subject which has more normal reflectance and take a spot meter reading from that area. This works well as long as the area is no smaller than the spot metering circle in the camera viewfinder. Pressing in on the partial metering button with your right thumb takes the reading and holds it as long as you keep the button depressed. It does not activate the autofocus mechanism, which you operate in the normal manner by light pressure on the shutter release button. In this way you may take a spot meter reading of the best area of the subject and then hold that reading while recomposing and focusing the image. I have found this to be the fastest method for metering under many different situations. It is particularly good for backlit situations.

On the EOS-1 the idea is the same but the operational technique is different. Here you use the main control wheel and metering button to

select the metering system; multi-pattern evaluative, partial or spot; then use the AE lock button to hold the exposure while recomposing the photo. On the EOS-1 the AE lock button does not have to be held in, once pressed it holds the reading for six seconds, plenty of time to recompose and take the photo.

The last way to cope with difficult metering situations is the one used by seasoned photographers. They follow the "$f16$ at the ISO" method for setting exposure under difficult metering situations outdoors operating the camera on Manual control and ignoring the built-in meter. This rule says that you will get proper exposure outdoors under direct sun if you set the lens aperture to $f16$ and the shutter speed at the same number as the ISO rating. As an example, when photographing outdoors with a film of ISO 125/22° sensitivity, you would set the camera to $f16$ with a shutter speed of 1/125th second. In other cases you would pick the closest available shutter speed to the ISO index.

Of course any other combination of shutter speed and f-stop can be used so long as it delivers the same overall exposure. 1/125th at $f16$ is equivalent to 1/60th at $f22$, 1/250th at $f11$, and so on.

In bright direct sun this is always the correct exposure. A haze or thin overcast will reduce exposure about 1/2 a step, overall clouds about 1 step. Heavy overcast would be about a 2 step reduction, which is also usually right for open shade.

I am always amazed when photographing events at which many photographers are working, as they are always asking each other the exposure. If they simply memorized the above basic exposure information they would never have to ask, and they would know right away if something was wrong with their camera and it was delivering erroneous meter readings.

There are some specific situations which you may encounter in which taking a meter reading of any sort is impossible. A common example is fireworks displays. Even the EOS camera's spot meter is no help here. Since your reaction time is not fast enough to fire the shutter at the proper point, this type of photography is best done with the camera mounted on a good tripod. The shutter should be set to "bulb" and opened prior to the firing of the rocket. You may leave the shutter open for several rockets if the sky is very dark, otherwise you should only get one or two on a frame. With the shutter set to "bulb" suggested f-stops for fireworks are: $f16$ for 400 speed film, $f11$ for 200, $f8$ for 100. Using film faster than 400 is not recommended as it will be too likely to pick up overall exposure

A spot reading from the skin tones provides the most accurate exposure for this subject with extreme contrasts.

from ambient light and render the background grey instead of black.

Thunderstorms are another opportunity for really unusual photos, but just remember that they are dangerous. If you want to take photos of lightning, be sure that you are at a safe distance from the storm itself. Never allow yourself to be the tallest object around during a thunderstorm, you will be acting just like a lightning rod. For thunderstorms at night, the above recommended exposures for fireworks will be a good starting point. Daytime thunderstorms are almost impossible because the ambient light level is usually too high to allow the long exposures which would be needed to capture several lightning bolts.

Another difficult exposure situation is photographing stage shows or concerts. If you just use the standard auto exposure modes you will get photos in which too much of the dark background has influenced the exposure and the stage will be too light. You should try to get in close enough to take a Manual mode light reading with the partial or spot meter of just one of the performers, and use this exposure for all of your photos. Remember that the exposure determined up close will be correct no matter how far you get from the stage. For heaven's sake don't make yourself look ridiculous by firing off your on-camera flash from the back rows of a concert – it will have no effect at all at those distances.

If you are unable to get close enough to take a good meter reading, then here are some suggested settings which work well for me. Since the EOS-1, 630(600), RT and 620's LCD panel can be illuminated, it is easy to set the exposure even in a dark audience. Simply press the LCD illuminator button and you will have eight seconds in which to make your adjustments. If you are dealing with spotlit performers, as is usually the case

Suggested Exposures for Difficult Subjects

Subject or Condition	Suggested Exposure at ISO 100
Bright sun on snow	1/1000th at $f6.3$
General subjects at dusk	1/60th at $f4$
Indoors under fluorescent lights	1/30th at $f2.8$
Indoors under tungsten lights	1/30th at $f1.4$
Stage performances lit by spotlights	1/30th at $f2.8$
Outdoors under full moonlight, clear sky	3 to 9 min at $f1.4$
Outdoors under full moonlight, overcast	9 to 20 min at $f1.4$
Fireworks	Shutter open on B at $f8$ to 11
Lightning	Shutter open on B at $f5.6$ to 8
The moon*	1/125th at $f16$

The above are given as general subject guidelines developed from personal experience. As with all important pictures under difficult situations, I would advise you to bracket your exposures.

When shooting colour under difficult circumstances it is usually best to use colour negative films of medium speed as these have the greatst exposure latitude and will often produce excellent prints even when exposed incorrectly.

* Remember that it is always a bright sunny day on the lighted surface of the moon, so the rule of the same shutter speed as the ISO at $f16$ applies.

at concerts, the best exposure with 400 speed film will be about 1/250th at $f2.8$. If you are photographing stage shows, plays and the like which are usually lit with floods, exposure will be about 1/125th at $f2.8$. Although the colour temperature of stage lighting is not really matched for daylight type colour film, I have found that my best results were made with this type of film, particularly when coloured spotlights are used.

There are many other situations in which a meter reading is almost impossible to get, and for some guidance in those situations the exposure suggestion table above should be of help. Use all of this information as a starting point only, when in doubt always bracket exposures.

WHEN AUTOFOCUS WON'T WORK

Although the Canon BASIS autofocus sensor is one of the best available, there are still limitations to its function. Since it works like all other SLR autofocus systems in responding to image contrast, there are certain types of subjects to which it will respond poorly or not at all.

The first situation which you will encounter in which the autofocus system will not work is when you attempt to photograph a subject with no detail. It may be the side of a building, the surface of a pavement, the smooth cheek of a portrait subject or any other smooth area with no strong texture and no surface detail. The sensor causes the lens to be driven rapidly between its closest focusing distance and infinity without stopping because it is seeking subject contrast and finding none. The autofocus indicator in the viewfinder will flash rapidly to warn you that the system is not able to find anything to focus on.

The Autofocus-Manual focus switch.

You may want to handle this situation by reverting to manual focus. To do this you move the slide switch on the left side of the lens from AF to M and then use the manual focus ring to focus the lens, just as in a non-autofocus camera. You will probably find, as I did, that those subjects which cause trouble for the autofocus system are just those subjects which are difficult to focus by eye, and for the very same reason: there is no subject detail or contrast for your eye to sense either.

If you are reasonably good at judging distances then you can simply set the lens to the estimated distance and take the photo. This will usually work fairly well, especially if you are shooting at a small aperture and have plenty of depth of field to cover errors in distance estimating. This is most chancy at close distances or with large apertures.

Another method which I frequently use with autofocus SLR cameras is the "alternative subject method". When the camera can't focus on a subject I look for another at the same distance and let the camera focus on that. Since the focus will lock and can be held by light pressure on the shutter release button, it is easy to hold this focus and recompose the photo to include the original subject. Even if you are a poor judge of distances you can usually judge when two subjects are at the same distance.

Sometimes when photographing people, particularly close-up portraits of smooth-skinned women and children, the camera will have difficulty in focusing on an area of skin. In this case, move the small rectangle in the viewfinder until it is on the subject's eye, or the border between eye and cheek and let the camera focus there. After it has focused maintain the light pressure to hold the focus while you recompose the portrait.

For technical reasons the BASIS sensor in all EOS cameras except the EOS-1 responds to bars of vertical contrast. The EOS-1 has a new crossed array BASIS which responds to both horizontal and vertical contrasts and is rarely fooled by the situations detailed here. Most subjects provide enough "vertical contrasts" so that the camera has no trouble focusing on them. However, certain subjects with strong horizontal lines and no vertical ones are definitely troublesome. The most commonly encountered subject which presents this problem is venetian blinds. Because the image is made up entirely of horizontal stripes the camera is completely unable to find anything to focus on. This problem, which will not occur very often, is easily solved. You simply turn the camera on its side so that the horizontal lines become vertical ones to the sensor and let the camera focus. Hold focus and return the camera to horizontal for the photo. Although I have been warned about this problem in the instruction book

Focusing on a smooth area of skin tone may prove difficult (right). In this case, moving the focusing rectangle to the subject's eye, letting the camera focus, and then re-composing the picture with the focus held provides the solution.

of every autofocus SLR camera I have tested I can't say that I have ever encountered this sort of situation in my work.

Another situation warned of in camera instruction books is strongly backlit situations. While this often does have the effect of fooling the metering system into giving incorrect exposure, I have not personally encountered a situation in which this sort of lighting made automatic focusing impossible.

Because the BASIS sensor has definite sensitivity limits there are times when it will not function because the light is too dim or too bright. Generally speaking, the situations in which the light is too dim for the sensor to work are situations in which photos can not be taken by the existing light. In such cases the camera should be fitted with one of the Canon Speedlites or flash units from other makers specifically made for the EOS cameras. These flash units have their own built-in illuminators which provide the autofocus sensor with enough light to focus. See page 169 for details on how this works and how to use it. Normally you will not encounter overall illumination that is so bright that the BASIS sensor will not work but small areas of very bright light can cause it not to work, and we all encounter them in our photography. They are highlights and reflections. For example I found that I could not get the camera to focus when taking a photograph of a sports car, and then realized that I had unthinkingly placed the focusing area on a bright reflection of the sun on the car. Once I moved to a darker area of the car the camera jumped to focus as usual.

Although not mentioned by Canon, I have found that the BASIS sensor does not like the colour red very much. In many situations in which a red subject was to be photographed the camera either would not focus or would focus at an incorrect distance. I assume that this has something to do with the colour sensitivity of the sensor or the colour correction of the small lens which directs light to the sensor, but whatever the cause I would suggest extra care in photographing red subjects. Either use manual focus or try the alternate subject method if in doubt.

Top right: the BASIS sensor seems to encounter problems with red – like the smooth bright red of these peppers. Placing the focusing rectangle over the green stalk ensures positive accurate focusing.

Bottom right: patterns of horizontal lines can fool the BASIS sensor (except on the EOS-1) but this shadow of a venetian blind, falling at an angle, provides a perfect focusing target regardless of how you hold the camera.

Another situation which you may encounter is that the autofocus system does not know what you want to focus on and if presented with a cluttered and busy area it may pick the wrong subject. Animals in a zoo are a possible problem as the camera may focus on the bars of the cage or the fence if there is one between you and the animal. Photographing banana trees in a botanical garden I found that the camera was sometimes confused by the large number of vertical lines at different distances. As with any other tool an autofocus camera must be used with thought, trying to rely on the automatic focus all the time will be just as disappointing as trying to rely on the automatic exposure all the time. Neither can do your thinking for you!

One last point about autofocus. The light which the autofocus sensor uses to determine focus is a small part of the light which passes through the camera lens and strikes the reflex mirror. Most of that light is reflected upward to the viewing screen but a small portion passes through a semi-silvered area in the middle of the mirror and is reflected down by another mirror to the BASIS sensor which sits in the bottom of the mirror chamber. In passing through this semi-silvered mirror the light becomes polarized. The semi-silvered mirror is a beam splitter in action, and beam splitters which use mirrors always polarize the light which passes through them. You cannot use an ordinary polarizing filter with the EOS cameras. It will not be aligned with the axis of polarization of the semi-silvered mirror and will cut off light to the BASIS sensor and prevent it from working. Filters are excellent for producing certain photographic effects, and the polarizing filter is one of the most commonly used and most versatile. If you want to use a polarizing filter with your EOS camera it should be the circular polarizer type. See the FILTERS chapter for more details.

If you use special-effects filters such as soft-focus, fog, split-field, multiple-image, etc., you may find that some of them interfere with the camera's autofocus operation. With these it is best to use manual focus, but you may use the trick mentioned above of focusing the camera with the autofocus before mounting the filter. As with everything else, you must determine what works for you.

Top left: if you use a polarizing filter to increase colour saturation and cut glare, you must fit a circular polarizer and not an ordinary 'linear' type.
Bottom left: autofocus may be difficult with a fog or special-effect filter, and with subjects where pre-focusing without the filter is impossible, switch to manual.

DEPTH OF FIELD

When we look at a selection of photographs one thing which can be seen is that the portion of the image which is in sharp focus varies. In some photos only a small section of the image is in sharp focus with the balance being more or less out of focus. In other photos every detail throughout the image is sharp. What you are seeing here is the visible effect of a photographic phenomenon known as depth of field.

Depth of field may be defined as the zone of acceptable sharpness before and behind the actual plane of focus. In truth any lens is only producing its sharpest focus at the plane on which is it focused, but in practice there is always a zone both in front of and behind this plane that is rendered acceptably sharp. In any photograph, each point on the image is actually a tiny blurred circle. These circles appear to be sharp to our eye when they are smaller than a certain size; as they define parts of the image away from the plane of focus these circles become larger until they reach a size at which they no longer appear sharp to our eyes. Within the range in which these circles appear as sharp dots, the image is perceived to be in focus, that is within the depth of field. These tiny circles

Left: the depth of field is less in front of the plane of focus than behind.

Right: sharpness from foreground to extreme distance can be achieved by using a very small aperture such as f16 or f22 with a wide-angle lens between 20 and 28mm.

The EOS Depth mode allows you to focus first on the foreground (in this case, the nearest clump of grass) and the background (the tree) and will set the shutter speed, aperture and intermediate focus point precisely to ensure sharpness through the entire picture.

are known as circles of least confusion, or more commonly today simply as circles of confusion. Depth of field (the size of the circles of confusion) is controlled by two factors.

The first and most important factor in determining depth of field is the relative size of the opening of the iris diaphragm compared with the focal length of the lens. Apertures as commonly identified are one half of a ratio, for example a lens set to $f4$ denotes the ratio of 1:4. The first half of the ratio is always the focal length of the lens, so in our example a lens set to $f4$ will have a diaphragm opening which is 1/4 the focal length. If the lens is a 100mm telephoto, the iris opening would measure 24mm at $f4$. (Actually, it is the apparent size of the diaphragm as viewed through the front of the lens, not the actual physical size which is measured.) The larger this opening the shallower the depth of field will be, the smaller this opening the greater the depth of field. By careful selection of lens aperture the depth of field can be adjusted to match the desired characteristics of the photo properly. In scenics and travel photos it is generally desirable to have a great depth of field so that both subjects close to the camera and those in the distance will be rendered in sharp focus.

However, there are many other situations in which a great depth of field may not be desired. When taking portraits, for example, it is frequently desirable to limit the depth of field to not much more than the subject's face so that potentially distracting background elements will be rendered out of focus and soft. This shallow depth of field may also be appropriate to photographs of flowers and animals and in any situation in which a single subject is to be given prominence and the background reduced in importance.

The second factor which affects depth of field is the image magnification of the lens in use. As explained in the section *Selectiong Canon EF Lenses*, page 126, the focal length of a lens is expressed in millimetres, with lenses shorter than 50mm generally classed as wide angle and those

Pages 120 – 121

Left: differential focus is the technique of using limited or restricted depth of field to pick a subject out against a blurred background, at the same time allowing any obtrusive foreground elements to be softened. Use a large aperture to achieve this – or the Portrait mode if available on your EOS model.

Right: to show this flower in its setting required precise control of depth of field. To much, and the background would have detracted from the subject – too little, and the background would not be recognizable. Here the Depth of Field Preview of the EOS-1, 650, 630 (600) and 620 is of great value.

longer than 50mm generally classed as long focus or telephoto. Image magnification increases with focal length. What is important to know about focal length and depth of field is that the depth of field will decrease as the focal length of the lens increases at the same subject distance and the same f-stop. That qualification is important, as will be seen later.

It would seem from this that a case could be made for using wide angle lenses whenever great depth of field is desired and telephoto lenses whenever shallow depth of field is desired. Although somewhat over-simplified, this is generally true in practice. However, it would be a mistake to generalize and state that wide angle lenses have more depth of field than telephoto lenses. If the image magnification is kept constant and the aperture is also constant, all lenses have identical depth of field.

Since the depth of field is controlled by image magnification, decreasing subject to camera distance to increase magnification will always result in decreased depth of field. This becomes very noticeable when photographing very close with macro lenses. In such cases, the depth of field can be very shallow, even with the lens diaphragm stopped down to its smallest opening.

Once you have decided on your subject and composition, just how can you tell what the depth of field will be? There are three ways. The first, and by far the least practical, is to always carry a set of printed universal depth of field tables with you and consult them for every photo. Such tables are given in many photographic reference books and will allow you to compute depth of field given the lens focal length, film format, subject distance and f-stop. The second method for determining depth of field is a little easier but much less precise. This method can only be used with lenses equipped with a depth of field scale. Among the lenses initially available for the EOS cameras, only the fixed focal length lenses have such a scale. Our drawing shows the depth of field scale on a hypothetical 50mm lens.

Range of sharp focus at $f22$

∞	30	20	15	10	8	6	5	4	3.5	3

| | 22 | 16 | 8 | 4 | | 4 | 8 | 16 | 22 | |

Diagram of a depth of field scale.

Once the lens has been focused this scale can be consulted. In our example we are assuming that the lens came to focus at just a little more than three metres (the scale is marked in both metres and feet, the lower scale in our example is the metre scale). We are using an aperture of $f22$ for our photograph. By looking at the two places on the scale where 22 is shown we can see the approximate limits of the depth of field at this f-stop. In this example the depth of field would extend from about six feet at the near end to about infinity in the distance. If we had chosen to use $f16$ instead, the depth of field would have extended from about seven feet to about thirty-five feet (from about two to about ten metres). Due to space limitations on the lens barrel and necessarily vague markings on the distance scale this method is obviously good only for very approximate determinations of depth of field. Because depth of field changes with focal length it has not been practical for Canon to put depth of field scales on the EF zoom lenses, there simply was no room for them.

The third method by which depth of field may be determined is by direct viewing. It must be remembered that the EOS cameras, in common with all modern SLR cameras, always show the viewing image with the lens open to its largest aperture. This is to provide maximum brightness for your viewing and for the autofocus sensor. When you take a photograph the lens diaphragm is closed down to the selected aperture by a stepping motor just a fraction of a second before the shutter opens to make the exposure. It then opens wide again as soon as the shutter has closed, so in viewing through the camera you never see this closing and opening action, it just looks like the camera blanks out momentarily during the exposure.

To preview the depth of field visually it is necessary to close the diaphragm down to the selected opening size without operating the camera's mirror or shutter. Most autofocus auto-exposure cameras do not allow the photographer to do this, and therefore do not allow direct viewing of depth of field. Canon has designed the EOS-1, 650, 630(600), RT and 620 cameras with an electronic depth of field preview control.

Operation of this system on these EOS cameras is very simple. On the camera's left side, just below the lens release button is a small black button. Besides the lens release it is the only unmarked button on the front of the camera. When this button is pushed in and held the camera body sends the appropriate electrical signal to the lens and the stepping motor closes the diaphragm (on the EOS-1 the depth of field button is on the opposite side of the lens mount at the bottom, but operates in exactly

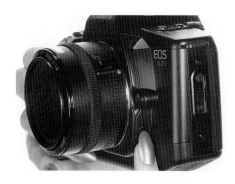

Depth-of-field preview button.

the same manner). Although the most obvious effect of the diaphragm's closing will be an overall darkening of the viewfinder, a careful inspection will show that it is possible to see which portions of the image are in focus and which are not. This takes some practice, so I would advise trying this a number of times with different subjects and with the focus set at different distances while teaching your eye not to strain at the dimmer image but just to relax and let you inspect the screen for image sharpness. Once you have the knack of using this you will consider it a valuable tool in controlling your photos to get exactly the effect you want.

When the stop-down button is released the diaphragm will spring back to its fully open position for maximum viewing brightness.

SELECTING CANON EOS LENSES

One of the main advantages of using the modern 35mm SLR camera is that many different lenses can be fitted to the camera body to allow many different photographic effects. While there are cameras in larger sizes which also offer interchangeable lenses, the variety of lenses is not as great, the lenses are physically much larger and heavier, and the cost of just a single lens can be more than an entire 35mm outfit. Recent improvements in films have allowed the 35mm camera systems to produce much better images than used to be the case, and today there are very few cases where an image from a 35mm camera will not be acceptable. This is one reason for the overall dominance of 35mm cameras.

Lenses can be roughly classified in four categories: wide-angle lenses, normal lenses, long focus (or telephoto) lenses and zoom lenses. Lenses are identified by their focal length and maximum f-stop, eg 35mm $f2.8$, 135mm $f3.5$, etc. Lenses of less than 50mm focal length may be generally regarded as wide-angle, those of approximately 50 to 60mm as normal, and anything longer as long focus or telephoto.

Many people are confused about the meaning of focal length and think that it has something to do with the physical dimensions of the lens. In fact it is simply the measurement of the distance from a point on the lens axis to the surface of the film when the lens is focused at infinity. The point from which this measurement is made is an optical point called the rear nodal point, and does not necessarily correspond to any physical part of the lens. It can even lie outside the physical limits of the lens itself, being either in front of or behind the lens. It is the point from which the image appears to be projected onto the film. To be able to use lenses it is really not important to understand the theoretical basis for this, you only need to know the practical applications for this measurement.

Focal length directly relates to magnification, field of view and perspective. Magnification is commonly thought of in relation to the image from a normal lens of about 50mm in focal length. If we arbitrarily assign

One of the great virtues of the zoom lens is the ability it gives for in-camera cropping. Here I was using a 70-210 zoom and was able quickly to adjust the composition I wanted before the bird was out of the way.

a magnification of 1x to such a normal lens, then we can easily think in terms of relative magnification. Working with this assumption, we can then say that a lens of 25mm would produce a magnification of 0.5x while a lens of 100mm would produce a magnification of 2x.

Field of view is a measurement of the area seen by the lens and projected onto the film. It is generally expressed in angular degrees and is usually measured diagonally across the image from corner to corner. The shorter the focal length of the lens the greater the field of view. Our normal lens with a focal length of about 50mm will have a field of view of about 45° Wide angle lenses have a field of view larger than this, going all the way up to 180° (in a few specialized lenses even wider). Long focus or telephoto lenses have a narrower field of view, going down to just a few degrees.

You may wonder why I am using the term "long focus or telephoto" lenses instead of just the commonly used "telephoto". The reason for this is that the term telephoto properly refers only to long focus lenses of a specific design and not all long focus lenses are actually telephoto lenses. A true telephoto is a lens which uses a special optical design to compress the length of the lens so that a lens of 400mm focal length, for example, will be considerably shorter than 400mm. Only lenses with this design ought to be called telephoto, but common use is eroding this distinction and you will frequently encounter the use of "telephoto" when "long focus" would be more correct.

Zoom lenses are the last category. Zoom lenses are simply lenses which can be varied in focal length by means of a control on the lens barrel. While a lens with only one focal length will be designated by the form 28mm $f2.8$, a zoom lens will be designated by the limits of its focal length range, as in 28-80mm $f2.8$. Due to limitations of practical design, zoom lenses frequently vary their maximum aperture as well as their focal length, so you will see this in the form 35-105mm $f3.5$-4.5. This means that the lens' maximum aperture is $f3.5$ when it is set to the 35mm focal length and $f4.5$ when set to the 105mm focal length. As the lens is set for intermediate focal lengths, the maximum aperture takes on an intermediate value. With some older lenses this focal length variation would cause problems when setting the lens from an external meter or when using flash, but the Canon EOS system automatically compensates for this effect and the f-stop you set in the manual or aperture priority modes will be the f-stop you get.

Zoom lenses were not much used by professional photographers in

the past because the optical quality of the early ones was not very good. This is now changing because the most recent generation of zoom lenses shows dramatic improvement over older zoom lenses. Modern zoom lenses give away very little to the fixed focal length lenses. While zoom lenses are generally slower, rarely having a maximum aperture much greater than $f3.5$ or so, the great convenience of being able to carry a full range of focal lengths in only a couple of lenses usually more than makes up for the limitation. Also zoom lenses allow you to fine-tune the focal length to exactly suit the needs of the photograph. If your photo requires a focal length of 43.7mm for the exact perspective and field of focus, you can get it. Zoom lenses save the photographer work as well by allowing him to stay more or less in one place and change magnification of the lens to control cropping of a sequence of photos. For action photography this is a great asset. As professional photographers try out more of the new zooms and realize just how good they are the old prejudice against them is melting away. The Canon EF zoom lenses for the EOS system are among the very best zoom lenses yet developed. I should probably mention that there are certain allowed tolerances in the marking of lenses, so that a 24mm lens may actually have a measured focal length of 25mm or so. Many manufacturers tend to exaggerate their focal lengths, particularly in wide angles where a shorter focal length is more desirable, and in zooms where both extremes of the zoom range may be exaggerated to give the impression of a greater than actual ratio. Canon does not play this game, the marked focal lengths and actual measured focal lengths are quite close. When buying lenses from other manufacturers it is important to keep this in mind. Frequently the lab tests in photography magazines will tell you what the actual measured focal length of a particular "on test" lens really is.

Pages 130 and 131: all eight photos were taken with the camera in the same position. The shorter the focal length of the lens, the bigger the angle of view and the smaller the magnification, so individual objects, such as the model, get smaller and smaller in the picture. However, the perspective remains the same – except for the fisheye lens with its curvilinear distortion.

Pages 132 and 133: in these photos the camera position was moved further away with increasing focal length so that the model appeared the same size in each picture – but see how the perspective changes with each change in viewpoint. As the focal length decreases, the model comes to dominate the background more and more as distant features are reduced to insignificance.

Above: 15mm fisheye lens

Above: 24mm wide-angle lens

Below: 28mm wide-angle lens

Below: 35mm wide-angle lens

Above: 50 mm normal lens

Above: 85mm telephoto lens

Below: 150mm telephoto lens

Below: 300mm telephoto lens

CAMERA MOVED FURTHER FROM SUBJECT TO RETAIN SCALE

Above: 15mm fisheye lens

Below: 28mm wide-angle lens

Above: 24mm wide-angle lens

Below: 35mm wide-angle lens

Above: 50 mm normal lens

Above: 85mm telephoto lens

Below: 150mm telephoto lens

Below: 300mm telephoto lens

In addition to field of view or magnification, the other factor which varies with the focal length of the lens is perspective. Before I am inundated with letters of protest from the seasoned hands among my readers, let me explain what I mean by that. In my first set of photos taken with lenses of different focal lengths, all of the photos are taken from the same distance so that the subject size varies greatly. However, if a portion of each image were enlarged so that the subject size remained the same, it would be seen that there was no change in perspective at all. For this reason it is technically correct to say that perspective does not change with focal length. However, as generally used, lenses are not kept at a constant subject distance and changes of subject size made by enlargement in the darkroom. In practice the photographer tends to move in closer to the subject as the focal length of the lens decreases. If the subject size is kept constant by changing the lens to subject distance, then perspective does indeed change with the focal length of the lens.

This change of perspective is evident in my second sequence of photos. In this set I moved closer to my subject with each lens until the apparent size of my model, from head to toe, was the same in the viewfinder. As you can see, the difference between the apparent size of the model and the background objects is radically different with the different lenses. In the photos taken with the wide angle lenses, distant objects appear tiny and at a much greater distance than they really are while just the opposite is true with the telephoto pictures. You must learn how different lenses change perspective in practical use if you are to be able to use them as they were intended. Study the photo sequences and then practice taking your own photos with a wide variety of lenses.

In addition to the general categories of lenses mentioned so far there are some specialized types of lenses which every photographer should be aware of. The first of these specialized lenses is the macro lens. A true macro lens is one which will focus very close to the subject, producing an image on the film which is nearly or actually the size of the subject. The closest focusing distance of such a lens is less relevant than the reproduction ratio. In the case of a lens with a stated ratio of 1:1, this means that the image of the subject on the film will be exactly the same size as the subject itself. A beetle which is four millimetres in length will produce an image on the film which is four millimetres long. If the lens produces an image which is half the actual size of the subject it will be written in the form 1:2 because the first number in the ratio is always the subject size.

The true macro lens such as the Canon EF 50mm f2.5 is ideally suited for the reproduction of flat subjects such as this portion of an old bank note.

Macro lenses can be designed in any focal length, but the most commonly encountered ones are 50mm and 100mm, and it is no surprise that Canon has introduced a 50mm as their first macro lens for the EOS cameras. I would anticipate that a 100mm macro would follow in the near future.

In addition to the ability to focus very close, the other distinguishing feature of a true macro lens is that it is a flat field design. This means the image plane is flat and parallel to the film. Subjects such as documents and postage stamps will be in sharp focus from the centre to the edge of the image. Ordinary lenses are not flat field designs and the plane of sharp focus is usually concave. In general photography where flat subjects are rarely encountered this is not a problem, but in macro work it may well be. For uncritical close-up photography of non-flat subjects ordinary lenses used with close-up lenses, bellows or extension tubes-may be perfectly adequate (see chapter on ACCESSORIES). A true macro lens is generally needed for the best results in photographing flat subjects.

This is probably a good place to briefly mention a confusion in terminology relating to the use of macro lenses. When taking photographs with macro lenses you are making photomacrographs, that is enlarged photos of small objects. You are not making macrophotographs, which means very large photographs, unless you are enlarging the resulting negatives to a very large size. The same distinction applies to working with a camera mounted on a microscope. What you produce in this manner is a photomicrograph. A microphotograph is a very tiny photograph of a large subject, such as the technique used in the electronics industry to make tiny printed circuits from large drawings of the circuit. These two mistakes in terminology are seen far too often.

It is unfortunate that Canon has chosen to follow an all too common practice in designating their zoom lenses as having "macro" focusing ranges. They do not. None of these lenses even comes close to producing a reproduction ratio which could be called macro, and these are not flat field lenses. Instead of carrying this false "macro" designation they should be honestly marked with a focusing scale. If any special designation is needed it ought to be "close focusing".

The photographer who has infrequent use for a true macro lens may be interested to know that enlarging lenses make excellent macro lenses. These lenses, because of their purpose of projecting a flat negative onto a flat piece of paper, are true flat field lenses, and they generally have much better optical characteristics for close-up photography than normal camera lenses. Most enlarger lenses are fitted with a 39mm thread which is the same as that used on older Leica cameras, and thus called Leica thread. Adapters are available to fit lenses with this thread onto the front of bellows units.

An interesting accessory which I have been using lately for macro work is the Zork Mini-Makro system. This consists of a helical focusing triple tube which can be fitted on the front with an adapter for 39mm threaded lenses and on the rear with a camera adapter. An option is to mount the focusing tube onto a ball and socket jointed tube which allows use of tilt movements as well as extension. Most photographers with darkrooms already have the enlarging lenses. This system is manufactured by Zorkendorfer Film und Fototechnik in Munich.

After macro lenses the next special purpose lens is a sub-category of the wide angle lens called the fish-eye. In the case of other wide-angle lenses the optical designers use all of their ability and knowledge to design away distortion. This is a problem of wide-angle lenses, and the

Macro photographs: above, detail of a butterfly's wing; below, coin. Flash lighting helps ensure sharpness in both cases.

wider the angle the more difficult it is to keep distortion to a minimum. Distortion shows up as curvature of lines which ought to be rendered as straight. Modern wide-angle lenses will render straight lines correctly in the image if used with care.

In designing fish-eye lenses no attempt is made to correct for distortion. Such a lens has a great deal of distortion which increases toward the edge of the image. The only way a straight line can be rendered straight with such a lens is if it passes exactly through the centre of the image. There are two types of fish-eye lenses, those which produce a circular image in the centre of the film frame and typically have an angular field of view of 180° across the diameter of the circle, and those called full frame fish-eye lenses which fill the frame but have a field of view of about 180° across the diagonal of the image. The Canon EF 15mm f2.8 Fish-eye is an example of the second type.

Although not a good lens for general photography, most professional photographers find that a fish-eye lens is a necessary lens for those occasional photographs which could be taken with nothing else. Our photographic examples of fish-eye photography should give you ideas of what can be done with them.

For the photographer who will only occasionally have use for the fish-eye effect, inexpensive fish-eye converters are available from a number of suppliers which screw onto the front of a normal lens and produce a semi-fish-eye image. While the quality is not as good as that from a true fish-eye lens, it may be adequate for the occasional user.

Another special purpose lens is the tilt-shift lens. Although there has been no formal announcement of such a lens for the EOS system at the time of writing, I am certain that Canon will produce such a lens for the EOS cameras. They pioneered this type of lens and have had great success with their tilt-shift lenses in FD mount. This type of lens allows the 35mm photographer to make use of two of the most important movements of the view camera. The tilt function does just that, it tilts the lens with respect to the film and allows the plane of focus to be tilted to match the needs of the photograph. This is particularly useful in the studio. The shift function allows the lens to be displaced with respect to the image centre. This is most useful when it is desired to keep parallel lines in the subject parallel in the image, as when photographing archi-

Left: distorted architecture for an atmospheric location portrait in an old barn, using the 15mm f2.8 fisheye Canon EF lens.

tecture. The camera may be aligned to make the lines parallel and then the lens may be shifted to compose the photograph. A good example of this would be in photographing a tall building. If you tilt the camera up to look at the building you will produce the appearance of converging lines in the building, it will appear narrower at the top. If you hold the camera parallel to the building so that the lines don't converge you cut off the top of the building. By shifting the lens it is possible to move the image of the building down into the frame without having to tilt the camera and produce a photo without the unappealing converging lines. This is such a useful lens that I hope that Canon will not make us wait too long for one in EOS mount.

Until Canon does decide to produce a shift lens for EOS, there is one way to have one. Zorkendorfer, mentioned above, also make a Panorama/Shift Adapter which can be used with the EOS and most other camera systems. This adapter allows some lenses from medium format camera systems (Hasselblad, Rollei, Mamiya, etc.) to be mounted onto 35mm camera bodies with full infinity focus and a sliding plate for perspective control. For the photographer who already works both in 35mm and medium format, this adapter makes a lot of sense.

The last special purpose lens I will mention is the soft focus lens. While soft focus effects can be produced with any lens by putting diffusing materials or special filters on the front, this is somewhat hard to control and setting fine degrees of softness is usually impossible. With Canon's 135mm f2.8 Soft Focus EF lens the degree of softness is infinitely variable between ultra soft and normally sharp. Softness is varied by two controls. On the lens barrel toward the front is a ring which allows setting the basic degree of softness. This ring is marked 0, 1 and 2. At the 0 position the soft focus is completely eliminated and the lens may be used as a normal medium telephoto for general photography. Moving the adjustment changes the internal position of a special glass-molded aspheric lens element. The position of this lens element governs the overall softness effect. The second control which varies the degree of softness is the f-stop setting. Generally the degree of softness at any setting of the softness ring will increase as the aperture is opened and decrease as it is closed. By balancing between the softness ring and the f-stop you may fine-tune the soft focus effect to suit exactly the needs of the photo you are taking. In addition to its obvious uses in portrait photography, the soft focus lens can be useful in a wide range of general photographic situations in which a dreamy, soft effect is desired.

Soft focus – by using the right lens or filter (see following section) can create romantic images without elaborate settings or lighting

FILTERS

Filters are devices which alter the light passing through the lens in specific ways. The dictionary definition of a filter is something which absorbs or reflects certain wavelengths of light and transmits others. It is important to remember this definition, as it will prevent the most common mistake in thinking about filters; the notion that they somehow add colour. A red filter, as an example, does not add red to the scene photographed through it, it holds back all the other colours.

Most commonly, filters are flat round pieces of optically flat glass mounted in metal rings and attached to the lens by the threads inside the front rim of the lens. Some filters common today are square or rectangular and are held in special frames which screw onto the front of the lens. The third type of filters are called gelatin filters or gels and are thin sheets of coloured gelatin or plastic and are used in certain lenses by way of a special holder which slips into a slot in the lens barrel, or in a holder which attaches to the front of the lens.

The quality of filters is quite important. It is a mistake to purchase an exceptionally fine lens and then degrade the image quality with an inferior filter. While all filter makers claim that their filters are truly optically flat and with parallel surfaces, tests I did several years ago showed that there is considerable variation in both. Generally the name brand filters tested out better than the very cheap ones, as would be expected, but even among name brands there was considerable variation. We did find that the expensive filters seemed to be made to much higher tolerances. My advice on this point is to buy filters sold by the camera maker in most cases, and when a filter you need is not offered by that source, go with one of the better known names. We had excellent test results from filters offered by Tiffen, B+W, Hoya and Vivitar, but I am sure that other top firms offer high quality as well.

One way to cut down a bit on the high cost of really good filters is to use what are called stepping rings. If you have several lenses which each require a different filter size, you can generally buy filters to fit the largest size and then use stepping rings to fit these filters to the other lenses. These rings are called step-down and step-up rings. Logically you would suppose that a ring used to mount a large diameter filter on a smaller

diameter lens would be called a step-down ring, but in fact the terminology has been reversed and you would purchase a step-up ring for this purpose. The rings are always marked with the lens thread size first and the filter thread size second, so in the case of fitting a 62mm filter to a lens with 52mm thread, you would require a 52-62 step-up ring.

When using these rings it is important to remember that they add thickness to the filter so that they may cause corner vignetting in extreme wide angle lenses. When contemplating use of such a ring and filter with a lens wider than 35mm, there is a simple way to test for this vignetting. You must mount the lens on test onto the camera with the stepping ring and filter and set the camera on Manual at the "bulb" shutter setting and the diaphragm set to f11 or so. With the back of the camera open, you must take a small screwdriver, paper clip, or other object and release the camera back latch by pressing in on the silver coloured tab visible inside the latch area. This is the tab pressed on by the camera back hook when the back is closed, so you may locate it by looking to see where this lines up as the back is closed. Pressing in on this releases the camera back latch and it will snap up to the closed position. The reason for doing this is that the EOS shutter will normally not fire with the back of the camera open, and this temporarily defeats this interlock. You then open the shutter by pressing in on the shutter release button and holding it. If your camera accepts the remote switch and you have one, it will be more convenient to lock the shutter open with the switch so that you do not have to maintain pressure on the shutter release button.

Once you have the shutter open you can then look through the back of the camera with the lens pointed toward a brightly lighted area and gradually tilt the camera so that you are looking through the lens from the corner of the image aperture. If, as you get close to this corner, you see a darkening of the circle of light, you are seeing the effect of corner vignetting. You may still want to use the filter and stepping ring, but if you repeat this process at varying apertures you can determine which apertures are safe to use with that lens and make a note of them.

Once you have completed the test you must release the shutter and then release the back latch as you normally would when opening the camera. This will return everything to normal operation.

Left: green thoughts in a green shade – but nobody wants green skin. An 81a warm-up filter (light pink in colour) greatly improves portraits taken in open shade in gardens, forest or parks where green predominates.

Of course, if you have reservations about poking into your camera you may want to allow a service technician to perform this operation for you, or you may prefer to simply shoot a roll of test photos at all apertures to see if there is vignetting and how severe it is. Remember if you do this that you should look at the negatives or transparencies, since the normal cutoff in printing may remove the evidence of vignetting you are looking for.

Filters are image modifiers. They can be divided into three main categories; those used primarily with black-and-white films, those used primarily with colour films and those which can be used with any sort of film.

Filters for Black-and-White

The primary use for filters in black-and-white photography is to selectively lighten or darken the black and white tone with which certain colours are rendered. If we use a standard colour wheel in which the primary colours form two triangles, we will have red, green and blue at the corners for the additive triangle, and yellow, cyan and magenta at the corners for the subtractive triangle. The additive colours of red, green and blue are the primary colours of light, and by mixing them all colours can be produced. Adding equal parts of all three produces white light. (Yes, I know that your school art teacher told you that the primary colours were red, yellow and blue. The teacher was wrong.) The subtractive primaries of yellow, cyan and magenta are the colours of printer's inks used in full colour printing, adding equal parts of all three of them produces black.

For our purposes in this discussion we need go into this no more deeply. If you wish to learn more about colour theory, there are many good books on colour photography and printing which explain this in detail.

A filter of a particular colour will pass certain wave lengths of light and will absorb others. Thus a red filter will pass red light and absorb both green and blue. This means that a red subject photographed onto black-and-white film through a red filter will be rendered lighter than without the filter, and both blue and green subjects will be rendered darker. Knowing this is quite useful when you need to separate colours into tones in black-and-white photography.

As a specific example, lets consider an apple tree full of ripe, red fruit.

If you photograph the tree on black-and-white film without using any filter you will be disappointed because the red apples and green foliage are rendered at just about the same shade of grey and there is little differentiation between the two. However, if you use a red filter to photograph the same tree the red apples will be rendered lighter and the green foliage darker and they will be well differentiated in the print.

Perhaps you do not like this effect, thinking that the light rendering of the apples and dark foliage is not very attractive. In this case you can create the opposite effect with a green filter. This will lighten the rendering of the foliage and darken the apples. In each case, remember that a filter will lighten its own and similar colours and darken the other colours in the triangle. The mixture of the other two colours is referred to as the complimentary colour, in this case the complimentary colour of red is blue-green, also known as Cyan.

Filters are made in a broad range of colours, so I will just give you a few of the basics for a well outfitted black-and-white photographer.

A deep red (number 25) filter was used to photograph this country scene. Notice that the sky has been rendered very dramatically because the blue areas have been darkened. Notice that the green foliage is also darkened, in this case almost to black.

147

Red – This filter, usually a Number 25, is useful for darkening blue skies to produce a dramatic effect when photographing clouds. It is also specifically required when using infrared film – see FILMS chapter.

Yellow – Also usable to accentuate clouds against the sky, but will not darken the sky as much as the red filter above. Many landscape photographers use a yellow filter nearly all the time. If you want a compromise between the strong effect of the red filter and the lesser effect of the yellow you can use an orange filter.

Light green – This filter is very useful for de-emphasizing facial blemishes (as long as they are reddish) in portraiture. It will bring the tone of the blemishes much closer to the overall skin tone than would be the case in a photo taken with no filter.

UV – This filter is designed to absorb most UV light. In spite of the fact that optical glass in the lens absorbs almost all UV, some still gets through and can cause a haze, particularly in landscape photographs. This filter will help to reduce this haze. Since it is otherwise photographically neutral many photographers leave one of these filters on the front of each of their lenses at all times as a protection against damage. It is far cheaper to replace a cracked or scratched filter than to replace a lens.

This landscape study was taken on a very hazy day. A skylight filter was used to cut through the haze and bring the distant mountains into visibility.

Filters for Colour Films

The above filters for black and-white can only be used with colour films when a photo with an overall colour cast is desired. Filters used with colour films are almost all designed to correct for imbalances in the colour rendition of the film caused by a mismatch between the light source and the film type.

FL filters – These filters are used to attempt to get a pleasing colour rendition of subjects which must be photographed under fluorescent lighting. Unfortunately, even the best filter is not always successful in this situation since a filter can only block or subtract light. It can not supply colours of light which are not there in the first place. Most types of fluorescent tubes are deficient in red light and no amount of filtration can supply the red which is simply missing. If you have no choice and must take colour photographs under fluorescent light, the FL-D filter is the one you would use if you are working with Daylight type film. The FL-B is the one to use with Tungsten type film. Although the above caveats apply in all cases, I have personally got closest to natural colour rendition with fluorescent lighting with the FL filters made by Singh-Ray which are different in formulation from other FL filters.

The 80 series – When working with photoflood lamps or other tungsten light sources and daylight film, these filters will allow you to balance the light to the film. While the colour rendition may not be perfect, it will generally be pleasing and accurate enough for non-critical applications. If you are using standard photoflood or photopearl lamps which have a colour temperature of 3200K you should use the 80A filter with daylight film. If you are working with certain types of photographic lamps which have a colour temperature of 3400K then you will have to use the 80B filter with these films. Although the colour temperature of ordinary household incandescent lamps varies considerably, it is generally lower than that of photo lamps. Using the 80A filter will generally produce a pleasing if slightly warm effect with these lights.

Skylight 1A and 1B – These filters are basically the same as the UV filters mentioned above for black and white films but with the addition of a slight reddish tint to give an overall warming effect which many photographers find pleasing. The 1B has more of a warming effect than the 1A. When taking photos of people this helps to give the appearance of a warm, healthy glow. Singh-Ray makes a special skylight filter for use with Kodachrome film which has become my standard when shooting

this film. Skylight filters also may be left on the lens all the time as general protection.

The 81 series – These are warming filters, available in different strengths. I have found these useful in shooting in open shade without fill flash, which often produces a very cool colour balance, and when working with certain films under studio flash.

Filters for Black-and-White and Colour

Polarizing filter – This is a very interesting filter which has uses for many types of photography. As I have mentioned before, light has both wave and particle properties, but it is the wave properties which concern us most as photographers. Natural daylight and light from most other sources is said to be unpolarized, which means that the waves are undulating in all directions about the axis of travel. A polarizing filter removes all of the light which is not undulating in a particular plane, and the light which passes through it is said to be polarized. Since the polarizing filter is usually mounted in a rotating ring, it may be turned to selectively block out light which has already been polarized in a particular plane.

This is important to us in photography because many natural forms of polarized light exist and by selectively blocking them we can have a greater degree of control over our photographs. Because much of the light which causes atmospheric haze is naturally polarized these filters may be used in both black-and-white and colour photography to darken blue skies and emphasize clouds by removing this haze. This effect will vary with the angle of the sun and time of day, being greatest when the sun is at more of an angle to the filter. By turning the filter while looking through the viewfinder the filter can easily be adjusted for maximum effect.

The other common use for polarizing filters is the reduction or elimination of reflections from shiny surfaces. All shiny surfaces (except unvarnished polished metal) polarize the light as they reflect it, so by turning the filter while looking through the camera it is possible to "tune out" the reflections. If you don't want to eliminate the reflections entirely, you can adjust the filter to give them just the amount of emphasis you want. Reflections on water in a landscape photograph are an example of a situation in which you would want to de-emphasize the

reflections without eliminating them entirely.

In colour photography a polarizing filter also will tend to give more saturated colours overall since it eliminates much of the polarized reflected light which reduces this saturation.

There are two types of polarizing filters, and only one of them is really suitable for use with the EOS cameras. Most older polarizers were of the linear type, passing light polarized only in one plane. Because the semi-silvered mirror used in the EOS autofocus system also polarizes the light sent to the BASIS sensor, such a filter will prevent the autofocus system from working. To solve this problem a special type of polarizer called a circular polarizer has been developed. These pass some light in every orientation so they will not defeat the autofocus system. Circular polarizers do not produce as great an effect as linear polarizers, so many photographers still prefer the older type and will simply focus the camera manually when using the filter.

Special types of filters – There has been a recent increase in interest in filters of all types with the result that a number of new types have appeared. Foremost among these are the systems which utilize a holder which screws into the lens and square or rectangular filters. These filters are generally made from plastic, although a few glass ones do exist. There is not space here go go into all of them in great detail, but I would like to mention a few which I have found to be particularly useful.

Fog filters – These are intended to produce somewhat the effect seen in natural fog, that is a softening of form and colour and a soft flare from subject highlights. They are available in several strengths and are quite useful in studio shooting of portraits, fashion and products.

Double fog filters – These are intended to more closely replicate the effects of natural fog by lowering contrast and producing flare, but at the same time not drastically lowering sharpness. Shots taken with these filters under overcast lighting are practically identical to shots made in natural fog.

Low contrast filters – These produce an overall lowering of contrast in the image without significant flare or image softening, and are excellent for shooting outdoors under very contrasty light in situations which do not allow the use of fill flash. The general effect is to lighten shadows, bringing them to a higher tonality.

Soft contrast filters – Just the reverse of the above, these filters tend to leave shadows dark and bring highlights down to a lower level. Which one to use depends on the scene being photographed and effect desired.

Diffusion filters – When an overall softening of detail is desired, these are the filter of choice. There are many different types from many different manufacturers. Some, like the famous Zeiss Softars use "dimples" on the surface of the filter, while others use a wavy overall surface. You will have to experiment to find exactly which brand and strength will produce the effect you desire. Diffusion filters are commonly used in portraiture to de-emphasize facial wrinkles.

Mesh net filters – In the early days of motion picture photography, actresses were photographed with a silk mesh stretched across the front of the camera lens. This had the effect of minimizing blemishes and wrinkles without producing an out-of-focus look. Today you may decide to make your own from various types of mesh and net fabric, or you can purchase them ready made with the mesh sandwiched between protective glass or plastic. Black netting works as the original, reducing surface detail without having too much effect on apparent sharpness. White net will work better in hard lighting and will lighten shadows. Coloured nets will impart just a trace of their colour to the image.

Graduated neutral density filters – These are designed so that they become gradually darker from one side to the other. They are most commonly seen in plastic or glass squares or rectangles which fit into a front-mounted filter holder. They may be fitted into the holder and aligned so that the darker portion of the filter affects only part of the picture. Such a filter is very useful when a bright sky needs to be darkened without darkening the rest of the picture. They come in different values, different degrees of darkening effect. Additionally they come in colours, so by the use of one of them a colourless sky may be made blue, or whatever other colour you desire.

Enhancing filters – In some situations it is desirable to emphasize the reds and oranges in a scene without having much effect on the other colours. Enhancing filters have the capability to do this, and are frequently used in advertising photography. They may also be used to exaggerate the reds and oranges of autumn foliage.

Star filters – I have to confess that these filters, which produce stars of light around image highlights, have been overused to the point that images produced with them are nearly always hackneyed and boring. While I suppose that there may yet be untried applications for these filters, I have not even put one on a lens for nearly twenty years. Many lenses will themselves produce a similar star effect when stopped down to small apertures.

Above: a blue enhancing filter emphasizes cool colours without destroying the red present in the composition. Below: a polarizer brightens autumn foliage.

Another type of filter for use in the front-mounted holders is a coloured sheet with a hole in the centre. This can be used to colour the background without colouring the central subject and may be used for a number of special effects in portraiture. Since the filter is held close to the front of the lens the outline of the hole is not rendered sharp but softly fades from coloured to uncoloured. The degree of colour imparted and the rapidity of fall off will be influenced by the focal length of the lens in use and the f-stop. Smaller stops and wider angles will produce a stronger demarcation between the coloured and uncoloured areas. These filters are also available with a clear centre and diffusion around the outer area, and the same generally applies to these when used with different lenses and f-stops.

Since the EOS-1, 630(600), RT and 620 have Multiple Exposure capability, another interesting filter which can be used is the split screen type. This is a black plastic piece which fits into the holder and covers part of the image. An exposure can be made of the uncovered part of the image and then a second exposure can be made of the other part after moving the filter to block the area previously uncovered. In this way you can create interesting double or multiple exposures. You may take a photo of a friend talking to himself, or if you are creative and take the time you can even come up with images of people lighting their own cigarettes or shaking hands with themselves.

You must be cautious when using this sort of filter system with the EOS camera for two reasons. The first is that the front filter ring of the zoom lenses turns along with the front of the lens when these lenses focus. If you are using a filter such as the split screen above you will have to let the camera reach focus and then switch to manual focus to lock it in place before you align the filter. Otherwise small movements of the lens will misalign your filters and spoil the picture. Similarly you must use this technique with any other special effect filter in which alignment is critical, as well as with polarizing filters.

It is also important that you attach nothing to the front of a EF lens which will interfere with the focusing action or which will be so heavy that it produces unnecessary drag on the focusing mechanism. Lens hoods, particularly bellows type, and other heavy accessories must never be used with the EF lenses. A filter holder and one or two filters is not likely to cause harm, but I would avoid anything heavier. Remember to use only the lens shades supplied by Canon if you need to shade these lenses.

4: Electronic Flash

An electronic flash is a device which produces a burst of very intense light for a very short time. This burst of light is produced by passing a high-voltage electric current through a gas-filled tube, called a discharge tube. Electronic flash units have different characteristics, largely determined by the amount of energy passed through the tube and the duration of that passing. Modern electronic flash units are designed so that the duration of the flash may be accurately controlled. This is accomplished by a switching circuit which uses a special type of transistor called a thyristor. I mention this because flash units are frequently advertised as "thyristorized" or "thyristor equipped". This merely means that this type of flash unit has a variable output controlled by a switching circuit.

Above: on camera flash can be excellent for capturing detail in badly lit museums and galleries – if it is permissible of course.
Left: fill-in flash eliminates unwanted patchy shadows from leaves, corrects the colour and adds sparkle to the eyes in this woodland portrait.

There are two ways in which this switching circuit is commonly controlled to provide just the right amount of light for correct exposure. The first way is through a light sensor mounted on the flash gun which receives light reflected back from the subject and shuts off the discharge tube when it senses that the subject has received correct exposure. This is a generally accurate system, but it suffers from the same drawbacks as external light meters (see *The Light Metering System*). To overcome most of these problems camera designers have mounted the sensor inside the camera just as they have done with TTL light meters. However, it is impractical to mount such a sensor in a position to pick up the light directly after it passes through the lens, so instead the designers have mounted it so that it points toward the film and picks up light reflected from the surface of the film during the exposure. These systems are referred to as Off The Film or OTF. Although the mounting of the sensor to pick up light reflected from the film eliminates any necessity to correct exposure for such things as filters, extension rings, bellows or macro lenses, it still suffers from the same problems as any other metering system which uses reflected light, it is set up to assume a subject of medium reflectance, the old 18% grey again. Subjects which reflect too much or too little light will fool this system just as they fool the camera's ambient light metering system. Such systems are also subject to problems caused by films with unusual surface reflectance characteristics, such as the Polaroid instant process 35mm films. When photographing unusual subjects or working with unusual films, the old rule of bracketing exposures always applies.

Modern flash units which interface with the camera to exchange data with the camera's electronic systems are referred to as dedicated flash units.

All of the current Canon Speedlites for the EOS system are what I would call fully dedicated, and operate with an OTF metering system (which Canon calls Advanced-TTL). When attached to the flash shoe on top of the camera they will operate in all of the flash modes to be described here. Any Speedlites later introduced by Canon will operate in this fully dedicated manner, I am sure. However you may decide that a flash from another manufacturer or supplier has features which will better suit your needs.

It is important to understand that different manufacturers use the term "dedicated" to mean different things. Since I am fond of taking close-up photos of tiny things I have purchased and used several differ-

The versatile TTL flash system of the EOS range allows you to experiment with creative lighting. This is a three-exposure shot using multi-exposure.

ent "macro flash" systems for lighting such photos. Not long ago I bought one which was advertised as being "dedicated" to the camera system I was using at the time. My natural assumption was that the unit would operate with the camera's OTF metering capability, which is a great asset in such photography since it eliminates the need to make exposure compensation at close subject distances. Nothing in the instruction book supplied with the flash advised me otherwise, so I had to learn from bad experience that this was not the case. I learned from experimentation that this particular flash unit is only "dedicated" in the sense that it couples with the camera to indicate that the flash is ready to fire. None of the other capabilities of the camera's dedication were used.

From this experience I have learned to question just what a manufacturer means when he says that his flash is "dedicated" for operation with a specific camera, and I would urge you to do the same if you contemplate purchasing a flash unit other than the ones sold by Canon.

One simple and quick way to check a flash unit to see if it could be completely coupled to the camera is to see if the flash foot has the same number of electrical contacts as the flash shoe of the camera you want to

use it with. In the case of the EOS cameras there are five electrical contacts within the shoe, and five mating pins on the Canon-supplied flash units. The metal surface of the shoe itself provides a sixth contact with a metal strip in the side of the flash foot. Any flash unit with fewer contacts could not possibly be "fully dedicated", regardless of the manufacturer's claims.

To use the EOS cameras with a flash unit other than the ones supplied by Canon, make sure that it is either an older unit which has only one central pin on its flash foot, or if it has more pins that it is specifically designed for use with Canon cameras. Attempted use of a multiple pin flash made for a different make of camera could damage the electronics of the EOS cameras. Before sliding the flash into the shoe on the camera, always make sure that it is turned off and discharged. Mounting a flash which is turned on or charged could result in damage. If you are using an older type of flash unit or a dedicated unit from another supplier with the EOS cameras you will have to follow the instructions for the unit to set it for proper exposure.

Studio flash units are normally connected to the camera through a cable with a plug on the end which is called a PC connector. At one time practically every camera had a PC socket to accomodate this plug, but today this has become a very rare feature on cameras. In the EOS series, only the EOS-1 comes factory equipped with a PC socket. You will find it under a screw-out black plastic plug on the lower left of the camera.

The EOS 650, 630(600), RT and 620 cameras, although used by many professional photographers, are not sold by Canon as professional cameras. They lack the PC socket which would allow them to be used with professional studio type flash units. I find this very odd, since many advanced amateurs as well as professionals have such flash equipment. I am told by Canon(USA) that a PC socket can be added by them, but at a substantial charge. I strongly feel that it should have been there in the first place. At any rate, if you wish to use your EOS 650, 630(600), or 620 camera with this type of flash equipment you must either have it modified by Canon or use what is called a hot shoe to PC adaptor. These may be found at many camera shops. Basically this adaptor is a small plastic block which slides into the camera's flash shoe and has a PC socket

Studio flash is needed for very controlled, localized lighting effects with a full preview of the result. EOS models can be adapted, but an infra-red synchronizer is probably a better way to fire studio flash with modern AF SLRs.

on its side or top. If you use one of these adaptors keep careful track of it as they are easily lost. It is important when using one of these adaptors to pick one which will make proper electrical contact with the EOS hot shoe. I have found that most of these adaptors will work perfectly on the EOS 650, but that the EOS 630(600), RT and 620 frequently cause problems because the upper surface of the side rails of the hot shoes on these cameras is painted with a black non-conductive paint. Adaptors which rely on making contact with the upper surface of the rails will not work on these cameras unless you are willing to scrape away some of the paint. In trying adaptors from several independent suppliers I found that three out of four would not work with these two cameras unless the paint was removed at the contact point. Canon also offer their own adaptor which works perfectly on all EOS models.

A point which may come up with the use of older flash units is the interpretation of guide numbers. Guide numbers are simply a way of stating the light output of the flash and they are quoted either in feet or metric versions. As a simple example, let us assume that the flash you wish to use has a stated guide number in feet of 160. To determine the lens aperture to use at any distance, you simply divide the distance from the flash to the subject into the guide number. In our example of a flash with guide number of 160, a subject at a distance of 10 feet would be exposed at $f16$. Be aware that manufacturers may overstate their guide numbers by using test procedures which do not truly emulate actual picture taking, so it is wise to bracket exposures the first time you use an unfamiliar flash rather than relying on the guide number to be stated accurately.

Program flash – recorded by the data back.

USE OF THE CANON EOS SPEEDLITES

While many beginners at photography think of using flash only when taking photos in dark places, actually flash is used more often and often more effectively in bright light. Using a flash to soften contrast and throw some light into shadows in otherwise well illuminated situations is called fill-in flash. Because of the difficulty in using older systems I was not much of a fan of fill-in flash in the past. Either the flash was too bright and gave very artificial looking pictures or it was too dim and accomplished little to reduce contrast. I approached the claims from Canon that their new Speedlites would automate the process with some scepticism. After much careful testing I have to say that I was wrong to have these doubts. In all but a very few situations, the Canon Speedlites for the EOS system provided a perfect balance between ambient light and flash, producing fill-in flash photos which neither look artificial nor lack the necessary softening of contrast. I have now shot hundreds of photos with the EOS cameras and the 420 and 430EZ flash units outdoors in daylight and I find myself liking the system more with each use. The 430 EZ flash is particularly useful because it allows you to adjust the fill-in flash ratio manually, effectively allowing full control over the amount of fill-in and enabling sequences of shots with bracketed fill-in amounts to be taken when you are uncertain of which setting to use. Because the flash may be adjusted up and down through its full range by simple pressure on the + and – buttons, there is no need to take your eye away from the camera's viewfinder, a bit of practice will allow you to locate the correct button by touch.

When used for fill-in flash under bright ambient light the camera may be used in the P, Tv or Av settings. In the Program mode, this system will work well for general photography, providing just the right "kick" of fill-in flash to get rid of overly dark shadows without washing out the bright areas. If you are using fill-in flash with rapidly moving subjects, however, you may sometimes get ghosting in this mode. This is when the ambient light produces a secondary image which, because of subject movement, is not aligned with the flash image or is streaked or blurred. To prevent ghost images of this type it is best to use the Tv mode and select a shutter speed fast enough to prevent the formation of secondary

For fill-in flash in bright ambient light (sunshine fill) you can use P, Tv or Av modes and shutter speeds up to 1/250. Above: without fill-in. Below: with fill-in.

images. In this case you would select a fairly fast shutter speed, say from 1/90th up to 1/250th. Of course, when you do this you have no control over the depth of field.

In cases where ghost imaging is not likely and where depth of field is important, Av is the mode to use. This allows you to select the aperture you want and the camera will balance the shutter speed and flash output to this aperture.

In all these cases the camera will pick the best exposure to produce an overall balance between the ambient exposure and the flash exposure. There may be times when this is not what you want. Sometimes when photographing isolated subjects you want to eliminate the background completely. If you make your exposure only by the flash you can do this. By setting the camera to M you may select an f-stop small enough to cause the area illuminated by the ambient light to be underexposed and rendered dark or black in the photo. You must also set the shutter speed, but you need not worry about setting it too high. If you try to do this the camera will automatically reset itself to the correct speed.

Since the flash cannot provide enough light to allow shooting at all distances and all f-stops, you must first check to see that you have not exceeded these limits before taking the photo. You do this by pressing the shutter release button lightly and allowing the camera to focus on your subject. On the rear of the flash is an LCD panel which will display the distance range for the f-stop you have set. If the distance to which the camera has focused is outside that range, this display will flash on and off as a warning to you that correct exposure is impossible. You would then have to change to a different f-stop or change your position to be within the distance range. The 420EZ or 430EZ may also be used as a manual flash. To do this on the 420EZ you press the button on the back of the flash marked MANU. The LCD panel on the flash will then display a large M on the left followed by the power ratio. The 430EZ is switched to this position by pressing the MODE button which produces the same indication. Pressing the 420EZ's MANU button more than once you can set the flash power to 1/1, 1/2, 1/4, 1/8, 1/16 and 1/32 power, while these ratios are set on the 430EZ with the + and – buttons. With the camera set to M also, you then pick an aperture value and press lightly on the shutter release button. The proper subject distance for that f-stop and flash power will be displayed on the flash's LCD panel at the bottom right. You may then either move until your subject is at that distance or you may change the f-stop or power setting to get the distance you want.

The 420EZ and 430EZ flash also have the capability of producing stroboscopic effects. This can only be used with the camera in the M mode. To use this feature you set the camera's shutter speed to one second or slower and pick the aperture you would like to use. On the 420EZ you then press the MANU and SYNC buttons on the back of the flash simultaneously. The display will then read "M 1/1 MULTI 1 HZ". The 430EZ is set to this mode by pressing the MODE button once again from the manual mode, and the same "1/1 MULTI 1 HZ" legend will appear on the LCD panel. This indicates that the flash is set for full power in the Multiflash or stroboscopic mode and that the flash will fire at the rate of 1 Hertz (cycles per second). By pressing the SYNC button on the 420EZ or the MULTI (HZ) button on the 430EZ you can change the cycles. The 420EZ has a range from 1 to 5 Hz, while the 430EZ has a range from 1 to 10 Hz. This will allow unusual stop-action photos of moving subjects. The effect is best when the subject is photographed against a dark or black background, or when the background is distant.

The flash heads of the 420EZ and 430EZ are made so that they can be tilted. In their normal position the head is aligned with the axis of the lens, which is the best position for most fill-in flash photography. However, when taking photos with little ambient light or in the manual flash mode, having the flash head in this position may produce ugly harsh shadows behind your subjects. To avoid or soften these shadows a technique called bounce flash is used.

By tilting the head of the flash upwards to one of its three positions (60°, 75° or 90°) the light from the flash will bounce from the ceiling and illuminate your subject from above, an angle perceived as more natural. In bouncing from the ceiling it will also be softened so that the shadows will not be so harsh. It is important to keep in mind that this will only work well with a white ceiling which is not too far away. Ceilings at about the usual eight foot height will work well, but very high ceilings will not because the light must travel too far. In working with the flash straight on to the subject this is not a problem because the distance from the camera to the subject is the same as the distance that the light must travel. With bounce flash you must figure the total distance the light travels, and with high ceilings this may exceed the maximum distance the flash is capable of working with. Also it is important only to use this

Right: bounce flash creates soft shadows and shows detail in the white top which would be burned-out with direct flash. A white ceiling is essential to avoid colour casts.

Bouncing light from a white card provides superb colours and attractive directional soft shadows.

technique with white or neutral coloured ceilings if using colour film, otherwise the light will take on the colour of the ceiling and tint the entire photograph with it.

In addition to tilting, the heads of the 420EZ and 430EZ also can be turned to the side, also through angles of 60°, 75° and 90°. This can be used to bounce light off a nearby wall or flat surface if no ceiling is available, and allows standard, off the ceiling bounce with the camera turned for vertical photos.

Bounce flash may be used in all the same modes as regular flash so long as you remember that the distance the light travels must not exceed the limits of the flash.

As an alternative to bouncing the light off a ceiling, some photographers use a large white card taped to the flash. In this case the flash head is tilted up and the card is attached at an angle of about 45 degrees so that the light bounces off it and onto the subject.

This works well for producing a softer light than direct flash. When photographed by light bounced from the ceiling, the subject often lacks contrast and needs just a little bit of direct flash to solve the problem. In

this case a small white or silver card is taped to the flash head so that it throws just a little of the light more directly toward the subject. Such a card is called a "kicker". I have known many photographers who create one of these in a hurry from a business card.

The 430EZ flash features a simple method for confirming sufficient light when using fill-in flash. When the head is tilted or swivelled from its normal, straight ahead, position this feature is automatically activated. With the EOS-1, EOS 630(600) or RT cameras, light pressure on the shutter release causes the flash to emit a small burst of light which is then read by the flash sensor and evaluated. If there will be sufficient light for a correct exposure, the shutter speed and aperture data in the viewfinder and on the LCD panel will remain constant, if there will be insufficient light one or both of these numbers (depending on the camera exposure mode) will flash as a warning of insufficient flash. This allows the photographer rapidly to assess flash exposure and take the photo simply by continuing to press the shutter release the rest of the way.

The 420EZ and 430EZ flash units are also equipped with a near-infrared pre-flash system to assist the camera in focusing in dim light. This pre-flash sends a flash of red light towards the subject when the shutter release button is pressed halfway. The beam is projected from the red coloured area in the base of the flash just above the mounting shoe, and it is important when using the flash in dim light that you remember not to block this area with your hands.

The last capability of the 420EZ and 430EZ flash units is called second curtain synchronization. As I mentioned when discussing THE SHUTTER, sets of blades which open and close the shutter are often referred to as curtains. When the flash is set for this operation it will fire just before the second curtain closes instead of just after the first curtain opens as in normal operation. In the case of long exposures this allows the creation of photographs in which streaking can be used creatively to lead up to the image frozen by the flash. This is a somewhat unusual capability to have in a flash and you will have to learn by experimentation just what it can do for you.

The Canon Macro Ring Lite ML-3

This new flash unit replaces the ML-2 which was designed for use with the T90 and Canon FD lenses. It is intended for use with the EOS system cameras and the EF 50mm $f2.5$ Macro lens. Certainly any future macro lenses introduced into the EOS system will have the fitting to accept this flash. For those photographers who still use the Canon FD lenses and the T90 camera in addition to the EF Macro lens and EOS, adapters are available to allow fitting of the ML-3 to FD lenses on the T90. (Adapter 52C for the FD 50mm $f3.5$ and 100mm $f4.0$ and adapter 58C for the FD 200mm $f4.0$. Since the adapters screw into the filter rings of the lenses, they could also be used with other lenses with either 52 or 58mm filter threads and non-rotating fronts.)

A very unusual feature for a ring flash is the focusing lamp which is part of the ML-3. This lamp provides enough light for visual focusing or autofocus, and automatically switches off when the shutter is released or after twenty seconds to conserve battery power. The focusing lamp may be turned off manually when not needed.

While called a Ring Lite by Canon, this unit really is not a traditional ring flash in which a circular flash tube surrounds the front of the lens and produces a very flat type of lighting. The ML-3 has two separate small flash tubes mounted on either side of a ring which attaches to the lens. These flash tubes may be fired together or independently. Using both tubes produces the flat, even illumination characteristic of older ring flash units, while using only one provides shadows on the opposite side for subject modelling.

The ML-3 consists of two sections. The flash head attaches to the front of the macro lens and consists of the flash tubes and the focusing light, while the control unit which houses the batteries and interfaces with the camera's electronics fits onto the camera hot shoe. A connecting cable couples the two parts.

The ML-3 operates with the EOS bodies for automatic TTL flash exposure in all exposure modes. It has a guide number of 11 metres, 36 feet at ISO 100, which means that it can also be used for interesting lighting effects at moderate distances. At one time the use of ring lights for fashion photography was very popular, perhaps the ease of use of this

The Canon Macro Ring Lite ML-3 is ideal for photographing small subjects requiring a directional quality of illumination to reveal texture, as well as those which need traditional ringlight shadowless lighting.

unit will bring this look back. The ML-3 can be used with films from ISO 6 to 6400, DX-coded film automatically sets the camera body which relays the information to the ML-3.

In the Program AE mode of the EOS 650, 630(600), RT and 620 cameras the flash aperture value is automatically set by the TTL program built into the camera body according to subject luminance information obtained from peripheral metering. This specialized metering pattern uses only the outer parts of the six-zone evaluative metering area of the EOS cameras. With the EOS 650, RT and 630(600) the shutter speed range for coupling ranges from 30 seconds to 1/125th second, while with the EOS-1 and 620 the upper limit extends to 1/250th second.

The ML-3 is powered by four AA cells, either alkaline or NiCd. Alkaline batteries will provide over 100 flashes with recycle times of 0.2 up to 13 seconds. NiCd cells produce only about 45 flashes with a recycle time of 0.2 up to 6 seconds.

The ML-3 weighs about 470g or about 1 pound with batteries.

Top left: you do not necessarily need elaborate studio sets and equipment to produce professional results. The model for this portrait study was lit with a single diffused light at camera right. The background is white seamless background paper available from many suppliers and the only props were a stool and a wooden crate.

Top right: an example of a slightly high-key studio portrait. The background paper was lit to be one stop brighter than the light on the model so that it would diffuse through her hair.

Left: for this unusual portrait study I used two lights on the model from the front, and a third bright light from the right rear to accentuate the loose flowing hair.

USE OF EOS CAMERAS WITH STUDIO FLASH

As I mentioned at the beginning of this chapter on flash, Canon has offered only the EOS-1 camera with a standard PC flash connector. While shoe-only flash may be adequate for amateur shooting and professional level fill-in flash, there are many times when the professional or advanced amateur will want to work with studio flash units. Not so long ago it would have been unthinkable to manufacture a camera intended for any level of shooter without the standard PC fitting; today the cameras which have this fitting are in the great minority. (Incidentally, PC comes from Prontor/Compur, the German shutters for which this fitting was designed many years ago.)

I have mentioned that adapters are available which allow conversion of the hot shoe to a standard PC fitting. In many studio situations this will be an adequate solution to the problem. Others may prefer to return their EOS cameras to Canon for a retrofit of the PC fitting, which places the outlet on the left side of the camera's prism hump. Obviously, this only applies to the EOS 650, 630(600), RT and 620 because the 850 and 750 lack manual aperture control and are thus unsuited for use with studio flash.

Another solution to the problem of the missing PC outlet is to use a cordless system to fire the flash. There are many of these on the market, consisting of a transmitter which fits into the camera flash shoe and a receiver which attaches to the flash. I have had excellent results from an inexpensive unit made by Wein Products which uses an infrared pulse to fire the flash. This system uses a small electronic flash unit which is filtered to produce only invisible infrared and a special receiver which attaches to the flash. Not only does it solve the problem of connecting the camera to the flash, it does away with the dangling connecting cord which may become entangled in the photographer's legs during the shoot.

For situations in which other photographers are working as well, their transmitters may trip your flash units. For such situations there are more advanced infrared units which produce coded pulses to which only specifically coded receivers will respond.

Another type of cordless flash firing system which has become popular recently is the radio system. This uses a pulse of radio waves instead

of infrared to fire the flash. This is particularly valuable in situations in which the infrared from the transmitter may be blocked from the flash. Before attempting to use a radio system, make sure to check local regulations as these units are prohibited in certain sensitive areas.

Another use for both the infrared and radio systems is that they may be rigged to connect to the camera's remote release outlet and can then be used to fire the camera from a distance.

While it is beyond the scope of this present book to go into studio lighting systems in great detail, some basic information may be of value.

Generally there are two types of professional studio flash units available. The first type is the more traditional in which a large floor level power supply is connected to relatively small light heads by cables. In these units the charging system and capacitors are contained in the power supply while the flash heads themselves usually contain only the flash tube, a modelling lamp and sometimes a cooling fan. These units are available from a number of suppliers, and come in a wide range of flash powers.

Studio flash units are generally not power rated by guide numbers as smaller flash units are because studio units feature interchangeable reflectors, and the guide number changes with each reflector. Instead they are usually rated in watt-seconds or joules. These numbers are difficult if not impossible to translate into actual light output because much depends on the efficiency of the design of the light heads. However, they may be used as a general guide in comparing the power of different systems.

For most studio work you will find that four light heads are a minimum requirement. In the example of a portrait, this allows one main light, one fill-in light, one hair light and one background light. If you are buying one of the professional units with a separate power supply and heads, then you need to look at the power rating as it would be used in practice. While a power rating of, for example, 800 watt-seconds may sound like a lot, in practice it would not be adequate if used to power four heads. Think in terms of a minimum of about 400 watt-seconds per head, preferably more, for general studio lighting.

It is also important to know if the power supply allows differential application of power to the heads. A system which only allows even distribution of power to all four heads will be very limiting.

While I know of many photographers who use such systems in their studios, I have always preferred to work with the second type of system.

In this system the light heads are self contained units with all electronics, capacitors, etc., packaged into a medium sized unit.

My main reason for preferring this type of system is that it allows for easy service in the event of trouble without down time. Since each head is totally self contained, if one fails you simply bring out a back-up and use that while the other head is off for service. With a more traditional system, if the power supply has problems you have to ship it off and the whole system is down until it comes back unless you have a spare (which is more expensive than a spare self contained unit).

When looking at these self contained units, the same guide-lines apply for power. Each head should produce a minimum of 400 watt-seconds. The most versatile types have multiple power range settings, either a two-position switch for full and half power, a rotary switch with several power settings or a sliding control which is infinitely variable. Obviously the last type is the most versatile, as it allows for fine tuning of lighting with ease. With systems which only have fixed power outputs the only way to vary the light is to move the entire flash closer or farther away from the subject. I find this to be an awful nuisance while working, so I have settled on a variable power system. Some of the best of these have remote control capability which allows the setting of all flash units from a central control box; this is the ultimate in easy light control.

All professional studio flash units must be supported by substantial studio stands to provide security against tipping over. My preference in support stands for professional flash are the units made in Italy by Lino Manfrotto, sold around the world under a variety of names. It is dangerous false economy to support expensive flash equipment on inferior stands. Always buy stands rated for double or more the actual weight of the equipment you intend to support.

All professional studio flash units support a range of reflectors and light modifiers on the front of the flash heads. Reflectors come in numerous sizes and types. Generally the large dish reflectors will produce a broader, softer light than the smaller ones. Typically the large reflectors are finished on the interior in a matte white or patterned silver surface to somewhat diffuse the light, and many come with a central baffle which blocks direct light from the flash tube from the subject, softening the effect even more. Small to medium reflectors with a polished silver finish will produce a harsher, more specular light.

A special type of attachment is the snoot which is a cone shaped attachment which attaches to the flash head or to a small reflector

mounted on the head and gives a narrow, focused beam of light. These may be thought of as semi-spot lights.

Somewhat the same effect can be produced by fitting a honeycomb grid over a medium reflector, but this will not give quite such a narrow beam of light in most cases. A lot depends on the design of the specific honeycomb grid.

To restrict the pattern of light from reflectors, attachments called barn doors are available. These are moveable flaps, usually in sets of four, which attach to the reflector and may be angled in or out to narrow or widen the coverage of the light.

There are also special small reflectors with a polished silver interior which are intended for use with photographic umbrellas. When using the umbrellas or brollies the flash unit is turned to face away from the subject and the light strikes the reflective inner surface of the umbrella and then bounces to the subject. While there is a light loss of 1 to 3 stops when using umbrellas, many photographers find the softening of the

For soft diffuse light in the studio, my preference is the soft box. Shown here is the Photoflex MultiDome which has removeable inner panels and a baffle to allow very precise control of the light. (Photo Courtesy of Photoflex, Inc.)

176

light to be ideal for flattering portraiture or fashion. Umbrellas with shiny silver surfaces will diffuse and soften the light less than those with white or gold inner surfaces. The gold coloured ones are frequently used to impart a healthy glow to skin tones which some flash units tend to cool down too much.

Although I used umbrellas in my studio for many years, I have recently made the transition to using soft boxes instead. These are large square or rectangular fronted devices which fit onto the front of the flash head. Inside they are lined with either a silver or a white fabric, and the front is covered with a translucent diffusing material. Internal design varies, but all intend to diffuse the light as much as possible without drastically cutting down on the amount of light passed out the front.

The effect is much like the light coming through a north window on a lightly overcast day, and for this reason these units are sometimes referred to as window lights. Because of their shape, some photographers call them fish fryers.

Here is a four light studio portrait. One light, in a large soft box was at camera right while a second in a smaller box was to camera left. The background was evenly illuminated by two lights at 45° to the background on left and right. Note that you can always tell how many lights the photographer has used in a portrait by counting the catchlights in the eyes.

A typical studio flash system and studio set

I find that the light from good soft boxes is ideal for most of the portrait, figure and commercial photography which I do. When used with people, it produces a flattering light which de-emphasizes blemishes and softens harsh detail without the diffusion caused by softening filters. On product shots it produces good detail and modelling, but again without harshness. My present favourite among the soft boxes I have tried is the Multi Dome from Photoflex. This unit is unique in having a dual lining, silver or white which can be changed easily by means of Velcro attaching strips. Not only is it possible to change the entire interior, it is also possible to have one or more panels in silver while the rest are white. This allows very fine control of the degree of diffusion, which is additionally supplemented by a removable internal baffle. This gives the greatest degree of control of any of the soft boxes I have worked with. All of the product photos I took for this book were made with this as the prime light source.

There are many different light modifiers which may be bought or home made for use in the studio. Lightweight cloth panels supported by PVC pipe frames are quite popular to use as reflectors, light blocks (often called gobos), large diffusers (called scrims) or backgrounds. These can be bought ready made or easily put together with a little work. Four of these panels can be put together and covered with fabric to form a convenient outdoor portable dressing room.

An effect often seen is that of a pattern of light thrown onto a background. This may be a random pattern, or it may emulate the light through blinds, tree leaves, etc. This effect can be produced by using a narrow angle reflector and shooting the light through a piece of cardboard which has been cut with the desired pattern. Such a cutout pattern is called a cukuloris or "cookie". The same type of effect, but usually with a more defined and harder pattern may be produced with a focusing spot attachment for a light head. These attachments use an optical or fresnel lens to focus the light and many have a slot into which a cutout pattern or even large transparency may be fitted for projection onto a background.

While there are formulae which can be used to compute the proper aperture based on the power output of each light head and the reflector or modifier in use (which produces a guide number similar to that discussed at the beginning of this chapter), I feel that the only practical way to determine exposure with studio flash is with a good flash meter. As I mentioned in Chapter 1, pages 43-45, there are many good hand meters available today which can do double duty as ambient light and flash meters. My preference is for a good incident meter for studio use since it allows me to determine flash ratios precisely and balance my light as I want it.

When first working with any studio flash system you will need to make film tests to determine if the ISO rating of the film is the correct exposure index for the flash units, and to see if the colour balance is desirable. Many studio flash systems produce a rather cool colour balance, and this may need to be corrected with warming filters over the flash tubes or with something like an 81C filter on the camera lens. You may find, as I have, that different films respond to the same flash in different ways, and that the warming filter may be essential with certain films and totally unnecessary with others. You will have to determine this to your own personal satisfaction with tests of any new film with the flash system you use.

5: Picture Taking

Now that we have covered most of the technical details of the EOS cameras, the time has come to take pictures. After all the whole point of all this technical sophistication is to make it easy for you to produce the pictures you want.

The best way to get to know your camera is to spend as much time as you can actually photographing. If you do this you will find that all of the operations which seemed to complex when you first read about them are actually simple and direct. Taking lots of pictures will let you see just what you can do with these very flexible cameras, will let you explore all of their capabilities. After all, film is still the cheapest thing in photography, so don't be afraid to waste it while learning. It is money well spent.

Old buildings sometimes have interesting old signs painted on them. The contrast is particularly great when these signs have prices on them.

CREATIVE CONTROL OF EXPOSURE

Although much of the previous text of this book has been devoted to the many ways in which the Canon EOS cameras have made it possible to determine perfect exposure, there may be times when the best exposure from a technical point of view is not the one you want. You may want to convey a special feeling which the normal exposure simply does not do.

There are many types of photographs in which this situation may come up, but two which will be encountered most often. They are called high-key and low-key photographs.

In a high-key photograph the tonal range has been entirely shifted towards the high end, there are no blacks and little in the way of dark areas. The photo is technically over-exposed, but this has been done

Left: photos need not show detail in every square centimetre of their surface. Here I have intentionally allowed the highlights in my model's hair to print without any detail or texture. This photo was taken outdoors in bright sun with the light coming from the upper left.
Right: this is one of my favourite outdoor portraits. Light was simply the diffused sunlight coming through the leaves which often produces a flattering, soft light.

intentionally to produce a light, soft effect. In these photographs, colours tend to be rendered in pastel shades, and they are often shot with soft focus lenses or through diffusion filters.

To successfully create high-key photographs you must be able to control your lighting, or work in a situation which produces the lighting best suited to this effect. This is a soft lighting without much contrast, typically of a hazy overcast day outdoors in which shadows are indistinct. In the studio such lighting is usually produced by large soft boxes, such as the Multidome made by Photoflex. This soft lighting has a low ratio between highlight and shadow and thus allows all of the tones to be shifted upward without disastrously washing out the highlights. In other words, this is low contrast lighting.

Left: there are many ways to eliminate a distracting background. For this dramatic fashion shot, I shot with a wide enough aperture to throw the houses in the background out of focus and then printed them quite dark to further eliminate their distraction from the main subject.

Top right: featureless white skies are usually deadly boring. Here I have relieved this problem by silhouetting the old truck, fence and small barn. This adds interest to the background without overpowering the foreground subjects.

Bottom right: when doing informal portraits, don't be afraid to try unusual poses. Often, as in this case, they will produce excellent results.

If you are taking a highlight and shadow reading with an incident meter you would want the lighting arranged so that the difference between the readings was only one step or less. You would then over-expose the film when making the exposures. With the EOS-1, 630(600), RT or 620 you can easily bracket the exposures with AEB if you are using natural light. With studio flash you will have to bracket manually since the flash will not be able to recycle fast enough to keep up with the rapid exposures made in the camera's AEB mode.

The opposite type of photograph from high-key is low-key, and in this case the entire tonal range of the subject is shifted downward so that blacks and dark tones predominate. In contrast to the above, there are few photos which benefit from a total low-key effect, it is usually more satisfactory pictorially to have at least some areas highlighted to bring them out against the overall dark tone of the photo. For this type of photograph I prefer to have a generally flat lighting ratio just as in high-key, but with one subject or parts of the subject highlighted by a direct light. Outdoors this can be a shaft of sunlight on a cloudy day. In the studio it can be a spotlight or a broad light controlled by barn doors, scrims or lighting panels. Portraits sometimes benefit from an effect in which the background and parts of the subject except for the face are low-key and the face alone is lit normally. This is difficult to do outdoors, but can sometimes be accomplished by putting the subject in natural shade and using a reflector to throw light just where it is wanted. Homemade reflectors may be made from cardboard covered with crumpled aluminium foil. Another handy reflector which can be used to direct light outdoors is a double sided make-up mirror, the flat side can be used for general fill light and the magnifying mirror side can be used like a spotlight to throw a concentrated beam of light where it is needed. A friend or assistant is generally needed for this type of work to position and hold the reflector.

Another possible effect is night-from-day, that is an underexposure taken during the day which will look like a night photograph. These can be difficult to do properly, but generally speaking an underexposure of two or more steps will be required. As with so many other unusual circumstances the rule is – bracket.

Apart from specifically high-key or low-key photographs, there are many times in which you will want to deviate from the exposure determined by the light meter simply to enhance a mood or to create a greater saturation in a transparency film.

COMPOSITION

Composition is probably the single most important aspect of photography. After all, it is ultimately the composition which will overrule all other factors and determine the final success of a photo. If a picture is perfectly exposed and lit but badly composed it will be just as worthless as if it suffered some other obvious technical flaw. In judging photography competitions, I have seen proof that this is the least understood aspect of photography, and one which seems to give so many photographers, even advanced practitioners, a bad time.

While a sense of composition is innate in certain people, I feel that everyone can learn enough about it to at least get by. After working for some time while thinking about composition it will begin to become automatic and you will no longer have to work at it. This is just like learning to use your camera, learning to drive your car, or any other task which at first requires constant attention and thought but after a time becomes so easy that you can not believe how difficult it was at first.

Modern buildings frequently offer the opportunity for interesting compositions. It is usually a good idea to include a figure or two to give some scale to the architecture.

Often interesting photos can be taken of old buildings. Here I was drawn to the texture of the logs in this old cabin and to the distorted reflection in the wavy window glass.

Although I have heard some people pontificate about "æsthetic rules", I personally feel that anyone who tries to insist that there are such rules is a fool. The only real rule is whether the picture works, and by that I do not necessarily mean that it has to be pleasing to the eye. What is important is that the photographer had a specific compositional intent and was able to carry it through to the finished photograph. What I am about to tell you about composition is the distillation of my own experience, and must not be considered as anything more than suggestions which you should consider and then use or discard as they apply or do not apply to your personal photography.

I will assume that your intent is to produce visually interesting, stimulating compositions which are pleasing to view. You certainly do not want them to be boring.

One thing I must get out of the way right at the beginning is something called aspect ratio. This is simply the ratio of the short sides of a rectangle

Framing a composition designed on divisions of a 2:3 ratio image: top, where no foreground is available, a 2:1 positioning of the horizon and the major element in the composition produces an attractive balance. Centre: introducing a framing foreground element on the 'near' side of the subject fails. Bottom: extending the framing over the top of the picture improves the balance.

to the long sides. A problem which you will frequently encounter in working with 35mm is that the aspect ratio is somewhat long; that is 1:1.5. The dimensions of a 35mm negative are nominally 24 x 36 mm or roughly 1 x 1.5 inches. This is close to the aspect ratio which the ancient Greeks considered ideal, and referred to as the "golden rectangle". It is certainly a pleasing aspect ratio and many commonly encountered objects maintain approximately this ratio.

The problem comes about when we try to make prints from our 35mm negatives. Most of the common print sizes do not have the same aspect ratio; for example the common sizes of photographic paper are (in inches) 8 x 10, 11 x 14, 14 x 17, and 16 x 20. All of these have an aspect ratio of approximately 1:1.25. You can easily see that enlarging a negative with an aspect ratio of 1:1.5 onto a sheet of paper with an aspect ratio of 1:1.25 causes problems. You always lose a bit off the long dimension.

You may solve this in several ways. The first is to order special 8 x 12 prints which some photofinishers now supply and then compose the photo exactly in the viewfinder. The other solution is to allow for this slight cut-off at either end when composing the picture in the camera. The last possibility is to ignore it altogether and face the prospect of cutting Aunt Agnes in half when taking a group family portrait!

Now lets get to the meat of the matter. All who have learned to read in Western cultures have learned to scan the page from left to right, starting at the top and working down. This is learned so early that we are not generally aware of it, but it carries over into our viewing of photographs and other art. We tend to start our viewing of an image on the left side and scan across to the right. We will typically start toward the top. In our drawing of the house you will see that there is nothing to interrupt this scan in the first image; our eye enters at the upper left and scans across and, since it is not stopped by anything it tends to just keep on going out of the picture. You will find that many photos also have this effect on your eyes and such pictures do not hold your attention.

In the second drawing we have placed a picture element at the right edge of the image. In this case it is a tree, but it need not be a solid object. A shadow or line would also work. In this case our eyes start across the top of the image as before, but now they are arrested by the tree and come back toward the centre of the image. There they encounter the house, and if it is interesting they will be held there for a time. If the house is lacking in interest the eyes may just bounce off it and travel out of the top or bottom of the image.

In the third drawing our tree has an overhead branch, and this would serve to keep the eyes from getting lost out the top of the picture and keep them in the area of the house. Of course this is a great simplification, but I am sure you get the point that I am trying to make that the eye must be held in the frame, either by a border of some sort or by the interest of the subject itself. You will also notice that the house was not placed in the exact centre of the frame. Novice photographers usually have the habit of putting the main subject at dead centre, and this tendency is accentuated by autofocus cameras like the EOS which will only focus on the subject in the centre. Make use of the focus hold and rearrange your composition, switch to manual focus, do whatever works to allow you to increase the visual interest in your photos. Do not leave everything at the centre, your photos will be terribly boring if you do.

The best places to put your main subject are generally positions obtained by the rule of thirds. If you divide the frame into thirds and place the subject along the line which divided the image into 2/3 or 1/3 you will usually find this placement produces an interesting photo. Of course, this does not mean that this has to be an exact placement, and I do not suggest marking lines of thirds on your viewing screen, just that you be aware of this as a general compositional aid.

Left: division of a golden rectangle with a 1:1.5 aspect ratio into a grid pattern which is used to identify major axes and points. Centre: the S-surve or line of beauty. Right: a pyramid or receding perspective composition.

Here I have divided a "golden rectangle" similar in proportion to a 35mm frame into thirds on each axis. Locating your main subject generally along one of these lines will usually be the best placement and locating it at the intersection of two of the lines is usually even better.

Of course not all subjects lend themselves to this sort of placement and there are many other arrangements which will produce visually interesting compositions. Two which are frequently used are the S curve and the pyramid. In the S curve the planes of the subject are arranged in a gentle curve with the first bend in the curve at about the 1/3 down line and sweeping through broad arcs to the bottom. This composition works especially well with figure studies.

The pyramid works well when you are dealing with groups of asymmetrical subjects, such as groups of people. By putting the tallest person in the middle and others around that person such an arrangement may be created.

One of the best ways to study composition and form is to get several books on the old masters. These great painters worked out the principles I have mentioned above hundreds of years ago, and put them through infinite permutations. Don't be afraid to borrow compositional ideas from the masters, you certainly won't be the first.

Take some time to study the photographs used to illustrate this book. Each of the compositional elements mentioned above can be found, as well as many images which make use of multiples of these elements. You will also find some which do not fit into any of these concepts.

Don't be afraid to break the rules, as many of these photographs have done. For every suggestion I have made above there will be pictorial situations in which just the opposite of what I have said will work better. Practice, experiment, break all the rules and learn

6: The EOS System

TECHNICAL SPECIFICATIONS AND APPLICATIONS OF THE EOS LENSES

This listing includes all EF lenses announced at press time. Some of these lenses were not actually on the market at that time, and in a few cases all specifications were not available. This is the reason for omissions in this listing.

Lens Coating

In the theoretically perfect lens all light which entered at the front would pass through and form the image. In practice this ideal does not exist since each glass surface in the lens reflects some of the light. The ground and polished surface of a lens element will reflect about 4% of the light striking it. This light loss through reflection becomes a serious problem when lenses are designed with many separate elements.

Early lenses had no provision to correct for this reflection problem, but they seldom had more than a few elements. When it was discovered by accident that surface reflection could be greatly reduced by coating the lens surfaces with a thin film of magnesium fluoride the practice of coating lens elements quickly became universal and lenses with more elements became practical.

However, even these coated lenses still reflected quite a bit of light. This reflected light not only somewhat reduces the total transmission of light, it also causes a specific problem called flare (actually we should properly call it veiling glare, but the term flare has become so common in photographic writing that I will stick with it here). Flare is simply an overall veiling haze produced by unfocused light which bounces around inside the lens. It causes an overall reduction in image contrast. Flare is particularly a problem when a bright light source such as a reflection is included in the image or is just outside the image field. In the worst cases, flare will be so high as to veil the entire image in a white haze.

Most modern lenses and all of Canon's EF lenses feature an improved

type of lens coating generally called multicoating. Canon calls their multicoating Super Spectra Coating (SSC). In multicoating, multiple layers of different composition are applied to each lens surface with the number and type of layers matched to the characteristics of the type of glass used.

Contrary to what you may have heard, these lens coatings do not absorb the light which would otherwise be reflected. Light has both particular and wave properties, but it is the wave properties which most concern us in dealing with optics. Light waves operate just like any other waves in that they can strengthen one another or weaken and even cancel each other out, depending on whether they are in phase (peaks aligned with peaks and valleys aligned with valleys) or out of phase (peaks aligned with valleys). In the case of lens coating, the light that passes through the coating and reflects back is shifted by one half of its wavelength so that it is out of phase with the incoming light. When this out of phase light emerges from the coating it encounters incoming light and the two waves cancel each other out completely. In this way reflected light is eliminated, but it is not absorbed.

In addition to the standard SSC used by Canon on their glass lens elements they have recently developed a special version of SSC matched to the optical characteristics of the UD or Ultra low Dispersion glass used in some of their lenses.

Internal Focus

Traditional camera lenses have always been focused by moving the entire lens with respect to the film, moving it away for closer focus and closer for more distant focus. All the lens elements were typically mounted in a metal lens barrel and moved as a group. This was usually done with a group of threaded tubes which moved the lens barrel when one of them was turned. Such threaded tubes are referred to as helicals. To keep the front of the lens from rotating when focused a double helical with one turning ring and two non-turning rings has usually been used. Some of the Canon EF lenses have used this system, and in these the front of the lens does not rotate as the lens is focused.

In the case of the zoom lenses it has not been practical to use this system because the friction would be greater, the physical size of the lenses would be greater and the cost would have been increased. Instead of using designs in which the entire lens moves for focusing, Canon has

used a simpler design on the zoom lenses, one in which only the front component (group of elements) moves during focusing. For this reasons Canon has used a single helical on the zooms with the sacrifice that the front of the lens turns during focusing.

A new type of focusing has been developed in recent years largely from experience with zoom lenses in which certain elements or groups of elements move differentially with respect to others during the zooming action. This is commonly done with a system using cam slots cut into tubular sleeves, the slots controlling the movement of the elements as the sleeves are turned. Optical designers quickly realized that such a system of differential element movement could be used to focus a lens as well as to make a zoom.

This has produced a new generation of lenses called Internal Focus or IF. This has the advantage of allowing the designers to dispense with the helical tubes which can cut down considerably on the cost and weight of the lens. Additionally, lenses with internal focus by-pass the problems associated with lenses in which the front component must rotate during focus as well as the change of balance which occurs with most lenses which change length as they focus.

Canon have designed several of the EF lenses for the EOS system with internal focusing, and I am sure that they will use this system on many future lenses as well.

Aspherics

Due to practical manufacturing considerations, all photographic lenses in the past were made using spherical surfaces. That is the faces of each lens element were ground as a segment of a sphere, with the curvature varying with the radius of the sphere. Spherical surfaces are fairly easy to manufacture but are far from photographically ideal. The reason for this is that spherically ground lenses tend to produce a field of focus which is curved. In the human eye, where the retina is curved on the inside of a sphere, this is ideal and a lens with spherical curvature can work quite well. For photographic purposes in which the film is flat it makes the design of lenses with reasonably flat fields of focus difficult.

Optical designers have long known that the ideal surface configuration for photographic lens elements would be non-spherical, or aspherical, with a curvature which is different in different parts of the lens surface. The process of making such lens elements was incredibly

difficult, involving much hand work. Such lens elements could only be produced in limited quantities and the cost was very high. All older lenses which used aspheric elements were very expensive.

Canon have succeeded in making aspheric lens elements in quantity at very low prices by developing their own manufacturing techniques which are different from any used in the past. All lens elements in the past were made from flat pieces of optical glass which were ground to shape and then polished. Canon have developed a method for moulding optical glass into the final form so that it need only be coated. Past attempts to do this by other firms have met with failure due to problems associated with cooling the glass without stressing it and the difficulties of polishing the aspheric surfaces after moulding. Suffice it to say that Canon have solved these problems and we are the beneficiaries of this technology. Canon are now able to give us lenses of greatly improved optical quality at prices which would have previously been impossible. Frequent use of these moulded glass aspherics has allowed Canon to greatly improve the optical performance of many lenses while at the

The lens element on the left is a Canon moulded glass aspheric element. The one on the right is a standard ground and polished spherical element. Notice how the lines curve in a serpentine manner when seen through the aspheric element. Also notice that Canon has gone to the extra step of blackening the edges of the lens element while the other element, from a cheap lens, has not has this treatment. Edge blackening absorbs light which would otherwise bounce back from the lens edge and degrade the image.

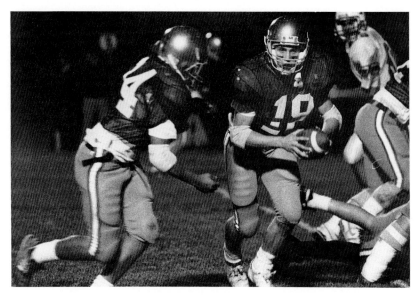

Control of flare and excellent sharpness at full aperture are given by aspheric elements –
and these qualities are needed for floodlit football action. Photograph by Randy Lilly.

same time reducing the number of lens elements needed for a particular design. Reducing the number of elements reduces the number of air to glass surfaces (making flare control easier), lowers manufacturing costs, and ultimately lowers the cost to the consumer. Serially produced aspheric lens elements at reasonable prices are one of Canon's greatest achievements.

FIXED FOCAL LENGTH LENSES

The Canon EF 15mm ƒ2.8 Fisheye

This lens was specifically designed for the EOS system and has better optical quality that the older 15mm ƒ2.8 lens which has been available for some time in Canon FD mount. While the old lens had nine elements in eight groups, the new lens has eight elements in seven groups. Since this lens is a full-frame fisheye type it is impractical to use filters on the front as they would cut off the corners of the image. Past designs have used an internal rotating wheel with permanently mounted filters, but this has limited the photographer to only those filters installed at the factory. In answer to complaints from professional photographers this new lens was designed to use gelatin filters instead. Gelatin filters are available in a wide variety of colours and types and are cut to fit the holder which then fits into a slot in the rear of the lens barrel.

Specifications:

Focal length/aperture:	15mm, ƒ2.8
Optical Construction:	8 elements in 7 groups – SSC*
Angle of view (diagonal):	180°
Drive motor system:	AFD
Drive motor speed**:	0.29 sec.
Manual focus system:	Mechanical clutch focus ring
Focusing system:	Straight helicoid – extension type
Closest focus:	0.2 metre
Maximum magnification:	0.14x
Aperture range:	2.8 – 22
No. of diaphragm blades:	5
Filter size:	Gelatin filters, see above
Dimensions:	73.0mm (2 7/8in) diameter
	62.2mm (2 7/16in) length
Weight:	360g (12 11/16oz)

* SSC, Super Spectra Coating, is Canon's trademark for their proprietary multicoating process. See LENS COATING at beginning of this chapter for an explanation.
* * This is the time required for the focusing motor to drive the lens from its infinity setting to its closest focus setting, and does not include the time needed for the autofocus system to function.

The Canon EF 24mm ƒ2.8

This lens was produced for those photographers who wanted a lens wider than 28mm without rectilinear distortion. The lens uses internal focusing through a cam system rather than a helicoid drive. As with almost all of the EF lenses, Canon has provided a completely new lens for the EF mount version.

Specifications:

Focal length/aperture: 24mm, ƒ2.8
Optical Construction: 10 elements in 10 groups – SSC
Angle of view (diagonal): 84°
Drive motor system: AFD
Drive motor speed: 0.3 sec.
Manual focus system: Mechanical clutch focus ring
Focusing mechanism: Cam drive, rear element focusing
Closest focus: 0.25 metre
Maximum magnification: 0.155x
Aperture range: 2.8 – 22
No. of diaphragm blades: 6
Filter size: 52mm
Dimensions: 67.5mm (2 5/8in) diameter
48.5mm(1 7/8in) length
Weight: 270g (9 7/16oz)

The Canon EF 28mm ƒ2.8

This newly designed lens makes use of Canon's recent developments in the manufacture of aspheric lens elements. In this case a single aspheric element is used which has allowed Canon's optical designers to minimize the number of lens elements needed while at the same time providing excellent optical quality and image sharpness all the way to the corners of the image. By using this aspheric element the design has been limited to only five elements in five air spaced groups, an economy of design which is responsible for the unusually low cost for a lens of this quality.

Specifications:

Focal length/aperture: 28mm, ƒ2.8
Optical construction: 5 elements in 5 groups – SSC
Angle of view (diagonal): 75°
Drive motor system: AFD
Drive motor speed: 0.44 sec.
Manual focus system: Mechanical clutch focus ring
Focusing mechanism: Straight helicoid extension type
Closest focus: 0.3 metre
Maximum magnification: 0.13x
Aperture range: 2.8 – 22
No. of diaphragm blades: 5
Filter size: 52mm

Dimensions: 67.4mm (2 5/8in) diameter
42.5mm (1 11/16in) length
Weight: 185g (6 1/2oz)

The Canon EF 50mm *f*1.8

Lenses in the 50mm range are commonly called normal lenses, once supplied with the camera body. Today, when many dealers are selling camera bodies with other lenses the 50mm is often neglected. Lenses of this focal length are considered normal because their image has approximately the same perspective as that seen by the human eye.

Normal lenses can, in fact, be very useful lenses, working well for general landscape photography, full length photos of people and even head and shoulder portraits. Such a lens is not nearly so likely to produce unwanted distortion as the wider angle lenses, and its generally higher speed makes it a valuable lens for shooting in low light. The EF 50mm *f*1.8 is essentially the same as the time-tested 50mm *f*1.8 Canon FD lens. Its optical performance is excellent. If you can only afford to start your outfit with one lens, this is a very good choice.

Specifications:

Focal length/aperture:	50mm, *f*1.8
Optical construction:	6 elements in 5 groups – SSC
Angle of view (diagonal):	46°
Drive motor system:	AFD
Drive motor speed:	0.44 sec.
Manual focus system:	Mechanical clutch focus ring
Focusing mechanism:	Straight helicoid extension type
Closest focus:	0.45 meter
Maximum magnification:	0.15x
Aperture range:	1.8 – 22
No. of diaphragm blades:	5
Filter size:	52mm
Dimensions:	67.4mm (2 5/8in) diameter
	42.5mm (1 11/16in) length
Weight:	190g (6 11/16oz)

The Canon EF 50mm *f*1.0 L

Canon has always had a reputation for optical innovation and this new lens is but another example of this. In the early 1960s when Canon was producing a fine line of rangefinder cameras they amazed the world by introducing a remarkably fast 50mm *f*0.95 lens which was surprisingly good optically. Now Canon has again surprised the world with this fastest lens ever for a 35mm SLR camera.

Canon's technological lead in glass-molded aspheric elements has allowed them to produce a lens which most other firms could only dream of. This lens uses two aspheric elements and nine spheric elements in a very complex optical design never before seen in a normal lens. All of this high speed and sophisticated optical design does have its price – this lens is both expensive and physically large. In spite of the price and size it may quickly become the standard for low light press photography.

Colour correction and elimination of optical aberrations is accomplished by the use of aspherics and special low dispersion types of glass. Additionally image sharpness is maintained throughout the focusing range by the use of differentially moving elements, often called floating elements.

Specifications:

Focal length/aperture: 50mm, ƒ1.0
Optical construction: 11 elements in 9 groups
 Special multicoating for
 low dispersion glass
Angle of view (diagonal): 46°
Drive motor system: USM
Drive motor speed: 0.74 sec.
Manual focus system: Electronic focus ring
Focusing mechanism: Straight helicoid extension type,
 differential element movement
Closest focus: 0.6 metre
Maximum magnification: 0.11x
Aperture range: 1.0 – 16
No. of diaphragm blades: 8
Filter size: 72mm
Dimensions: 89.0mm (3 1/2in) diameter
 80.0mm (3 5/16in) length
Weight: 985g

The Canon EF 50mm ƒ2.5 Macro

Rather than carrying over the design of the 50mm Macro lens they have made for some time in FD mount, Canon's designers decided that the time was right for an entirely new lens design. Although it was very good in optical quality the FD 50mm Macro lens had a maximum aperture of only ƒ3.5, and many people considered this too slow. The new, faster lens should answer these objections. The new lens incorporates a floating element design to optimize image quality throughout the focusing range. Since this lens will also focus to infinity, those photographers who do a lot of photomacrography may want to substitute this lens for a normal 50mm. The lens alone will focus down to a reproduction ratio of 1:2. To reach 1:1 a special Life Size Converter is attached between the lens and camera.

Specifications:

Focal length/aperture: 50mm, ƒ2.5
Optical construction: 9 elements in 8 groups – SSC
Angle of view (diagonal): 46°
Drive motor system: AFD
Manual focus system: Mechanical clutch focus ring
Closest focus: 0.23 metre, lens alone
 0.26 metre, with converter
Maximum magnification: 1:2 lens alone, 1:1 with converter
Aperture range: 2.5 – 32
Filter size: 52mm
Dimensions, lens: 67.5mm (2 5/8in) diameter
 63mm (2 1/2in) length
Dimensions, converter: 67.5mm (2 5.8in) diameter
 34.8mm (1 3/8in) length
Weight, lens: 285g (9 15/16oz)
Weight, converter: 205g (7 3/16oz)

The Canon EF 85mm *f*1.2 L

This lens is an ultra-large aperture medium telephoto lens developed to meet the needs of professional photographers. It gives low flare and high contrast as it utilizes an aspherical element as well as employing a floating mechanism to compensate for aberration alterations during focusing. It has been designed to give high performance by using glass with a high refractive index to compensate curvature of field.

The built-in USM (ultrasonic motor) gives a superior AF performance with quiet operation. The lens with its large 1.2 maximum aperture meets the needs of photographers in fields such as commercial and fashion photography by providing high image quality, viewing brightness and excellent differential focus effects.

Specifications:

Focal length/aperture:	85mm, *f*1.2
Optical Construction:	8 elements in 7 groups
Angle of view (diagonal)	30°12'
Drive motor system:	AFD
Drive motor speed:	1.2 sec.
Focusing mechanism:	Straight helicoid method
Closest focus:	0.95m
Maximum magnification:	0.11x
Aperture range:	1.2 – 16
Filter size:	72mm
Dimensions:	91.5mm diameter
	84mm length
Weight:	1025g

The Canon EF 135mm *f*2.8 Soft Focus Lens

It should be understood that while this lens is designated as a soft focus lens, the soft focus feature may be disengaged at will allowing the lens to be used for ordinary photography. When the soft focus control ring is set to the 0 position this lens is as sharp as any other high quality 135mm lens. So when you purchase this lens you can consider that you are really adding two lenses to your outfit, a sharp medium telephoto and a special-purpose soft focus lens.

Until recent developments by Canon the production of aspheric lens elements in quantity was a laborious and expensive process. This lens uses one aspheric element in its optical formula. This aspheric element is moved inside the lens in response to the setting of the soft focus control ring and produces a greater softening of the image as the ring is turned toward its maximum setting. Additional control is available through the diaphragm setting, as the choice of aperture will also have an effect on the softness of the image. The effect will be increased by larger apertures, decreased by smaller ones. Since the EOS cameras are provided with an electronic stop-down button for depth-of-field previewing this button may also be used with this lens to preview the degree of softness which will be produced at any setting.

Portrait photographers who work in 35mm will find this lens an indispensable tool for their work, and generalist photographers will find it useful in many pictorial situations.

Specifications:

Focal length/aperture: 135mm, f2.8
Optical construction: 7 elements in 6 groups – SSC
Angle of view (diagonal): 18°
Drive motor system: AFD
Drive motor speed: 0.39 sec.
Manual focus system: Mechanical clutch focus ring
Focusing mechanism: Internal focus through
moving rear component
Closest focus: 1.3 metre
Aperture range: 2.8 – 32
No. of diaphragm blades: 6
Filter size: 52mm
Dimensions: 69.2mm (2 3/4in) diameter
98.7mm (3 7/8in) length
Weight: 410g (14 7/16oz)
Special features: Soft focus capability with
softness control ring

The Canon EF 200mm f1.8 L

This remarkably fast medium telephoto lens should find immediate favour with press photographers, nature photographers, fashion photographers and anyone else who needs a very fast lens of this focal length. The lens makes use of Canon's UD ultra low dispersion glass in three elements and also utilizes internal focus driven by the USM motor system. The manual focus ring can be set for three focusing speeds; half speed, normal speed and double speed. The lens also has three quick focus zones allowing for faster action when the approximate zone of focus is known in advance. These zones are: from 2.5 metres to infinity, from 2.5 metres to 5 metres and from 5 metres to infinity.

Additionally the lens has a focus memory which allows setting of a specific focus and instant return to that focus position at any time by activation of the preset focus switch.

This lens uses the same rear-mounted filters as the 300mm f2.8 L and the 600mm f4 L lenses.

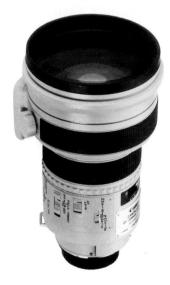

Specifications:

Focal length/aperture: 200mm, f1.8
Optical construction: 12 elements in 10 groups
3 elements from UD glass – SSC
Angle of view (diagonal): 12°
Motor drive system: USM
Drive motor speed: 0.6 sec.
Manual focus system: Electronic focus ring
helicoid internal focus
Closest focus: 2.5 metre
Maximum magnification: 0.088x
Aperture range: 1.8 – 22
No. of diaphragm blades: 8
Filter size: 48mm, rear mounted.
Dimensions: 130mm (5 1/8in) diameter
208mm (8 3/16in) length
Weight: 3,000g (6 5/8lb)

The Canon EF 300mm f2.8 L

For the wildlife photographer, for the sports photographer, for the photojournalist, for anyone who needs a fast and powerful telephoto lens this lens will be indispensable. When first shown in prototype form this lens amazed all of us by its compact size for its high speed, by its balance and by its incredibly fast autofocus action.

The lens uses Canon's USM (UltraSonic Motor) to drive the focusing action which allows it to focus from infinity all the way down to three metres in just over half a second. In addition to being incredibly fast, the USM is very quiet.

To maximize optical quality this lens was formulated using one element of special UD (Ultra low Dispersion) glass and one of crystal fluorite. This allows excellent colour correction and great sharpness.

A useful feature seen for the first time on this lens is the focus memory. This allows you to prefocus the lens at a specific distance in anticipation of action. Once the distance is entered into the lens memory it can be recalled at will by operating the focus preset ring which causes the lens to quickly return to the memorized focus distance. An audible beep tone signals when the lens has reached the memorized focus.

To speed up operation when working within known distance ranges the lens can be switched from it normal mode to either of two ranges: 3 metres to 6.5 metres or 6.5 metres to infinity.

When manual focus is used there is no mechanical connection between the focusing ring and the lens mechanism, instead the turning of the ring generates a signal which is used to control the movement of the drive motor in the proper direction. The speed of this focusing action can be set to half speed, normal and double speed to handle different shooting situations.

Because the front of this lens is so large (nearly five inches), filters for the front would be impractically expensive. For this reason Canon has provided a filter holder for the rear of the lens which will accept 48mm diameter standard threaded filters.

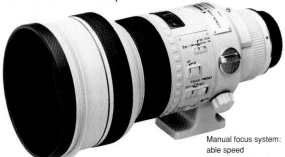

Specifications:

Focal length/aperture:	300mm, f2.8	Manual focus system:	Electronic focusing ring, variable speed
Optical construction:	9 elements in 7 groups – SSC	Focusing mechanism:	Straight helicoid type
Angle of view (diagonal):	8° 15'	Closest focus:	3 metre
Drive motor system:	USM	Maximum magnification:	0.11x
Drive motor speed:	0.60 sec.	Aperture range:	2.8 – 32
		No. of diaphragm blades:	8
		Filter size:	48mm, rear mounted.
		Dimensions:	125mm (4 15/16in) diameter
			243mm (9 9/16in) length
		Weight:	2850g

The Canon EF 600mm ƒ4.0 L

After the introduction of the EF 300mm ƒ2.8 L lens, Canon received many requests for an even longer lens which would match the peformance of the 300. The 600mm was produced in response to these requests.

Using one fluorite element and two UD glass elements along with four optical glass lens elements and protective front and rear neutral glass protective elements, Canon designers have produced a 600mm lens of spectacular performance.

In general appearance and in operation this lens is very similar to the 300mm and 200mm L lenses. It has the same USM drive motor system, and the same electronic manual focus ring. The electronic manual focus ring has three speeds, half speed, normal speed and double speed.

There are three focusing distance zones which may be preset: from 6 metres to infinity, from 6 metres to 15 metres, and from 15 metres to infinity. The lens is also fitted with the focus memory which allows instant return to a pre-set focusing distance at the touch of a switch.

Specifications:

Focal length/aperture:	600mm, ƒ4.0
Optical construction:	9 elements in 8 groups, 1 fluorite element, 2 UD glass elements – SSC
Angle of view (diagonal):	4° 10'
Drive motor system:	USM
Manual focus system:	Electronic focus ring, internal focus
Closest focus:	6.0 metre
Maximum magnification:	0.105x
Aperture range:	4.0 – 32
No. of diaphragm blades:	8
Filter size:	48mm, rear mounted
Dimensions:	167mm (6 9/16in) diameter
	456mm (18in) length
Weight:	6,000g (13 3/16lb)

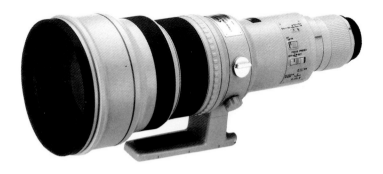

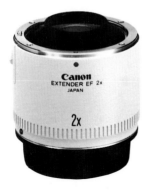

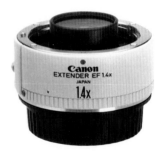

The Canon Extender EF 2x

This is a lens converter designed specifically to match the characteristics of the EF 200mm ƒ1.8 L, EF 300mm ƒ2.8 L, and EF 600mm ƒ4.0 L lenses. Optical performance of the lens is not degraded when used with this converter. When used in combination with the EF 200 mm ƒ1.8 L the combination produces a 400mm ƒ3.5, with the EF 300mm ƒ2.8 L the combination becomes a 600mm ƒ5.6, and with the EF 600mm ƒ4.0 L a 1200mm ƒ8.0 is produced.

These combinations are very useful and still quite fast for their respective focal lengths.

Due to the fact that only these three lenses at present are fitted with the necessary eleven electrical contacts for operation with this converter, other Canon EF lenses may not be used.

The converter is made up of 7 elements in 5 groups and is SSC coated. It measures 67.6mm (2 11/16in) in diameter and 50.49mm (2in) in length.

NB: Manual focus only with 600mm ƒ4.

The Canon Extender EF 1.4x

By restricting the magnification of this converter to only 1.4x, the light loss through the converter is only one stop. This allows the use of the following lenses:

EF 200mm ƒ1.8 L becomes 280mm ƒ2.0
EF 300mm ƒ2.8 L becomes 420mm ƒ4.0
EF 600mm ƒ4.0 L becomes 840mm ƒ5.6

As you can see, this produces some very interesting focal lengths at quite fast apertures.

Because of the fact that only these three lenses are fitted with the proper eleven electrical contacts, they are the only lenses at present which may be used with this converter.

The converter is made up of 5 elements in 4 groups, fully SSC coated. It measures 67.6mm (2 11/16in) in diameter and 27.3mm (1 1/16in) in length and weighs 200 g(7oz).

THE ZOOM LENSES

The Canon EF 20-35mm ƒ2.8 L

This large aperture wide-angle zoom lens uses a single aspherical element which provides sharp, high resolution images with minimal distortion. It employs a floating system for improved image quality at close shooting distances which gives sharp images while minimizing aberrations throughout the entire shooting distance range. It features a design in which the total lens length remains the unchanged and the front edge of the lens does not move during focusing and zooming, providing superior operability. This feature is especially useful when a circular polarising filter is attached to the lens.

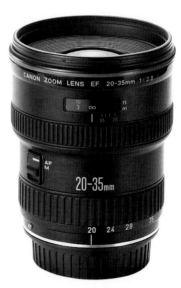

Specifications:

Focal length/aperture:	20-35, ƒ2.8
Optical construction:	15 elements in 12 groups
Angle of view (diagonal):	94° – 63°
Drive motor system:	AFD
Drive motor speed:	0.3 sec.
Focusing mechanism:	Inner focus rotational helicoid system
Closest focus:	0.5m
Maximum magnification:	0.085x
Aperture range:	2.8 to 22
Filter size:	72mm
Dimensions:	89.8mm (diameter) 79.7mm (length)
Weight:	540g

The Canon EF 28-70 ƒ3.5-4.5 II

Canon has been able to make this lens with a 2.5:1 zoom range and still keep the size amazingly small by the use of a sophisticated optical design using one glass molded aspheric element. A special moving internal baffle helps to arrest flare and improve overall image quality, particularly in the outer part of the image. The lens does not change in length as it is zoomed, it uses a rotating zoom ring control and internal differential element movement in its zooming action. Unhappily the front component of this lens does rotate during focusing making the use of polarizing and special effects filters very difficult.

Specifications:

Focal length/aperture:	28-70mm, f3.5-4.5
Optical construction:	10 elements in 9 groups – SSC
Angle of view:	75° – 34°
Drive motor system:	AFD
Drive motor speed:	0.36 sec.
Manual focus system:	Mechanical clutch focusing ring
Focusing mechanism:	Rotary helicoid type
	– front of lens rotates during focusing
Closest focus:	0.39 metre
Maximum magnification:	0.22x
Aperture range:	3.5-4.5 to 22-29
No. of diaphragm blades:	5
Filter size:	52mm
Dimensions:	70.0mm (2 1/4in) diameter
	75.6mm (2 9/10in) length
Weight:	285g (10 1/10oz)
Zoom mechanism:	Rotating zoom ring, 2 component
	3 group zoom system, ring rotation 55°.

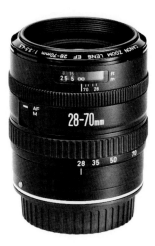

The Canon EF 28-80mm f2.8-4 L

This lens, part of Canon's series of ultra-high-performance lenses designated by the L suffix, is one half stop faster and ten millimeters longer in maximum focal length than the preceding lens. Due to the use of low dispersion glass and two aspheric elements, this lens is able to offer exceptional image quality throughout its zoom range.

This lens will also focus quite close at all zoom settings.

Specifications:

Focal length/aperture:	28-80mm, f2.8-4.0
Optical construction:	16 elements in 12 groups – SSC
Angle of view:	75° – 30°
Drive motor system:	USM
Manual focus system:	Electronic focusing ring
Focusing mechanism:	Rotary helicoid type
	– front of lens rotates
	during focusing
Closest focus:	0.5 metre
Maximum magnification:	0.2x
Aperture range:	2.8 – 4.0 to 22 – 32
No. of diaphragm blades:	8
Filter size:	72mm
Dimensions:	83.0mm (3 1/4in) diameter
	122.0mm (4 13/16in) length
Zoom mechanism:	Rotating zoom ring,
	3 group zoom system,
	ring rotation 70°
Weight:	945g

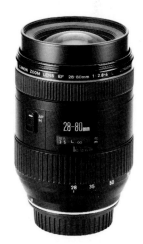

The Canon EF 35-70mm, *f*3.5-4.5

For those photographers who do not need a high lens speed, this one is a good alternative to the normal lens of fixed focal length. The optical quality of this lens is remarkably good throughout the zoom range, far better than most zoom lenses I have used in the past. The lens is not only very compact and light in weight, but it does not change in length as it is zoomed. The front component does rotate during focusing, however, which is a nuisance with many filters.

Instead of the common push-pull type of zoom action, it uses a separate zoom ring to control the action of the internal elements which move to change focal length. Personally, I much prefer this type of action to the push-pull zooms.

Specifications:

Focal length/aperture:	35-70mm, *f*3.5-4.5
Optical construction:	9 elements in 8 groups – SSC
Angle of view (diagonal):	63° – 34°
Drive motor system:	AFD
Drive motor speed:	0.41 sec.
Manual focus system:	Mechanical clutch focus ring
Focusing mechanism:	Rotary helicoid type
	– front of lens rotates during focusing
Closest focus:	0.39 metre
Maximum magnification:	0.2x
Aperture range:	3.5-4.5 to 22-29
No. of diaphragm blades:	5
Filter size:	52mm
Dimensions:	68.8mm (2 11/16in) diameter
	63.0mm (2 1/8in) length
Weight:	245g
Zoom mechanism:	Rotating zoom ring
	3 group zooming system, ring rotation 55°

The Canon EF 35-105mm, *f*3.5-4.5

This is an exceptionally nice all-round lens, one which I immediately came to like after only a short introduction. The lens is remarkably compact for its zoom range, the shortest from any manufacturer with this range. Size has been kept small and optical quality high through the use of an innovative optical design using a molded glass aspheric element.

Although this lens does suffer from a moderate amount of barrel distortion, as do most zoom lenses in the wide angle to telephoto range, this is not a problem in general photography.

Flare has been kept to remarkably low levels through the use of SSC coating and a special moving internal light baffle. Zoom action is of the push-pull type, which I generally dislike, so it is a tribute to the other qualities of this lens that I have adopted it as my "normal lens" for most situations.

Specifications:

Focal length/aperture: 35-105mm, *f*3.5-4.5
Optical construction: 14 elements in 11 groups – SSC
Angle of view (diagonal): 63° – 23° 30'
Drive motor system: AFD
Drive motor speed: 0.40 sec.
Manual focus system: Mechanical clutch focus ring
Focusing mechanism: Rotary helicoid type
 – front of lens rotates during focusing
Closest focus: 0.85 metre
Maximum magnification: 0.16x
Aperture range: 3.5-4.5 to 22-29
No. of diaphragm blades: 5
Filter size: 58mm
Dimensions: 73.2mm (2 7/8in) diameter
 81.9mm (3 1/4in) length
Weight: 400g (14 1/8oz)
Zoom mechanism: Push-pull type, 3 component,
 4 group zoom system, movement
 through full zoom range 16.06mm

The Canon EF 35-135mm, *f*3.5-4.5

For the photographer who finds the upper limit of the previous lens' zoom range a bit too short, Canon offers this lens with a little more magnification. You may wonder why Canon would continue to offer the 35–105 after the introduction of this lens, but the answer (as it so often is in photography) is the photographer's budget. This lens is much more expensive to manufacture than the 35–105 and thus costs the consumer considerably more.

For the photographer who must have the extra "reach" of this lens and can justify the expense, this is an unusually versatile lens, covering the entire range from medium wide angle to medium telephoto all in one. The lens is very easy to operate, and in my experience the optical quality is excellent.

Specifications:

Focal length/aperture: 35-135mm, *f*3.5-4.5
Optical construction: 16 elements in 12 groups
Angle of view (diagonal): 63° – 18°
Drive motor system: AFD
Manual focus system: Mechanical clutch focus ring.
Focusing mechanism: Rotary helicoid type – front
 of lens rotates during focusing
Closest focus: 0.95 metre
Maximum magnification: 0.103x
Aperture range: 3.5-4.4 to 22-29
No. of diaphragm blades: 6
Filter size: 58mm
Dimensions: 73.4mm (2 9/10in) diameter
 94.5mm (3 7/10in) length
Weight: 475g (16 8/10oz)
Zoom Mechanism: Push-pull action,
 4 group zoom system movement
 through full zoom range 24.6mm

The Canon EF 50-200mm, ƒ3.5-4.5 L

To answer the needs of the photographer who has little use for wide angle range and a greater desire for more of a telephoto range this L series lens was designed. For many photographers this one lens may cover all of their lens needs. While not an inexpensive lens, due to the use of both fluorite and UD glass, the remarkably good optical performance will justify the cost for those who need this lens.

As with all L series lenses, the optical performance and mechanical construction are fully up to professional demands.

Specifications:

Focal length/aperture:	50-200mm, ƒ3.5-4.5
Optical construction:	16 elements in 14 groups, 1 fluorite element, 1 UD glass element – SSC
Angle of view (diagonal):	12°19' – 47°37'
Drive motor system:	AFD
Manual focus system:	Mechanical clutch focus ring
Focusing mechanism:	Rotary helicoid type – front of lens rotates during focusing
Closest focus:	1.2 metre
Maximum magnification:	0.25x
Aperture range:	3.5-4.5 to 22-29
No. of diaphragm blades:	8
Filter Size:	58mm
Dimensions:	75.6mm (3in) diameter
	145.8mm (5 3/4in) length
Weight:	690g (24 3/8oz)
Zoom mechanism:	Push-pull type, 4 group zoom system movement through full zoom range 36.9mm

The Canon EF 70-210, ƒ4

This is a nicely compact zoom lens with a range that has become very popular, starting just a bit longer than a normal lens and carrying through to a medium telephoto. In this lens as well as in many others Canon's designers have made use of a molded glass aspheric lens element to help keep the optical performance very high.

Unlike the previously described EF zoom lenses, this lens is not a variable aperture design. This means that the aperture you have set does not vary as you change focal length.

The photographer not concerned with high lens speed could have a complete outfit for everyday work with just this lens and the 28–70. Only unusual circumstances would call for anything else.

Specifications:

Focal length/aperture: 70–210mm, *f*4
Optical construction: 11 elements in 8 groups – SSC
Angle of view (diagonal): 34° – 11°45'
Drive motor system: AFD
Drive motor speed: 0.68 sec.
Manual focus system: Mechanical clutch focusing ring
Focusing mechanism: Rotary helicoid type – front of lens rotates during focusing
Closest focus: 1.2 metre

Maximum magnification: 0.24x
Aperture range: 4 to 32
No. of diaphragm blades: 8
Filter size: 58mm
Dimensions: 75.6mm (3in) diameter
137.6mm (5 7/16 in) length
Weight: 650g
Zoom mechanism: Push-pull type, 3 component, 4 group zoom system, movement through full zoom range 36.4mm

The Canon EF 80-200 *f*2.8 L

This lens is the first large aperture telephoto zoom lens in the EF series, and was developed as a high performance L series lens. It utilizes 3 lens elements made of UD glass to attain high image quality and compensate for chromatic aberrations which often occur with large aperture lenses. It has a rear focusing system to realize high speed, high precision AF control while providing a large maximum aperture. This lens is ideal for a wide variety of photographic applications from outdoor photography requiring easy handling to studio photography requiring compositional flexibility.

Drive motor speed: 0.5 sec.
Closest focus: 1.8m
Maximum magnification: 0.127x

Specifications:

Aperture range: 2.8 – 32
Focal length/aperture: 80-200 *f*2.8
Filter size: 72mm
Optical construction: 16 elements in 13 groups
Dimensions: 84mm (diameter)
Angle of view (diagonal): 30° – 12°
185.7mm (length)
Drive motor system: AFD
Weight: 1330g

The Canon EF 100-200, ƒ4.5 A

This may be the ultimate medium telephoto zoom. It covers a highly useful range for all sorts of action photography with a relatively fast aperture for outdoor shooting. The only drawback of this lens is its minimum focusing distance, which is limited to 1.9 metres compared to the 70-210mm's 1.2 metres.

Specifications:

Focal length/aperture:	100-200mm, ƒ4.5
Optical construction:	10 elements in 7 groups – SSC
Angle of view:	24° – 12°
Drive motor system:	AFD
Drive motor speed:	0.7 sec.
Manual focus system:	Mechanical clutch focus ring
Focusing mechanism:	Rotary helicoid – front of lens rotates during focusing
Closest focus:	1.9 metre
Maximum magnification:	0.126x
Aperture range:	4.5-32
No. of diaphragm blades:	8
Filter size:	58mm
Dimensions:	74.4mm (2 15/16in) diameter
	130.5mm (5 1/8 in) length
Weight:	520g (18 1/5oz)
Zoom mechanism:	Push-pull type 3 group zoom system movement through full zoom range 31.18mm

NB: Manual focusing is not possible

The Canon EF 100-300mm, *f*5.6

This lens is for those photographers who need something longer than the 210mm maximum focal length and can tolerate the slower lens speed. For such a broad range of telephoto focal lengths this is a very compact lens.

While not well suited to low light photography, this lens is ideal for outdoor photography under normal light. It would be an excellent choice for wildlife and sports photography. Its small size and relatively light weight make it practical for hand holding.

This lens is a more traditional design than the ones previously discussed, having no aspheric elements or other exotic design features.

Specifications:

Focal length/aperture: 100-300mm, *f*5.6
Optical construction: 15 elements in 9 groups – SSC
Angle of view (diagonal): 24° – 8°15'
Drive motor system: AFD
Drive motor speed: 0.89 sec.
Manual focus system: Mechanical clutch focusing ring
Focusing mechanism: Rotary helicoid type – front of lens rotates during focusing
Closest focus: 2.0 metre
Maximum magnification: 0.26x
Aperture range: 5.6 to 32
No. of diaphragm blades: 8
Filter size: 58mm
Dimensions: 72mm (2 15/16in) diameter
166.8mm (6 9/16in) length
Weight: 720g (25 3/8oz)
Zoom system: Push-pull type, 3 component, 4 group zoom system, movement through full zoom range 27.86mm

The Canon EF 100-300mm, ƒ5.6 L

You may wonder why Canon would make two lenses with exactly the same range of focal lengths and the same maximum aperture. The primary reason is cost. While this 100-300mm ƒ5.6 L lens is of exceptional optical quality, its price may make it impossible for many photographers to afford it, and for them the preceeding less expensive alternative is offered. Where only the best will do, this lens is the one to use.

In addition to using one element made from Canon's UD low dispersion glass, this lens also uses one element made from crystal fluorite. This fluorite is a very difficult material to work with during manufacturing, with the result that such elements are very expensive to make. Fluorite offers some unique characteristics which are particularly valuable in controlling optical aberrations in telephoto and telephoto zoom lenses. This greater degree of correction leads to better rendering of colours without colour fringing and overall better sharpness than is possible with glass elements.

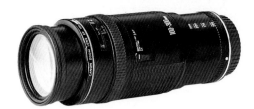

Specifications:

Focal length/aperture:	100-300mm, ƒ5.6
Optical construction:	15 elements in 10 groups – SSC
Angle of view (diagonal):	24° – 8° 15'
Drive motor system:	AFD
Drive motor speed:	0.89 sec.
Mechanical focus system:	Mechanical clutch focusing ring
Focusing mechanism:	Rotary helicoid type – front of lens rotates during focusing
Closest focus:	2.0 metre
Maximum magnification:	0.26
Aperture range:	5.6 to 32
No. of diaphragm blades:	8
Filter size:	58mm
Dimensions:	75mm (2 15/16in) diameter
	166.6mm (6 9/16in) length
Weight:	720g (25 3/8oz)
Zoom mechanism:	Push-pull type, 3 component, 4 group zoom system,
	movement through full zoom range 27.86mm

THE DATABACKS

The Technical Back E

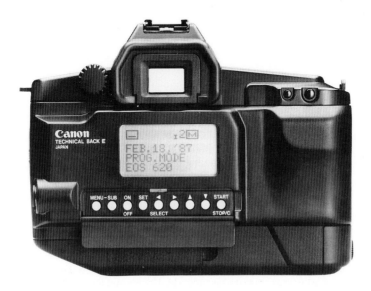

While many cameras offer data backs, Canon also offers this special back which is the most sophisticated data back yet seen, as well as a camera back offering features which are totally unique. The technical back E can be fitted to the EOS 650, 630(600), RT and 620 cameras by opening the standard camera back and removing it by releasing the upper hinge pin. The Technical Back E then replaces the standard camera back.

There are three components of the Technical Back E system. The first is the Technical Back E itself, the second is the Keyboard Unit E and the third is the Interface Unit TB.

The technical back itself is powered by one CR2025 lithium battery in an internal battery compartment. This battery should last about one year in normal use. A battery warning will appear on the back's LCD panel when the battery begins to get low. It is important to replace the battery promptly when this warning appears.

The Technical Back E is basically a small onboard computer combined with a data back. It has the capability to store and imprint typed comments and notes (up to 30 characters each). It can also imprint seven different types of data. During the use of the camera, the Technical Back E can store thirteen pieces of exposure data for each exposure, up to a total of 361 exposures for later recall. It allows custom programming of the camera's program exposure modes by alteration of the program graphs. It can perform auto exposure

bracketing up to nine exposures. Lastly it can be used as a self timer, intervalometer and long release timer.

The operation of the Technical Back E is somewhat complex, but easily understood with a bit of concentration. When the Technical Back E is closed and any of its nine control buttons pressed the LCD panel will display the menu screen. This pictorially represents the seven choices of operation. In addition to the main menu screen, there are three sub-menus; one for control of data storage and imprint, one for number and character input and one for display of main function settings and execution status.

On the main menu a flashing cursor indicates which function is to be operated. There are four buttons with arrows for up, down, right and left. These are used to move the cursor to the desired position.

The first function is the data imprint function. In this setting the Technical Back E can imprint up to three of the following types of exposure data:

Date	Either month/day/year; day/month/year; or year/month/day
Time	Hour/minute/second
Exposure Data	Shutter speed and *f*-stop
Shooting Mode	Shutter priority AE, aperture priority AE, program AE, manual or depth of field AE
Frame Counter	4 digit serial number, or film cassette number and frame counter number
Notes	Comments up to 30 characters

In the notes function, characters are input to the Technical Back E with the Keyboard Unit E, which is attached to the Technical Back E through a cord and a socket on the left side of the Technical Back E. This Keyboard Unit E is a miniature keyboard with most of the functions of a standard computer keyboard.

Information is stored in the Technical Back E during the exposure of the roll of film. It is imprinted onto the film during the rewind cycle. This imprinting operates when the film rewinds automatically at the end of the roll, it will not imprint if the film is rewound in mid roll or if the rewind cycle is actuated by the film rewind button on the camera. Data imprint appears in a single line along the bottom of the negative or transparency. The brightness of the imprinting light is automatically adjusted to the proper brightness to match the ISO speed of the film in use and can be manually adjusted for certain films which have a higher base density. This is important because the Technical Back E imprints its data through the back of the film. (See note under Quartz Data Back E below.)

In the data storage function, the Technical Back E has two separate data storage modes. In the normal capacity mode 13 types of data can be stored, for a maximum of 361 exposures. The types of data which can be stored are:

1. 4 digit serial number or film cassette number
2. Frame number
3. Shooting mode
4. Metering mode
5. Flash used or not used
6. Shutter speed
7. Aperture
8. Focal length of lens in use
9. Exposure compensation if used
10. ISO speed
11. Date
12. Time
13. Notes

For jobs in which it is anticipated that more than ten rolls of 36 exposure film will be used, there is a reduced capacity mode which stores seven types of data for up to 824 exposures or about 22 rolls of film. In this mode data which can be stored are:

1. 4 digit serial number or film cassette number
2. Frame number
3. Shooting mode

4. Flash used or not used
5. Shutter speed
6. Aperture
7. Focal length

When the entire onboard memory of the Technical Back E has been used, "full" will appear on the LCD panel. At this time, the information stored in memory may be dumped to the Keyboard Unit E making the Technical Back E's memory available for more data storage. This data stored in the Keyboard Unit E can later be transferred back to the Technical Back E once its memory has been cleared.

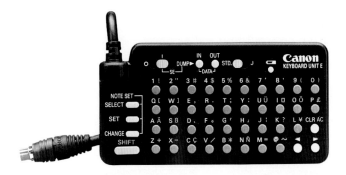

Stored data may be viewed on the LCD panel of the Technical Back E sequentially from the most recent exposure backward. The most practical way to retrieve the stored data, however, is through the use of the Interface Unit TB, the third part of the system.

The Interface Unit TB allows the Technical Back E to be connected to and interface with most standard personal computers. For different parts of the world, the Interface Unit TB is supplied with the applicable software for proper operation. The connecting cable from the Interface Unit TB to the computer is not supplied by Canon and must be obtained from your computer supplier.

Once connected to the computer, the Technical Back E can transfer its stored data to the computer for display, storage on disk or printout as a hard copy. It is beyond the scope of this book to go into detail about this process, which will vary with the type of computer used, but the instruction manual supplied by Canon with the Interface Unit TB covers operation in detail. Having the ability to print out all data for every exposure for a photography job is a wonderful capability. It frees the photographer from taking notes while working, and allows reference back to data, frame by frame, for later evaluation. For technical and scientific recording it can be a very valuable tool.

The Technical Back E also allows for customized exposure programs through its program setting function. When this function is activated the Technical Back E displays a

graph of the program mode on the LCD panel. Two separate graphs may be displayed, labeled program A and program B. Either of these programs may be redrawn to your personal specifications by calling up the set screen and using the up and right buttons to draw in the desired program graph. Once entered, the on-off button is used to activate the drawn graph, which also locks the camera into the program AE mode.

To display the graph at any time you press the menu button. While the graph is displayed, partial pressure on the shutter release button will cause an EV line to appear across the graph. The intersection of this EV line and the program line will indicate the shutter speed and f-stop chosen for that EV value.

The Technical Back E also may be used to operate the EOS 650, 630(600) and 620 cameras in a special auto exposure bracket mode. Up to nine exposures per bracket may be made, varying from one another by as little as 0.25 step.

The last function of the Technical Back E is its use as a timer. This allows the Technical Back E to be a self timer with a delay up to 99 hours, 59 minutes, 59 seconds. It also allows intervalometer control with spacing between exposures from one second up to 99 hours, 59 minutes, 59 seconds. The maximum number of exposures which may be timed in this way is 9. However the Technical Back E may also be used to time groups of exposures, allowing from 1 to 99 groups of exposures to be timed, each group made up of up to 9 exposures. It may also be used to time long exposures, up to 99 hours, 59 minutes, 59 seconds.

The Quartz Data Back E

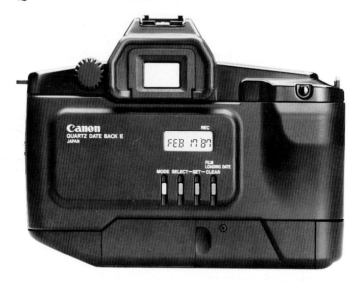

This is one of the more interesting of the EOS accessories, and one which I have enjoyed using. To attach it to the camera you must first open the camera back and remove it. To do this you press down on a small metal pin protruding from the hinge on the upper end and

swing that end away from the camera body, and lift upward to free the back. To attach the Quartz Data Back E you simply reverse the process. The back makes direct contact with the camera body's electronics through a series of electrical contacts along the far right of the camera body.

This special back allows you to record important data directly on to the film during exposure. This is done through a slot in the film pressure plate behind which are a series of tiny alpha-numeric LEDs.

You may record the date of the photo in year/month/day; day/month/year; or month/day/year form. Once you have set the back for the correct start-up date it will automatically keep up with the proper date. If you want to record the time of day of a particular photo, you may set the back for this and it will imprint day/hour/minute.

For technical or record-keeping purposes, you may set the back to imprint any six digit number of your choice. You may also set the back to imprint the frame number as you take photographs. Since this keeps count whether it is imprinting or not, you may also use it to keep track of the total number of exposures taken with a particular camera. In this way I am able to state with some assurance that I have taken 4,340 photos with one of my EOS bodies so far. Although it does not imprint this data, the back also keeps track of each time the camera is loaded and will, on demand, display the date that the film in the camera was loaded. If you are the forgetful type this can help you to remember not to leave a roll of film in the camera for too long.

Of course, you may turn off the imprinting and leave this back on the camera for normal shooting.

When using the Quartz Data Back E or the Technical Back E it is important to remember that they imprint data with light and they can only successfully imprint into dark areas of the image. Keep in mind where the imprint will be, both to keep the area dark and to keep the imprint away from areas of compositional importance. This shot was taken with on-camera flash, with the camera held vertically with the flash to the right so that there is a shadow cast to the left where the imprint is to appear.

The data you have selected for imprinting will appear in the bottom right hand corner of the image. Brightness of the imprinting LEDs is automatically adjusted to match the ISO of the film loaded, making sure that the imprint is clear with most types of film.

NOTE:
If you are the sort who shoots photos with re-spooled motion picture film such as Kodak 5247, be advised that these films have a black Rem-jet backing which will make it impossible for the Quartz Data Back E and Technical Back E to imprint information since it imprints through the back of the film.

The Canon EOS 750 QD

While neither the Technical Back E nor the Quartz Data Back E can be used with the EOS 750 camera, there is a special model of the EOS 750 referred to as the 750 QD which has a permanently attached simplified quartz data back. This camera is capable of imprinting the date only onto the film when desired.

Command Back E1 for EOS-1

This camera back, made for the EOS-1, performs all of the functions of the Quartz Data Back E as far as imprinting is concerned; date, time of day, frame counter number, and an arbitrary 6-digit number, plus the letters A to F. But, as its name implies, its prime function is as a time control for the camera which makes unattended time-lapse photography possible. The interval timer can be set to release the shutter at fixed intervals, which can be from one second to almost a day (23 hours and 59 minutes to be precise). The possibilities are endless, from recording the opening of a flower bud, to the growth of a plant over a month, from changing weather patterns to astronomical studies. The frame counter setting can be used to stop the camera after a set number of exposures. The Comand Back E1 can also act as a self-timer to release the shutter after a predetermined time, or as a long-exposure timer to hold the shutter open for a pre-determined time on 'bulb'.

Power Drive Booster E1 for EOS-1

The built-in motor drive of the Canon EOS-1 can advance the film and fire the shutter at a rate of 2.5 frames per second. This is fast enough for most ordinary purposes, but if you need to capture the right moment in a rapidly changing scene, or a fleeting facial expression, then the Power Drive Booster E1 comes into its own, with a speed of 5.5 fps. For anyone engaged in sports photography, some types of wildlife photography, news reporting – particularly "doorstepping" celebrities – it is an essential tool. But beware! It is not the lazy man's way of getting the perfect picture – press the button and hope that one of the shots will be IT. It goes through film so fast that you could well find that the vital moment was lost because the 36 exposures were already used. Using a motor drive of this speed needs the fine judgement and split-second timing in pressing the release that only comes from experience.

Besides these exciting, heat-of-the-moment applications, the Power Drive Booster E1 is also used in careful scientific and technical work. Examples might be the study of machinery in motion or the gait of an animal.

The Power Drive Booster E1 adds a lot of weight and bulk to the camera, but the combination improves balance and provides a better grip than the camera alone. It also has a shutter release button and an AE-lock on the base. This unique feature makes the camera equally easy to operate in both the vertical and the horizontal formats because these two controls always fall in the same position for the fingers whichever way the camera is held. When it is attached to the camera, it powers the camera as well from its eight size AA cells. Three film wind modes are available with the Booster: S (single frame); CH (continuous at up to 5.5 fps); and CL (continuous at up to 3 fps).

THE SPEEDLITES

Canon call their electronic flash units Speedlite and sell four units designed for general use with the EOS cameras as well as a special unit for close-up and macro.

The Speedlite 160 E

This small unit is designed for use with the EOS 850 and 750 cameras but it can be used with all EOS models. The 160E is powered by a lithium battery and recycles in 0.3 to 0.7 seconds. The flash guide number is 16 metres or 52 feet at ISO 100 which produces a usable range of about 18 feet. This flash uses TTL exposure and can provide automatic fill-in flash in outdoor shooting.

The Speedlite 300EZ

This is the simplest and least expensive of the three advanced Speedlites. Although designed primarily for the EOS 650, 630(600), 620 and EOS-1, this flash may be used in a more limited manner with the EOS 850 and 750. In addition to the simple OTF metering capability of many flash units, this one also has the capability of balancing the light from the flash with the ambient light to allow its use as fill-in flash in contrasty outdoor situations. This is very nice in use because its automation eliminates the complicated process of computing flash to ambient light ratio which used to be required. I have found that the system performs very well, living up to all of the claims Canon has made for it.

This small unit is powered by four common AA size alkaline batteries. It will produce

from 200 to 2,000 flashes from a set of batteries depending on the subject distance. If desired it may also be powered by rechargeable NiCd batteries, but will produce only 65 to 650 flashes per charge.

Recycling time is reasonably short (from 0.3 to 8 seconds). The flash also has a switchable low voltage operation which will speed up the recycling time but at the sacrifice of light output. This operation would be good for use in the continuous film advance mode at moderate subject distances.

Since flash is frequently used below the EV 1 low light limit of the autofocus system, this flash has a built-in system to provide the camera with sufficient light for focusing. This is called the auxiliary pre-flash and provides a burst of near-infrared light when the shutter release on the camera is partially depressed. This will provide sufficient light for the camera's autofocus system to operate up to about twenty feet. If the subject is too far away for the system to operate the flash indicator in the camera's viewfinder flashes as a warning.

The flash is fitted with a zoom head, that is a system in which a concentrating lens moves back and forth inside the head to control the width of the flash beam. When a lens of fixed focal length is fitted to the camera the flash automatically adjusts the width of its flash beam to match the angle of view of the lens. When a zoom lens is used the flash will set itself just prior to each photo to match the zoom setting which is in use.

The Speedlite 300EZ can be used with both standard TTL and A-TTL modes and with second-curtain synchronization, all of which have been described in the chapter ELEC-TRONIC FLASH.

The Speedlite 420EZ

This is the "big brother" of the 300EZ, providing all of the features offered by that unit and a handful of its own.

This flash is about 1/3 more powerful than the 300EZ, and as you can see from the photo is quite a bit larger. It is also powered by four AA size alkaline or rechargeable NiCd

batteries. When used with alkaline batteries it will produce from 100 to 2000 flashes, when used with NiCd from 45 to 300.

The flash head is of the motorized zoom type, just like that of the 300EZ, but the 420EZ has a greater zoom range, covering angles of view to match lenses ranging from 24mm up to 80mm. In the 24mm and 28mm settings the reflector also tilts slightly to provide automatic parallax compensation. As with the 300EZ, the flash interfaces with the camera to sense the focal length of the lens in use, or the zoom setting if the lens in use is a zoom.

For more detailed information on the use of this flash, see our chapter on ELECTRONIC FLASH.

The Speedlite 430EZ

This is the top of the range of Canon's current EOS series Speedlites. It physically resembles the 420EZ, but has expanded capabilities suited to professional use. Instead of a single fill-in flash ratio, it features user-controllable fill-in flash ratios. This is controlled by + and – buttons on the back of the flash and can be set from +3 to –3 in 1/3rd step increments.

Other features are similar to the 420EZ, with a greater stroboscopic rate when set for multi-flash operation. While the 420EZ will fire up to 5 Hz, the 430EZ expands this to 10 Hz.

Because some photographers have had problems with the flash units sliding out of place in the hot shoe and not making proper contact, Canon have devised a new locking system for this flash. When the locking collar on the flash foot is turned a metal pin protrudes from the bottom of the flash foot and fits into a matching hole in the camera's flash shoe. This arrangement firmly locks the camera and flash together into a single unit. At present only the EOS-1 and EOS 630(600) have the extra hole in the flash shoe to accomodate this feature,

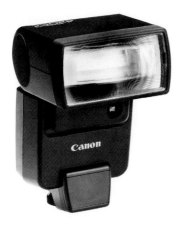

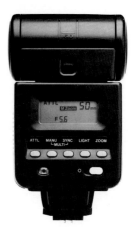

but the flash may be used on all EOS cameras because the locking pin is spring loaded and will retract on all other cameras.

The Speedlite 430EZ features a new flash verification system for use when the light is bounced. This feature works only on the EOS-1 and EOS 630(600) cameras. A short burst of pre-flash is emitted when the camera's shutter release is lightly depressed and the flash sensor determines from this if the actual flash will be sufficient for proper exposure. A more complete description of this is found in the chapter ELECTRONIC FLASH.

Macro Ring Lite ML-3

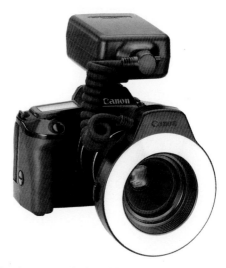

A description of how to use this specialised accessory flash will be found in the chapter ELECTRONIC FLASH.

THE ACCESSORIES

Canon has provided a number of new accessories for the EOS system, some of which are absolutely unique in the features they offer. A few accessories from the older Canon system also may be used with the EOS cameras, and I have made a point of mentioning them below.

Carrying Cases – Straps – Eyepiece Cover

If you are going to use your camera in dirty environments, or simply carry it around a lot and want to preserve its appearance you may want to purchase one of the Canon ever-ready cases. These cases fit over the camera and lens to exclude dust and dirt and are fitted with a front flap which may be opened and dropped out of the way so that the camera may be used without having to remove it from the case. Photographers who work in a hurry generally consider these cases a nuisance because of the time needed to get the front open.

Canon offers three cases for the EOS cameras. The first is the Semi-Hard case S which is for the camera with the 50mm f1.8 lens. The second is the Semi-Hard case L which is for the camera with the 35-70mm zoom lens and the third is the Semi-Hard case LL which will accommodate the camera when fitted with the 35-105mm zoom lens.

An important accessory comes with the camera when you buy it, the carrying strap. You may find that the standard strap and thin rubber shoulder pad as supplied by Canon does not really support the camera to your liking, particularly with a heavy lens attached. Your camera dealer should be able to fit your camera with a wide strap, available from a number of different manufacturers. Just make sure that the strap you get is designed for the strap fittings used by Canon. These are not the same as those used on older cameras, and straps made for those cameras will fit poorly and scratch the finish of the EOS cameras.

The eyecup is removed from the camera eyepiece by grasping the sides and pulling straight up. This allows other accessories to be attached to the eyepiece.

Dioptric Adjustment Eyepieces

Should you find that you have difficulty seeing the whole of the viewing screen with your glasses on, but that you can't see the screen of the camera clearly without them, a series of Dioptric Adjustment Eyepieces is available from your Canon dealer. You should first find out from your optician what the prescription is for your viewing eye and if you have astigmatism. If you have no astigmatism you may get your dealer to order an appropriate diopter value eyepiece from Canon. These are available in diopter values from +3 to –4 and clip on to the frame of the existing eyepiece to allow you to clearly see the viewfinder screen without your eyeglasses. If you have significant astigmatism these factory eyepiece lenses will not work for you, but you may be able to have one custom ground by a good optical laboratory.

Eyepiece Magnifiers and Right Angle Finders

Should you find that you need to do critical manual focusing with your EOS camera, perhaps through a microscope or telescope, you will want to obtain the Canon Eyepiece Magnifier S. This slips on over the viewfinder eyepiece frame and magnifies the central part of the viewing screen 2.5 times. The eyepiece of this magnifier is adjustable for variations in eyesight ranging from +4 to –4 diopters. Because of the magnification you cannot see the whole viewfinder screen through the magnifier, just the central portion, but the magnifier is hinged so that it may be quickly flipped out of the way after you have focused.

Sometimes you may want to use your camera to take photos from positions which are difficult to get into. For example when working with a macro lens you may want the camera down low practically at ground level. You can always lie down on the ground, but that may not be comfortable and you may still not be able to get the angle you want for the photograph. For these situations Canon offers the Angle Finders. These are telescopic eyepiece extenders which have a right angle prism or mirror inside. When attached to the camera they allow viewing by looking down into the top of a chimney-like tube.

Canon offers two versions of these useful accessories. The less expensive Angle Finder A2 uses a simple mirror to reflect the image at a right-angle. This has the disadvantage of reversing the image left to right. I personally find this very difficult to work with and really do not recommend it. The second model, Angle Finder B is equipped with a prism viewing system which makes the image come out right way round. This is much easier to use! Since the part of the angle finder which mounts on the eyepiece is a swivel, the finder can be rotated to allow viewing from the side, the bottom or any angle you wish. When using the camera on a copy stand to take photos pointed straight down one of these devices will save many a sore neck.

Both models are fitted with eyepieces which can be adjusted for individual eyesight variations through a range of +2 to –4 diopters.

One important accessory comes with the camera and you might not realize that you have it, or what it is for. In the middle of the shoulder pad supplied with the Canon neckstrap is a small rectangular rubber piece which snaps out of the pad. This is an eyepiece cover. If you use your camera on a tripod or stand and do not keep your eye to the eyepiece there is a possibility that light coming in through the eyepiece can cause the camera's light meter to give an incorrect exposure. For this reason you should use this small rubber cover

over the eyepiece under these types of situations. To put the eyepiece cover on the camera you will first have to remove the rubber eyecup. This is done by grasping it on both sides and sliding it upward and off the camera. The rubber cover is then slid into its place.

Viewing Screens

The image you see when you look into the viewfinder is focused by the lens onto a small plastic screen with a specially treated surface. The one supplied with the camera is the **Type C or Overall New Laser Matte/AF Frame** type. It is usable with all lenses and forms a bright, contrasty image which is good for viewing and works well for manual focus as well. The other screens are suited for specific purposes. All screens are marked with a circle to indicate the field of view of the spot meter.

If you should decide that you want to try some of the other screens, be very careful when changing them. The screens are supplied in a storage box and come with a special tweezer-like tool which is used to change them. Use only this tool, do not try to make the change with your fingers. If the screens become dirty, remove them from the camera and clean with a soft brush and compressed air. Do not shoot a stream of high-pressure air up into the camera to try to clean the screen. If you only have the screen which came with the camera and it becomes dirty, it would be best to have a technician clean it for you unless you can borrow one of the screen changing tools. When changing screens follow the instructions packed with the replacement carefully.

The Type A or Microprism screen is used with lenses of maximum aperture of $f5.6$ or larger to aid in manual focusing. This makes use of a central area of the screen which is covered with an array of tiny pyramid-shaped prisms (Dodin prisms) which cause a shimmering effect in an out of focus image. When the lens is in proper focus this shimmering disappears.

The Type B or New Split is usable with all lenses. In the centre of the screen is a split image rangefinder prism which will assist in manual focusing. When the image is out of focus the split image rangefinder will show two portions of the image horizontally displaced. As the focusing ring of the lens is turned these two displaced part of the image can be brought together. Once they are lined up the image is in focus.

The Type D or Laser Matte/Section is made with a surface similar to that of the standard Type C screen supplied with the camera. It is engraved with a grid pattern which is useful in architectural and technical photography where the placement of the image must be critically controlled. This is the screen to use with a tilt-shift lens.

The Type H or Laser Matte/Scale screen is engraved with a measuring reticule calibrated in millimetres. This is useful in scientific photography, particularly photomacrography, in which the exact reproduction ratio must be determined.

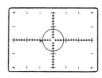

The **Type I or Laser Matte/Double Cross-hair Reticule** is equipped in the centre with a clear circle engraved with double cross-hairs. This is the type of screen which is used for aerial image focusing as would be used with a microscope or telescope. Focusing is done by moving your head back and forth from left to right while changing the focus. When the apparent motion of the cross hairs on the subject stops and both seem to move as one, focus has been achieved.

The **Type L or Cross Split Image** is a special form of the split image rangefinder used in screen type B. Instead of splitting the subject in half horizontally, this splits it into four quarters in both horizontal and vertical planes. When all four quarters of the image line up it is in focus. This may be used with lenses having a maximum aperture of ƒ5.6 or faster.

The Handgrips

The EOS 620 camera is supplied with the GR20 grip as standard equipment. This grip is fitted with a remote control terminal, but is otherwise the same as the GR30 which is supplied with the EOS 630(600) and 650 cameras.

The GR20 is available as an accessory to convert the EOS 630(600) and 650 for use with remote switches.

An accessory grip the GR 10 (also called Grip L) is available for the EOS 650, 630(600) and 620 for those with larger hands. It is fitted with a leather strap which goes around the hand for more comfortable holding and shooting. This grip does not have the remote control terminal.

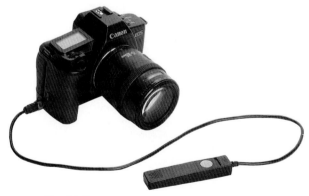

The Remote Switch

The Canon Remote Switch 60T3 is a necessity if you want to trip the camera from a distance. It also helps to prevent camera vibration when taking time exposure photographs by isolating the camera from any vibration which the photographer might induce in pressing

the shutter release button. The Remote Switch consists of a small control box and a cable with a special fitting. It is attached to the camera by unscrewing the plastic protective plug from the socket in the GR20 grip and screwing in the cable fitting. The camera may then be operated from the release button on the Remote Switch. Additionally this button is equipped with a lock so that it may be set and need not be held in for long exposures. The Remote Switch 60T3 is approximately one metre in length. If this is not long enough for your purposes, Canon also makes an extension cable called 1000T3 which is ten metres (33 feet) in length.

If you wish to use EOS cameras in addition to another existing system, you may already have long cable releases or air bulb releases. These cannot be used directly on the EOS cameras because there is no socket for them. An adapter which converts the GR20 grip's electronic socket to a standard fitting for a mechanical cable release is available (Canon code T3).

When the longest cable is not long enough, Canon also make a device for cable-free operation – the Wireless LC-1. It has a receiver and transmitter. The receiver fits into the camera's flash shoe and is attached to the release socket in the GR20 grip by a short cable. It is sensitive to a pulse of infrared radiation which is produced by the transmitter. The transmitter is hand-held, aimed at the receiver and will fire the camera up to a distance of 200 feet. A Remote Switch Adapter T3 is also required for use with the LC-1 set.

An interesting accessory from Canon is the Wireless LC-2. This allows unmanned operation of the camera in surveillance photography. It consists of a transmitter and receiver also, but operates on a different principle. The receiver is attached to the GR 20 grip on the camera by its cable and then placed near the anticipated location of the subject. The transmitter is set up nearby and aimed at the receiver. Once the system is in place it will automatically take a photograph of anything which interrupts this infrared beam. When set up in this way this unit is excellent for scientific use, such as taking an automatic population survey of animals passing along a game trail. I'm sure you can think of many other uses for this accessory.

The Lens Hoods

A lens hood or lens shade is a tubular device which fastens to the front of the lens and extends outward enough to keep stray light from coming in at an angle and causing lens flare. Although modern lenses are much less prone to this problem because of the use of multicoating and internal baffles, the problem can still occur under strong lighting or with a very bright light source just outside the picture area.

Additionally, lens hoods protect the front of the lens from physical impact.

Because of the way in which they operate, the moving parts of Canon's EF lenses must have low mass and low friction. Anything which adds an extra mass or drag to the focusing mechanism should be avoided. For this reason, standard lens hoods from other suppliers which screw into the threaded front rings of the lenses should not be used. This threaded ring should be reserved for the attachment of filters. Only the special lens hoods made by Canon should be fitted to these lenses. These special lens hoods attach to the front of the non-moving part of the lens barrel which is made from a shiny black plastic and has a groove. The Canon lens hoods snap into this groove.

CLOSE-UP DEVICES

Bellows Units and Extension Tubes

Normal lenses such as the Canon EF 50mm $f1.8$ focus by moving the entire optical section as a unit. The more this is extended the closer the focus. For design reasons there are limits to how far it is practical to have such a lens extend. This is why special macro lenses with greater extension are made, but such lenses are usually much larger than standard lenses and slower as well. For the person who does not do enough close-up photography to justify a macro lens a less expensive alternative would be the Close-up Lenses described later.

To take photos with the normal lens, or other lenses, at very close distances some photographers prefer to use extension between the camera and the lens. This can be done in two ways, with a set of tubes and with a bellows.

At the time of writing only independent suppliers offer extension tubes or bellows for the EOS system. An extension tube set is a set of (usually) three tubes of different lengths which can be used singly or combined to produce the desired range of extension. Because they maintain full electrical connection between the camera body and lens there is no necessity to make special compensation for the exposure change caused by the tubes, so long as used in automatic exposure or OTF flash modes. Lenses designed for normal photography will generally function well with extension tubes so long as the subject does not require a flat field and the lens is stopped down at least three stops from wide open.

Bellows units operate in the same way as the tubes but because they use a light-tight cloth bellows, extension may be infinitely varied and you are not restricted to the specific increments of extension provided with the tubes. When used with the Canon Speedlites and the Macrolite for the EOS system full automation is maintained for OTF automatic flash exposure. Of course, the camera's other non-flash automatic modes will work as well.

Close-up Lenses

If you find that the closest focusing limits of your lenses are a frustration, but you are not yet ready to make the investment in a macro lens, close-up lenses are a good alternative. These are simply magnifying lenses which are mounted in threaded rings like filters and screw into the front of the lens.

Although numerous firms make close-up lenses, the cheapest ones are usually not of very high optical quality. Even the best will not equal the resolution of a macro lens, but will not be too far off for general photography.

Canon make close-up lenses of a special, high quality type to match the quality of their lenses. These are offered in two powers and in several screw-in sizes. Unlike the cheaper lenses these are optically ground, two element achromatic magnifiers.

For general close-up photography these lenses will work very well with most lenses. It is a good idea not to try to use them at the widest apertures, stopping down two or three stops from wide open will provide much better quality.

7: Appendix

Maintenance

Keeping your camera clean will keep it in working order and eliminate most trips to the camera repair shop. It is a good idea to perform a basic dusting off at least once a week even if you do not use the camera heavily, and if you do use the camera heavily this should be done more often.

To clean the outside of the camera you will need a blower to provide a stream of pressurized air at a safe pressure and a soft brush. You may use one of the combination blower-brushes sold in photo shops if you like, but I prefer to have the two as separate items. The blower which I prefer does not come from a camera shop at all but from a pharmacy, it is sold as an ear syringe. The ones I like best are large and made from soft natural rubber. The brush I have found best is a number 7 or larger artist's red sable brush, but if you buy one of these do not buy the more expensive grades, you do not need them for this purpose.

I use the brush to loosen dust and dirt and then the blower to get rid of it. If you like the outer surfaces of the camera except for the lens glass and viewfinder glass may be wiped with one of those silicone impregnated cloths also sold in photo shops.

To clean the front surface of the lens use the brush to loosen any adhering particles and the blower to blow them off. For greasy spots and water spots you will need to have some lens cleaning tissue and lens cleaning fluid on hand. This is a special tissue which does not produce lint and has no abrasive components. In an emergency you may use ordinary facial tissue, but be very careful not to scratch the lens. To use the tissue, fold it over several times and then tear it across to produce a fluffy end surface. Wipe the lens gently in a spiral motion, starting at the centre and working outwards. Then blow away any debris with the blower. If you have a stubborn spot which this does not remove, dampen a fresh piece of lens tissue (also folded and torn) with just a drop of the lens cleaning fluid and repeat the spiral wiping motion. Repeat this with a new piece of tissue each time until the spot or smear is gone. Never apply the cleaning fluid directly to the lens as it may run down around the edges of the glass and cause damage. Never use any liquid other than lens cleaning fluid or distiled water. Only in an emergency you may use a little cologne water in place of the lens cleaning fluid.

Although it is unlikely that it will need cleaning if handled properly, the rear lens element should be cleaned in the same way as the front lens.

Use the same technique to clean the glass in the viewfinder window. You need not exercise as much caution here as this glass is much harder than the glass used in the lenses.

The reflex mirror, visible inside the camera lens mount when the lens is removed, is probably the most delicate part of your camera. It is so easily damaged that it is best not to try to clean it other than an occasional light blowing away of dust. Any grease, water spots or fingerprints should be cleaned off by a professional.

To clean the interior of the camera, use your brush and blower. Hold the camera pointing upward with the back held open (or removed) for the final blowing so that any debris will fall downward out of the camera. Be very careful not to touch the shutter while

doing this. Next to the reflex mirror, the shutter curtains are probably the easiest part of the camera to damage.

Periodically it is a good idea to wipe down the film pressure plate (the spring loaded plate inside the camera back) and the film guide rails (the polished metal surface along which the film travels). The best thing to use for this purpose is a soft cloth dampened with a mixture of distilled water and a little dishwashing detergent. I use a mixture of about two drops of Joy brand in a film can filled with distilled water. This cleans the area and leaves a thin coating of detergent which has anti-static properties.

Under normal use this is all you should have to do to keep everything in prime operating condition. In unusually dusty environments or at the beach it is important to keep the camera as clean as possible. Just a few grains of sand can do great damage to the autofocus mechanism of the lens. If you must take photos in such dusty or sandy locations, here's a tip I have used. After loading the camera, put it into a medium sized plastic bag, after first cutting a hole the size of the front of the lens. Hold the bag to the lens with a rubber band, putting the rubber around the non-moving part of the lens where the groove for lens hood attachment is. Allow some of the plastic to extend ahead of the band to form a protective shade for the lens. The bag can then be sealed shut and nothing can get inside. This will not protect the lens totally, as grit can still get into it, but the likelihood will be less. This same plastic bag trick also works well in wet weather to keep the camera dry. With the EOS cameras all of the normal controls can be operated right through the bag.

If your camera malfunctions please do not attempt to fix it yourself. These are highly advanced machines with electronic control and the amount of damage you could do would likely greatly increase the ultimate repair bill. If you do take your camera in for repair, make certain that the repairman who works on it has been trained in the service of these cameras.

Shooting Capacity

The following are Canon's estimates for battery life based on starting with a new 2CR5 battery and operating the camera in the Continuous winding mode and using Canon's standard test conditions.

EOS-1, 650, 630 (600) and 620

Temperature	No. 24 exp.Rolls	No. 36 exp.Rolls
Normal (20°C)	150	100
Cold (–20°C)	15	10

EOS 850 and 750

Temperature	No. of 24 exposure Rolls	
Normal (20°C)	75 no flash	40 w/ 30% flash use
Cold (-20°C)	35 no flash	25 w/ 30% flash use

EOS Specifications at a Glance

Type:
35mm Single Lens Reflex type. Uses standard double perforation 35mm film in cassettes. Automatic and manual focus. Automatic (all models) and manual (EOS-1, 650, 630 (600), RT and 620) exposure. Film advance and rewind by built-in motor.

Construction:
Composite body design using metal central casting to which all important components are attached and balance of body made from glass fibre reinforced resins. Top cover double plated with metal for shielding of electronics from interference. Tripod socket in bottom of camera body is metal and attached to central metal casting.

Format:
24 x 36mm (1 x 1 $^1/_2$")

Lens mount:
Canon EF Mount, total electrical information transfer system.

Viewfinder:
Fixed eyelevel viewing through pentaprism. Viewing screen shows 100% of actual image area in EOS-1, 94% in all other EOS cameras, approximately the same area visible in a mounted slide. Viewfinder magnification 0.72x in EOS-1, 0.8x in all other EOS cameras, with 50mm lens. Eyepiece of the EOS-1 can be adjusted from –3 to +1 dioptres by a knob on left of eyepiece. Eyepiece of all other EOS cameras is set for standard of –1 dioptre, accessory dioptric lenses available. EOS 850, 750, 650, 630(600), RT and 620 exit pupil apparent diameter: 19.3mm. Apparent distance of viewing screen: approx. 1 metre.

Viewing screens:
Overall new laser matte with autofocus frame is provided as standard. Six optional types available for 650, 630(600) RT and 620. All show area of partial metering as well as autofocus frame.

Seven optional screens available for EOS-1. All show area of partial metering and spot metering as well as autofocus frame.

Mirror (except for RT):
Quick-return motor driven. Shock damped. Central portion semi-silvered for transmission of autofocus image to sensor via secondary mirror hinged to back of main mirror.

Metering:
TTL full aperture metering using six-area SPC. Two metering patterns, overall evaluative and partial in 650, 630(600), RT and 620; three metering patterns, overall evaluative, partial and spot in EOS-1. Evaluative only in 850 and 750. Stopped down metering is not possible with EF lenses but may be used with lenses and accessories from other makers on the EOS-1, 650, 630(600), RT and 620.

Metering range:
EOS-1: EV 0 to EV 20 at ISO 100, evaluative and partial metering. EV2 to 20 at ISO 100 spot metering. EOS 650, 630(600), RT and 620: EV –1 to EV 20 at ISO 100. EOS 850 and 750: EV 1 to EV 18 at ISO 100

Film speed range:
Automatic film speed setting from DX-coded cassettes between 25 and 5000, with manual settings from 6 to 6400, non-DX-coded cassettes cause camera to default to ISO 100, on EOS-1, 650, 630(600), RT and 620. On EOS 850 and 750 automatic film speed setting from DX-coded cassettes between ISO 25 and 3200, non-DX-coded cassettes cause camera to default to ISO 25 on EOS 850 and 750.

Exposure compensation:
+ or –3 steps in 1/3 step increments on EOS-1
+ or – 5 steps in 1/2 step increments on 650, 630(600), RT and 620.

Auto Exposure Bracketing:
+ or – 3 steps in 1/3 step increments on EOS-1
+ or – 5 steps in 1/2 step increments on 630(600), RT and 620. Auto Exposure Bracketing on 650 only with Technical Back E.

Multiple Exposure:
Up to nine exposures per frame on EOS-1, 630(600), RT and 620. More possible through manual defeat of system (see text MULTIPLE EXPOSURE). Multiple exposures possible on 650 only with Technical Back E.

Audible signals:
Camera has two audible signals, one for autofocus confirmation and a second to warn if the shutter speed is too low for hand held photos. Audible signals can be turned off if not wanted on EOS-1, 650, 630(600), RT and 620. 850 and 750 also have audible battery test.

AF sensitivity range:
EV –1 to EV 19 at ISO 100 with EOS-1
EV 1 to EV 18 at ISO 100 with all other EOS cameras. Assisted below sensitivity threshold by auxiliary preflash from LED in Canon Speedlites 300EZ, 420EZ and 430EZand by built in illuminator on 750.

Shutter:
Special, high speed vertical shutter on EOS-1 with speeds form 30 seconds up to 1/8000th second, flash synchronization up to 1/250th second.
 Vertical travel electronically timed EMAS module on all other EOS cameras. Metal plated plastic blades. Speeds from 30 seconds to 1/4000th second on 620, up to 1/2000th on other models. Flash synchronization up to 1/250th second on 620, up to 1/125th on other models.

Self timer:
Electronic. Approximate 10 second delay. Operation confirmed by blinking countdown light on EOS-1, 650, 630(600) and 620, by an audible signal on 850 and 750. EOS-1 also has 2 second delay.

Film loading and advance:
Automatic take-up if film is inserted properly. Motorized film advance by motor inside take-up drum. EOS 850 and 750 feature automatic loading with film pre-wind which winds film fully to the end when loaded and rewinds frame by frame as photos are taken.

Film rewind:
EOS-1, 650, 630(600), RT and 620: Automatic film rewind triggered by frame counter and information derived from DX-code on cassette, triggered by film tension sensor on rolls of odd length or non-DX-coded cassettes. Impossible to shoot more than 36 exposures. Rewind is motorized, uses same motor that cocks shutter and moves mirror.

Because the EOS 850 and 750 rewind the film frame by frame as it is exposed, there is no need to rewind at the end of the roll.

Depth of field preview:
EOS-1, 650, 630(600), RT and 620: Electronic system operates diaphragm motor to stop down lens aperture.

Power source:
One lithium battery pack type 2CR5. Six volts. Optional power from 8AA cells on EOS-1 when used with power booster E1.

Body dimensions:
EOS-1: 160 x 105 x 74mm (6 6/10 x 4 1/3 x 3in)
EOS 650, 630(600), RT and 620: 148 x 108 x 67.5mm (5 13/16 x 4 1/4 x 2 5/8in)
EOS 850: 149.3 x 97.2 x 69.5mm (5 7/8 x 3 13/16 x 2 3/4in)
EOS 750: 149.3 x 102.2 x 69.5mm (5 7/8 x 4 1/16 x 2 3/4in)

Body weight:
EOS-1: 1 Kg (35 oz approximately)
EOS 650, 630(600), RT and 620: 640g (22oz)
EOS 850: 600g (21oz)
EOS 750: 660g (23oz)

8: Stop Press!

Close to press time for this book, Canon introduced a number of new products. We wanted our EOS book to be a complete as possible, so we have added this section on the new cameras and lenses.

The Canon EOS 10

This camera is the first of a totally new generation of EOS cameras, with some interesting and unusual features. It will be sold as the EOS 10, EOS 10S and EOS 10SQD in various parts of the world. The EOS 10SQD version features a date imprinting capability in addition to the other features discussed.

Because Canon found that some users of the earlier EOS camers were not happy with the system of operating the camera through push buttons and the control wheel, they have deleted the buttons from the upper left top of the camera and replaced them with a new control dial. Most users will appreciate this change as it is indeed faster to operate than the other system. It also makes it possible to determine the mode to which the camera is set without reference to the LCD panel.

Other styling changes have produced a camera which handles and looks more like the EOS-1 than the EOS 600 series camera. Great attention has been given to simplifying and speeding up all operations, even down to the loading of the battery. To change the battery in the EOS 10 you simply open the hinged door on the bottom of the hand grip, slip out the old battery and slip in the new.

Film leading has been simplified with a new advance system which does not use a traditional sprocket wheel. Instead, the film is pushed across a small metering roller which governs the correct framing, and has proven in my test to be accurate. Not only is it more accurate in film spacing, it speeds up film loading by slicing seconds off the procedure.

The EOS 10 is the first camera to offer custom programming through an accessory bar-code reader. This reader is supplied with a book featuring examples of 23 different types of photography. Accompanying each illustrative photo is a bar code which will set all of the camera's controls to produce that type of image. You simply set the camera's control dial to the bar code mode, activate the bar code reader by pressing the button on it, run its reader tip across the bar code from left to right, and then place the opposite end of the bar code reader against the receiver (below the EOS name on the bottom front of the camera) and press the button again to feed the information into the camera. The LCD panel with then display the number of the bar code so that you can make certain that the transfer has taken place properly. Bar codes are provided for several types of portraits, pictures of children, several typical types of wedding photos, a selection of landscape and close-up types, and some special types of images which do not fit any of the other categories, such as interiors with stained glass windows. Additional bar code books will be available later with other types of images. I found this rather unusual method of programming the camera worked very well once I got the knack of operating the bar code reader, which is very sensitive to the speed and smoothness of the scanning action. However, if it has not scanned

properly it lets you know this by not beeping; the beep assures you that the bar code has been registered properly in the reader.

In addition to the bar code mode, the control dial has icons to denote action-stopping mode, close-up mode, scenic landscape mode and portrait mode. These are the modes used most often, and having them onboard instead of in put by the bar coder is a great convenience. Additionally, the camera features the "green zone" programme as found on the EOS 600 series cameras, and the same programme, aperture priority, shutter priority, depth-of-field, and manual modes found on the EOS 600 series cameras.

The camera features a small built-in flash which will pop up automatically from the top of the prism housing and fold away again when not needed.

The greatest operational improvement in the EOS 10 is in the autofocus sensor system, which now has three separate sensing areas. One is placed centrally, and reads both horizontal and vertical contrasts, while the other two are placed to the right and left, at mid-positions, and read only horizontal contrast. All three are indicated by the viewing screen by scribed rectangles. The camera has an onboard computer program which allows it to determine which sensor is likely to be more important to the subject and automatically to select that sensor. The sensor chosen is indicated by a brief flashing red outline which appears on the viewing screen directly, a totally new type of display technology specifically for this camera. Should the photographer prefer it is possible to select any of the sensors manually by pressing the large button with the right thumb and moving the control wheel. The LCD will then indicate which of the three sensors is active. In the automatic sensor select mode it is possible to focus track a moving subject as it moves across the screen by first letting the camera lock on to the subject with the central sensor, and then composing the photograph. The sensors will then switch automatically as the subject crosses the field. A unique and innovative system.

Built into the camera body is a receiver for an optional infra red remote control unit. This allows control of the camera from up to 5 metres away. It also allows a choice between instantaneous release and a two-second delayed release.

The EOS 10 also expands the number of custom functions to fourteen. These are:
1) film rewind cancel
2) film leader in or out after rewind
3) cancel automatic DX setting of ISO film speed
4) switch autofocus activation to partial metering button
5) change from aperture control to shutter control by control wheel in manual exposure
6) turn camera shake warning on/off
7) allow manual focus with USM lenses
8) turn autofocus auxiliary light (built into camera) on/off
9) lock AE w/flash to 1/125th second
10) turn off autofocus sensor indicator system in viewfinder
11) convert partial metering button to depth-of-field preview
12) switch AE lock from evaluative to partial metering
13) mirror pre-release when self-timer used on/off
14) cancel speed limit function which prevents shutter speeds slower than 1/focal length

Other features of the camera are basically identical to the EOS 600(630), and it is expected that the EOS 10 will ultimately replace both the 650 and 600(630) models. There

will definitely be other new EOS models based on the same basic body as the EOS 10, but with other innovative features.

The Canon EOS 700

This new model upgrades and replaces the EOS 750. The control dial on top of the camera now features a number of icons to represent the various Programmed Image Control modes. Modes are:
- landscape
- portrait
- deep focus (depth priority program as distinguished from the automatic depth of field mode)
- indoor or party (symbolized by an icon of a cocktail glass)
- close-up
- stop action (programme favouring higher shutter speeds)
- flowing (programme favouring slow shutter speeds good for panning with action)
- slow synch fill-in flash (gives proper ambient light exposure to backgrounds while freezing foreground with flash)
- depth-of-field mode
- standard programme

Additional icons on the control dial allow setting of the self-timer and a battery test.

The most innovative feature of the camera is that this control dial can be removed, by loosening the knurled thumb-screw in the centre, and flipped over. On the reverse side, the dial is marked with shutter speeds from 1/2000th down to 1/4 and B. Attaching the dial in this orientation converts the camera to a traditional shutter priority automatic exposure system. Users of Canon's AE-1 and AE-1 Program cameras who wish to enter the EOS system may find that this system makes them most comfortable with the EOS 700.

Introduced with the EOS 700, and initially sold only as a package with the camera is the new 35-80mm ƒ4-5.6 power zoom. The new lens has a motorized zoom control operated by two buttons on the lens barrel and omits the manual zoom and focus rings completely. Optical construction is 7 elements in 7 groups, one of the elements being Canon's first use of a moulded optical plastic aspheric element in an SLR camera.

New EF Lenses

Four new EF lenses in addition to the 35-80mm motorized zoom have been introduced. Three of these feature a totally new USM drive system. The original USM was only suitable for lenses of high aperture because the workable diameter of the motor itself was quite large. Also, production levels forced the original USM to be quite expensive, and this limited to special, high-performance lenses. Canon's research staff worked long and hard to solve these problems, and have now come up with a revised USM which uses much smaller mating plate surfaces and allows the USM to replace the AFD in lenses of smaller diameter and more moderate cost. These new USM lenses will replace the current AFD lenses of similar specifications.

The EF 35-135mm ƒ4-5.6 U is a great lens for general photography, encompassing the most commonly used focal lengths all in one compact unit.

The EF 70-210mm ƒ3.5-4.5 U is the general use telephoto best suited for most photographer's needs.

The EF 100-300mm ƒ4.5-5.6 U would be the perfect lens to combine with the 35-135mm for an ideal two lens system. With only minimal overlap you have everything from moderate wide-angle to moderate telephoto in two compact lenses.

All three of these new USM lenses feature internal focus so that the barrel length does not change during focus and the front filter ring does not rotate.

The EF 100mm ƒ2.8 Macro was also introduced at the same time as the above lenses. This, however, does not use a USM drive system, since the ultra long extension necessary to provide focus all the way to 1:1 without adaptors was judged inappropriate for that system. The new macro uses an entirely different motor from any of the other EF lenses, a coreless shaft motor which uses a long shaft and worm gear to move the lens barrel. The lens also incorporates a focus limiter control for those situations in which the photographer knows in advance the approximate distance range to be used and wants to prevent the lens from searching through its entire focusing range.

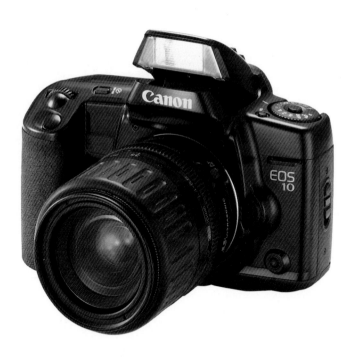

9: Index